Elderpark Library

228a Langlands Road Glasgow G51 3TZ

Phone: 0141 276 1540 Fax 276 1541

This book is due for return on or before the last date shown below. It may be renewed by telephone, personal application, fax or post, quoting this date, author, title and the book number

Glasgow Life and it's service brands, including Glasgow Libraries, (found at www.glasgowlife.org.uk) are operating names for Culture and Sport Glasgow

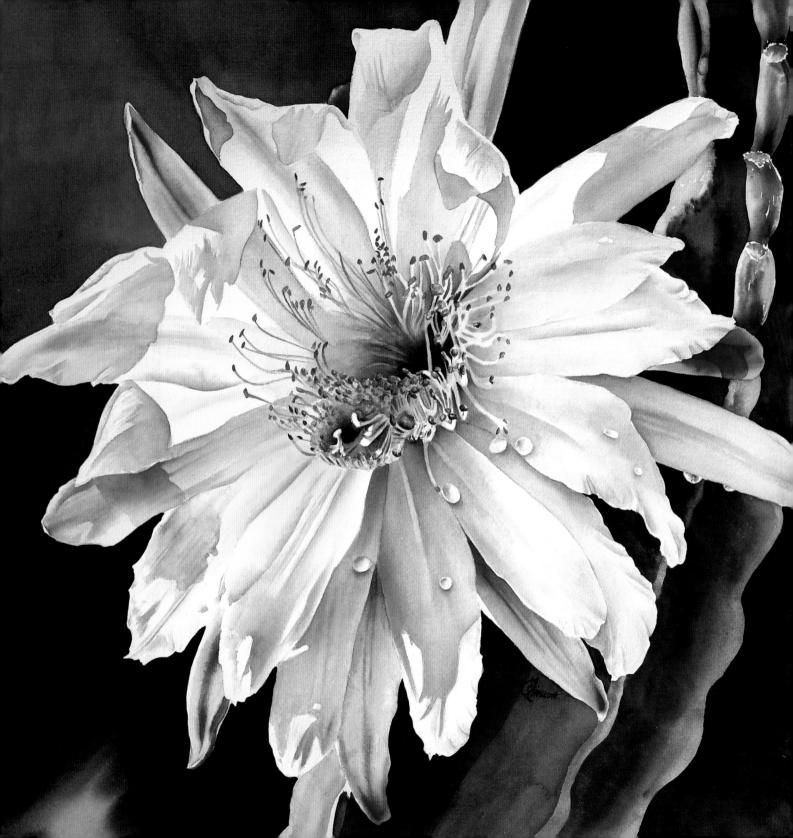

THE ENCYCLOPEDIA OF Watercolour TECHNIQUES

Hazel Harrison

A QUARTO BOOK

This edition published in 2017 by Search Press Ltd. Wellwood, North Farm Road Tunbridge Wells Kent, TNR 3DR United Kingdom

Previously published by Search Press Ltd. as The Encyclopedia of Watercolour Techniques in 2004, and The New Encyclopedia of Watercolour Techniques in 2011.

Copyright © 2004, 2011, 2017 Quarto Publishing plc

All rights reserved. No part of this publication may be reproduced, stored in a retrieval system or transmitted in any form or by any means, electronic, mechanical, photocopying, recording, or otherwise, without the written consent of the copyright holder.

ISBN: 978-1-78221-604-9

Conceived, designed and produced by Quarto Publishing plc an imprint of The Quarto Group The Old Brewery 6 Blundell Street London N7 9BH www.quartoknows.com

QUAR:EWTN

Printed in China

10987654321

Page 2, Caroline Linscott, Catching the Last Light I (detail)

Contents

Introduction	6
TOOLS & TECHNIQUES	8
CHOOSING PAINTS	10
MEDIA	13
BRUSHES AND OTHER TOOLS	14
PAPER	16
SETTING UP A WORKING AREA	18
WORKING OUTDOORS	20
PRIMING PAPER	22
FLAT WASH	24

GRADED WASH	26
VARIEGATED WASH	28
WET-ON-DRY	30
WET-IN-WET	32
BLENDING	34
HARD EDGES	36
GLAZING	38
BACK RUNS AND BLOSSOMS	40
FEATHERING AND MOTTLING	42
LIFTING OUT	44
SPRAYING WATER	46
GRANULATION	47
RUNNING IN	50
BRUSHWORK	52
BRUSH DRAWING	54
DRY-BRUSH	56
TONED GROUND	58
LINE AND WACH	10

RESERVING HIGHLIGHTS	62
SCRAPING BACK	64
MASKING	66
WAX RESIST	68
SPONGING	70
SPATTERING	72
BLOTS AND DROPS	74
USING SALT	76
SCUMBLING	78
CREATING TEXTURE	80
BODY COLOUR	82
MIXED MEDIA	84
CORRECTING MISTAKES	88

PICTURE MAKING 90

CHOOSING PAINTS	92
COMPLEMENTARY AND ANALOGOUS	
PALETTES	94
CHOOSING A PALETTE	96
COLOUR MIXING AND OVERLAYING	100
ANALYSING TONE	102
MAKE A TONAL PANEL	104
LIGHT AND SHADOW	106
WORKING WITH LIGHT SOURCES	108
PERSPECTIVE	110
ORDER OF WORKING	112

THEMES	114
THE ANIMAL WORLD	116
BIRDS	118
MOVEMENT	120
DOMESTIC AND FARM ANIMALS	122
BUILDINGS	124
TOWNS AND CITYSCAPES	126
DETAILS AND TEXTURE	128
INTERIORS	130
BUILDINGS IN LANDSCAPE	132
THE FIGURE	134
FIGURE STUDIES	136
PORTRAITS	138
THE FIGURE IN CONTEXT	140
GROUPS	142

I FLOWERS	144
SINGLE SPECIMENS	146
COMPOSITION	148
NATURAL HABITAT	150
I LANDSCAPE	154
TREES AND FOLIAGE	156
ROCKS AND MOUNTAINS	158
CLOUD FORMATIONS	160
WATER	162
REFLECTIONS AND STILL WATER	164
LIGHT ON WATER	166
STILL LIFE	168
FOUND SUBJECTS	170
ARRANGING GROUPS	172
INDEX AND CREDITS	174

AHOOMANA CARA BROWN

Introduction

Artists have been painting in watercolour for centuries, yet this traditional and time-honoured medium can also be one of the most exciting and innovative. This book covers the subject of watercolour in the broad sense of the term, suggesting ways of working with gouache and acrylic as well as explaining the techniques associated with transparent watercolour. In addition to the comprehensive techniques section, there is a superb gallery of paintings by a number of leading artists, demonstrating the huge array of styles and effects that can be achieved.

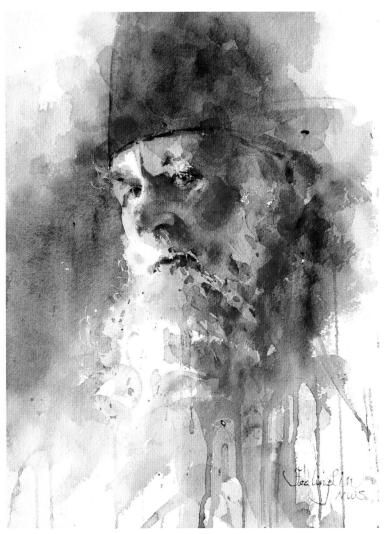

AJUST A THOUGHT FEALING LIN

∢GUBBIO MICHAEL REARDON

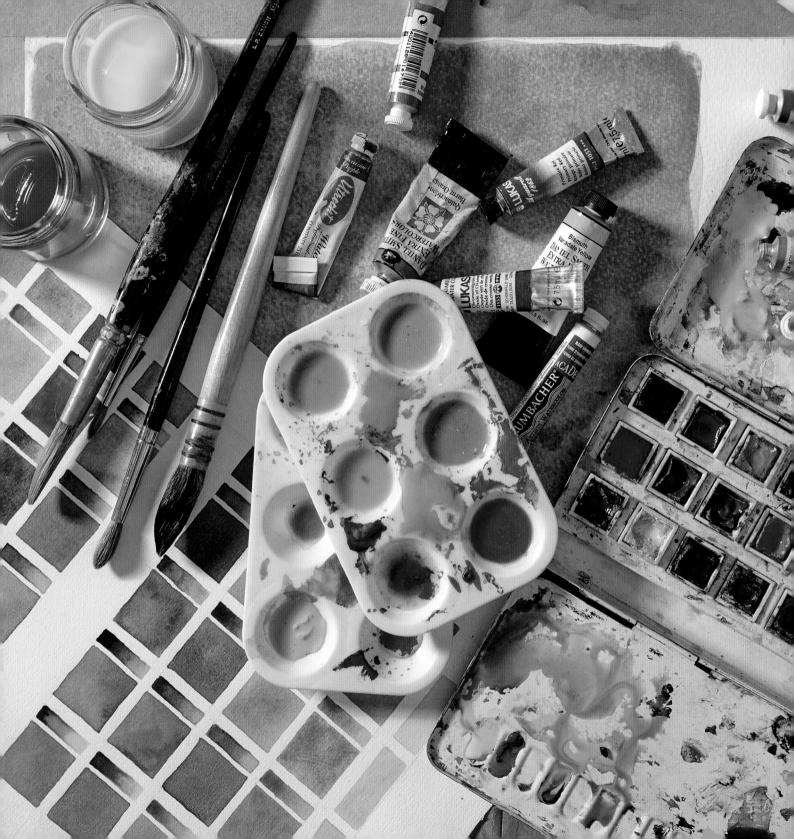

Tools and Techniques

Paints, paper and brushes are the watercolourist's essential toolkit. A sound knowledge of the materials that are available, their uses and the effects they can produce will make painting a more enjoyable process and ensure better results. There are other practical concerns to consider, too, such as caring for tools, setting up a workspace, what equipment to buy – and learning those tips and tricks that can save time and make for greater artistic success. The following pages give information and advice on all the tools and materials the watercolour painter will need.

Choosing Paints

Watercolour has many advantages over other media and perhaps the greatest is that you need only a small amount of relatively inexpensive equipment to get started. In fact, the essential materials for painting in watercolour are just paint, paper, brushes and clean. clear water.

Types of watercolour

Before you buy your paints, you'll need to decide first between tubes and pans. Both have their merits. Pans are easier to carry around because you simply slot them into your paintbox. Tubes have to be carried separately, and the colours squeezed out as needed. Tubes are better when you need to mix up a lot of paint for washes.

■ Pans

All watercolours contain gum arabic to keep them moist, so don't be put off pans because you think they may dry up. Pans are available in whole and half-sizes. Try a half-pan if you are unsure about a colour. There is a wide range of paintboxes designed to hold pans and half-pans, which can be removed and replaced when used up. Like the tube paintbox, the lid can be used as a palette.

Pan paintbox

If you have decided on pan paints, there are advantages to keeping them in a box. First, it's a neat way of storing and protecting them; and second, the troughs in the lid can act as a mixing palette. However, you should avoid boxes prefitted with a selection of colours. You won't know whether they are good quality, and you may well find yourself stuck with colours you don't need. It's better to buy an empty box that can be filled with colours that you have personally chosen.

◀ Tubes

Regular tubes of watercolour are quite small. Some manufacturers make larger sizes, but these are not necessary - it takes a long time to get through even a regular tube. Good-quality paints can be kept indefinitely as long as you remember to screw the caps back after use.

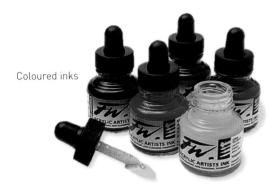

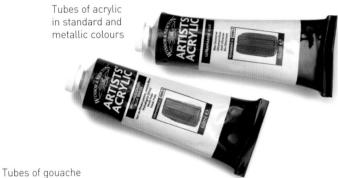

Acrylic paints and inks

As you build up your collection of materials, it's useful to add acrylics and inks to widen the range of results you can achieve. Both media can be used in combination with traditional watercolour, with interesting results. Thinned with water, acrylic paint behaves much like watercolour. Choose water-soluble or waterproof ink depending on the effect you want.

Gouache paints

Gouache paints are an opaque version of watercolours, which can be used more thickly and sometimes in combination with the transparent colours. Gouache white, in particular, is a useful alternative to Chinese white for adding highlights or thickening paint for certain effects. Gouache is sold in tubes, jars or bottles.

Choose the best quality

Whether you opt for tubes or pans, be sure to buy artist's-quality watercolours. These are worth the extra cost because they are pigment-rich, providing greater vibrancy and depth of colour. Don't be tempted by the inexpensiveness of special 'sketching sets' or 'students' colours; they may be inferior paints that will not produce the vibrancy you are after. Regard your initial outlay as a one-off investment; a tube or pan of paint will last a long time and, although you may sometimes need to replace an individual colour, you'll never have to buy a whole set again.

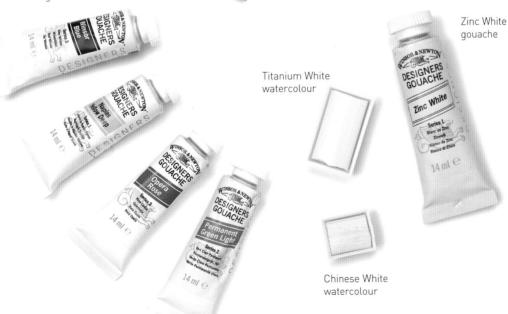

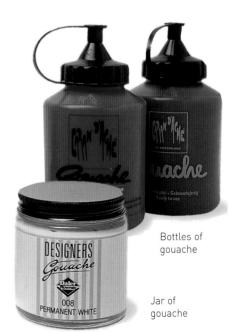

Iridescent and pearlescent paints

Glowing, luminescent watercolour paint has been in use for centuries, but now a whole new range of paints is available to enrich the artist's palette further and produce some exciting and rather unusual effects.

At one time, the artist had few choices with regard to metallic and luminescent effects beyond conventional pigment colour. Then, in the 1960s, the automotive industry began developing various mineral-based, interference and iridescent pigments of great durability.

Now, artists' paint manufacturers use this technology to create new colours every year new ones are released and others discontinued. These two pages provide a survey of some of the exciting and relatively recent developments within the industry, but you should also regularly check the catalogues and websites of all the manufacturers for their latest launches.

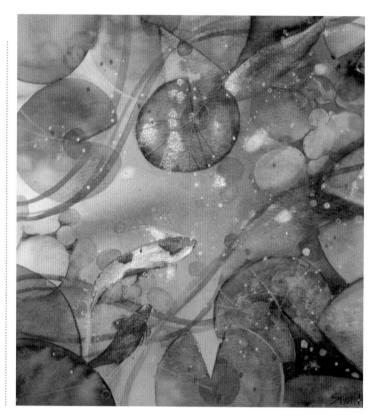

SHARI HILLS

FISH POND

Using iridescent paint

In this exquisite painting (left). Shari Hills has used delicate watercolour glazes to depict a watery world. She has then dabbed on spots of iridescent colour for the sparkles on the water surface and the sheen where the fish scales catch the light. As with any special medium or technique, a 'less is more' treatment works best. Just a few iridescent accents are much more effective than an overall application.

Interference and pearlescent paints

Transparent paints that contain uncoated mica particles and are not mixed with another pigment are nearly invisible on white paper. The optical phenomenon of colour is visible only when painted over a dark undercolour. Here, nine interference and pearlescent paints have been applied over both dark undercolour and white paper. Notice that all are very nearly invisible over the white paper and only appear when painted over the dark.

Red

Lilac

Copper

Blue

Green

Gold

Silver

Pearlescent Pearlescent Shimmer

White

▼ Iridescent paints

Paints that contain coated mineral particles as well as a tinting pigment are called 'iridescent'. The optical phenomenon of a change in hue occurs according to the angle of observation. The example here shows iridescent paints applied over both a dark band of Ultramarine Turquoise and Napthamide Maroon (above) and white paper (below). Notice how some iridescents fail to cover the dark, whereas others create a gauze-like sheen and nearly disappear over white paper.

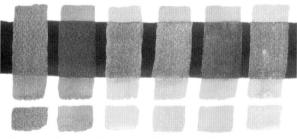

Blue Silver Scarab Sunstone Moonstone Russet Topaz Red

Media

A wide range of effects can be created by simply mixing clean water with good-quality watercolour paint. There are also several watercolour media that can be used to good effect.

Gum arabic is one of the major constituents of watercolour paint. It not only helps bind the pigment, but also contributes to the transparency and depth of the colour. Gum arabic can be added to paint by placing a few drops in the general mixing water, or it can be added to specific washes or mixes. Adding gum arabic will make your colours more transparent, give them greater depth and imbue them with a slight gloss. It will also increase the solubility of the dry paint, making corrections possible.

- Advantages: makes a number of textural effects possible, and makes corrections easier.
- **Disadvantages:** over-use can result in paint drying with a gloss finish; heavy use can cause paint to crack when applied too thickly.
- **Cost:** inexpensive, when used sparingly.

Watercolour medium behaves like – and has similar qualities to – gum arabic, but it also improves the flow of washes. It can be added to the mixing water, or used selectively on individual washes.

- Advantages: increases the brilliance and transparency of colours.
- **Disadvantages:** over-use can result in areas of work drying to an unsightly gloss finish.
- Cost: relatively inexpensive.

Iridescent medium adds a pearlescent effect to watercolour. Add when the wash or colour is being mixed, or apply over the paint once it is dry. It is shown off to best effect when mixed with transparent colours and applied over a dark background.

- Advantages: particularly useful for design and decorative work.
- Disadvantages: can contaminate paints, or show up in parts of the work in which it is not required.
- Cost: relatively inexpensive.

Texture medium contains small particles suspended in a gel. It can be mixed with wet paint and

medium

then applied, or it can be brushed directly onto paper and then worked over with colour. With patience, multiple layers can be built up to create pronounced textural effects.

- Advantages: increases the capability of the watercolour medium.
- **Disadvantages:** brushes can be ruined if not cleaned thoroughly.
- Cost: relatively inexpensive.

Granulation medium causes watercolour to granulate – an effect that occurs naturally with certain relatively coarse blue and earth pigments that separate out from a wash and settle into the texture of the support, giving a granular, textured effect.

- Advantages: gives added drama.
- **Disadvantages:** can lose effectiveness if overdone.
- Cost: relatively inexpensive.

Permanent masking medium can be used in two ways: it can

can be used in two ways: it can be applied undiluted onto the support; once dry, the medium is invisible, but it will isolate the masked area and repel any washes painted over it. Alternatively, the medium can be mixed with paint. When dry, it will resist any further washes.

- Advantages: does not have to be removed, and thus allows for the creation of complex layers of masking.
- **Disadvantages:** impossible to remove or alter once an area as been treated and masked.
- Cost: relatively inexpensive.

Liquid frisket is also known as masking fluid, and is neither an additive nor a medium. It is a liquid latex solution that is painted onto the support. Once dry, it isolates the area from any unwanted washes painted over it. Once the wash is dry, the masking fluid is removed by gentle rubbing.

- Advantages: can be applied in any number of ways, and the fluid colour makes it is easy to see masked areas.
- **Disadvantages:** may tear the surface if care is not taken when removing the dry fluid from the support. Also, brushes can be ruined if not cleaned thoroughly.

Cost: relatively inexpensive.

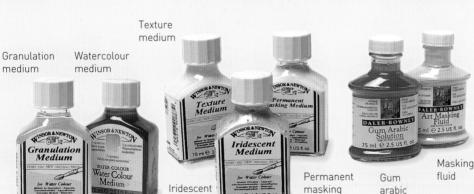

Masquepen: masking fluid can be applied with a masquepen, a bottle with a built-in applicator that allows for precise markmaking.

Brushes and Other Tools

Brushes come in a range of shapes, sizes and fibres - the choice depends on personal taste and the effect that the artist wants to create. But brushes are not the only tools for mark-making.

Types of brushes

There are three main shapes of watercolour brush: rounds, flats and mops. All are made in a range of sizes, usually identified by number but sometimes by

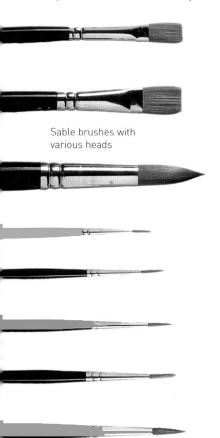

their actual size (for example, 15mm or ½in). In most lines, the biggest brush is No.12 or No.14, and the smallest No.1. No.0 or even No.00

As well as size and shape, the fibre from which the brush head is made determines its properties, and you should take this into account when choosing which brushes to buy.

Sable brushes This is the traditional fibre of choice for watercolour brushes. Sable is springy and resilient, and forms firm tips that point well - a topquality sable brush will return to a point with one flick of the wrist when wet. Sable also carries a large amount of colour, yet releases it quickly and cleans rapidly. On the down side, this fibre is expensive. However, if cared for properly, a sable brush should last for years. Synthetic brushes A much cheaper option, synthetic-fibre brushes mimic many of the

qualities of sable. They have their own distinct qualities and can point well, making them useful for detailed work. When changing from one colour to another, though, they are more difficult to clean. Successful, long-lasting synthetic brushes (made of nylon or a mixture of nylon and sable) are available. which have some of the qualities of sable but at a much lower cost.

Squirrel-hair brushes Also known as camel hair, these can hold even larger amounts of colour than sable and therefore are useful as wash brushes in the larger sizes. They lack both the firmness of sable and

synthetic fibre and the controllability needed for accurate, detailed work. Their advantage is that they are a fraction of the cost of sable brushes. Composite sable/ squirrel brushes are available too; less expensive than sable, they retain some of its qualities for controlled or detailed work. Goat-hair brushes These large. flat brushes with very soft and long, whitish hairs are also known as hake brushes. They are useful for applying large amounts of colour rapidly, yet are gentle enough to cause minimum disturbance to any underlying colour. When wet. the long, straight edge of the tip can be used to paint a range of shapes.

Hogshair brushes Traditionally used in oil painting, these firm brushes are useful for lifting colour as well as applying large amounts where accuracy is not important.

Chinese brushes A useful and cheaper alternative to sable. these can create detail as well as superb flowing lines.

Waterbrush pen This handy tool is a water holder and brush, all in one. The brush houses water in the barrel of the pen.

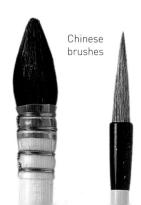

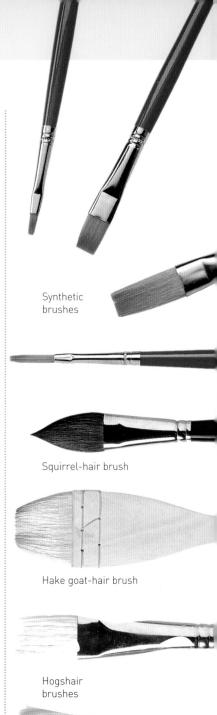

Other mark-makers

Brushes are not the only markmaking tools available to the watercolourist. There are a range of others, from fairly conventional to experimental.

- Sponge A small natural sponge, available from art shops, is an extremely useful piece of equipment. It can be used for applying colour, laying washes and making corrections as well as for cleaning up.
- Cotton balls These serve much the same purpose as a sponge, although they do not have the same colour-retaining properties and tend to be drier in use.
- Cotton buds These are good for lifting out small highlights, or for doing corrections.
- **Toothbrush** An old toothbrush is the perfect tool for the spatter technique.
- Clingfilm, bubble wrap, aluminium foil Usually found in the kitchen or stationery cupboard, all these materials can be pressed into wet paint to create surface texture.

Water jars

You will also need a jar to hold water. Old, clean jam jars are fine for indoor work. If you are going to be working outdoors, use a lighter plastic pot with a lid.

Other useful tools

- Paper towel almost essential, for lifting out colour, wiping brushes and general cleaning up.
- Pencil and eraser, for preliminary drawing. A B-grade pencil is soft enough not to indent the paper.
- **Pens** felt-tip and India ink nib for line and wash.
- Gummed tape, for stretching paper (see page 17). Never be tempted to use masking tape for this.
- Craft knife or scalpel, and scissors.
- Wax candles or crayons, for the wax-resist technique.
- Water spray bottle, to soften colour or for spraying wet paint to create surface texture.
- Small, flexible palette knife, for mixing colour this is preferable to mixing large quantities of a colour with a brush, which could shorten its life.

When you are starting out, you don't need a vast range of brushes. One flat, square-ended brush and three rounds of different sizes, in a sable and nylon mix, will be enough to get you going. You can slowly build up your collection, according to

personal taste and your pocket.
• Regardless of a brush's makeup, it should be resilient and springy. You can test this by wetting the brush to a point and dragging it lightly over your thumbnail; springy bristles will

 You also need your brushes to hold a good quantity of water. Test by loading the brush with water, then squeezing it out.

return to their original position.

 Keep your watercolour brushes solely for watercolour painting.

• Do not leave the heads of your brushes standing in water – you will ruin them. Instead, stand them upright in a jar.

 Rinse your brush under running water after each painting session. Use a little soap if traces of dried colour stick to the end near the metal band.

Reshape gently with your fingers.

• If you have to carry your brushes around, be sure to protect the points. Use an old ruler and a couple of rubber bands to make a splint for them, or use a purpose-made cylindrical container. Keep the brushes upright, otherwise the tips may bend.

If you store your watercolour pans or tubes in a paintbox, the lid will be designed for use as a mixing palette. An alternative is an individual palette, with recessed 'wells' to hold the colour and divisions to separate one colour from another. Palettes are available in china or more inexpensive plastic, which is light enough for outdoor work. However, if you don't want to go to the expense of buying a purpose-made palette, you could use an old plate (preferably white and unpatterned, so you can judge the mixes more

(preferably white and unpatterned, so you car judge the mixes more accurately) – although because there are no troughs you won't be able to keep your colours separate so easily.

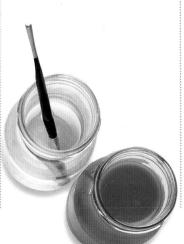

Paper

Watercolours are almost always painted on white paper, which reflects back through the thin layers of paint, giving it its luminous quality. It helps to know the qualities of the different watercolour papers available in order to achieve the effects you want.

Types of paper

The finest-quality watercolour paper is made by hand from pure linen rag. These papers are expensive, and if you are a beginner you won't need them. The papers you'll find in your local art supply store are machine-made. There are many different brands, all with slight variations, but they can all be divided into three groups.

Weights of paper

Sheets of watercolour paper come in different thicknesses. These are measured in weight this is important because it dictates whether you will have to stretch them. The weight of paper is usually expressed in grammes per square metre. A thin, lightweight paper may be no more than 160gsm (108lb), while medium-weights start at

250gsm (168lb), with heavier weights at around 400gsm (270lb) - although really heavyweights can go up to 600gsm (405lb) or more. As a general rule, any paper heavier than around 400gsm (270lb) can be used without being stretched to prevent buckling or cockling. The paper used in most watercolour pads is 250gsm (168lb).

- 1 and 2: Handmade paper
- 3: Hot-pressed paper,
- 4: Rough paper

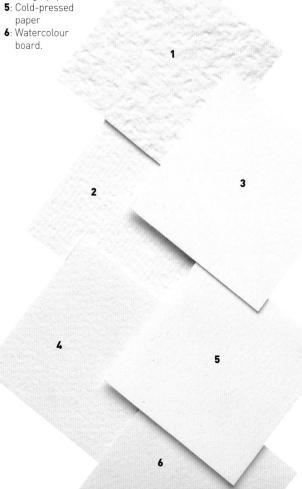

smooth by passing it through heated rollers after it is made. Its smooth surface makes it ideal for detailed work, such as botanical painting, but it has none of the pleasing surface texture of rougher papers.

▶ Hot-pressed paper This is made

- Cold-pressed paper To achieve its characteristic 'tooth', or surface texture, this paper is pressed between unheated rollers lined with felt mats. It is the most popular paper and is referred to as 'not surfaced', which means it hasn't been hot-pressed. It has a moderately rough texture, just enough for colour to drag off the brush and create many useful effects.
- Rough paper Not pressed at all, this has a distinctly characteristic rough surface. This rough surface acts as a moderating influence and helps control the flow of pigment, contributing to an even finish, if desired. Alternatively, if pigment is used fairly dry, it can be dragged across the surface to produce many textures. Never underestimate the capacity of even the roughest paper to produce accurate, detailed work, especially on larger paintings to be viewed at a distance.

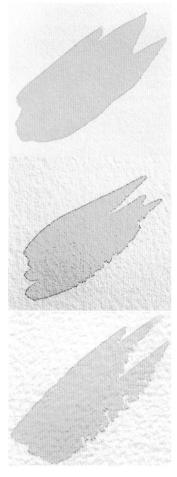

Stretching paper

When paper becomes very wet, it has a tendency to buckle, and an uneven flow of paint will result. Often this does not matter, and the very unevenness can add vitality to a painting. At other times, more control is required; if that is the case, it is advisable to stretch the paper first, to ensure a flat, taut surface on which to paint.

To stretch paper, you will need a drawing board, gummed tape, a sponge and a craft knife and scissors.

Using watercolour board

If you have no time to stretch paper, you could use watercolour board, which is simply paper stuck to a firm backing.

◀ Finding the right side

Not all papers have watermarks but, if they do, this indicates that there is a 'right' and 'wrong' side. Hold the paper up to the light, and if you can read the watermark, this is the side to paint on.

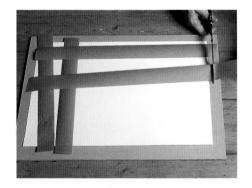

1 With dry hands, cut four strips of gummed paper tape, slightly longer than the sides of the painting paper. Then put the roll of gummed paper away in a dry place – it should always be handled with dry hands. Rule light pencil lines about 1cm (½in) from the edges of the paper to help you put the tape on straight.

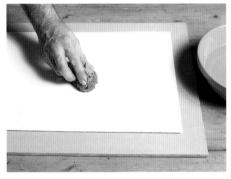

2 Immerse the paper briefly in water in a bath, sink or plastic tray, turning it over once to make sure both sides are evenly wetted. Place the paper on a board and smooth it with a damp sponge to remove any creases or air bubbles.

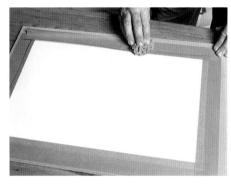

3 Run the sponge over the paper strips to just dampen them. Using the sponge, neatly smooth the strips along the edges of the paper, following your pencil lines: The tape should overlap the edge of the paper by at least 6mm [¼in]. Trim the corners. Stand the board upright until the paper is completely dry. You can now paint on the paper. To remove the painting from the board, cut through the tape with a craft knife.

■ Pads or sheets?

The major manufacturers produce their paper in large sheet and sketchpad form. The pads usually contain 10 or 12 sheets, and are available in a variety of sizes. If you are painting a large work, or if you have very specific requirements of the paper, it is better to buy your paper as a loose sheet.

Setting Up a Working Area

Painting with watercolour can be a real joy, but to make the experience as pleasurable and as successful as possible, you need to have a well-organized working area.

Having a designated area in which to work is an ideal to aim for. Not only will it provide practical storage for your tools and materials, but it will also give your mind the subliminal message that you are taking your art seriously.

Artists who work in acrylics or oils have the potential to work big, but this isn't usually true of watercolourists, who don't therefore need vast studios. If you don't have a spare room, an

unused corner or perhaps a well-lit landing are the kinds of spaces that can be put to good use.

Set up your workspace so that you can, as far as possible, look down on the paper you are painting on rather than viewing it at an angle. Distortion in a painting is often caused by the angle at which you are working. It's also important to step back

often to assess your work. (Fortunately, watercolourists don't need as much space for this as oil painters who often have to stand quite a way back to view their enormous canvases.) There is nothing more soul-destroying than finding that the painting that you thought looked great close up does not work when it is viewed from a distance.

▼ Lamps

Working lights need not form part of your 'starter kit', but you will need to consider suitable lighting if you intend to work in the evenings. Anglepoise lamps are useful because they can be angled to throw light exactly where you want it. They are available from good suppliers of graphic materials.

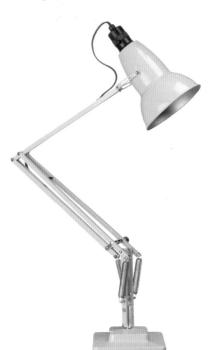

Light bulbs

There is no substitute for daylight, but it may not always be possible to paint during the day. If you have no choice but to paint by artificial light, avoid working under tungsten lighting; it has a yellow cast and distorts colour, flattens tone and reduces definition, and will make it harder for you to judge what you are doing. When you look at your painting the following morning, it may look quite different from the way it did the night before - and you may wonder why you did not notice that bright colour or that rather crude brushwork. Clear, bright, white lighting is a much more effective choice. Fluorescent and halogen are better than tungsten, but the best option of all are the blue, daylight-simulation bulbs that are the closest artificial approximation to daylight. They are available from art shops.

Using an easel

Watercolour is not like oil paint, which stays where you put it - when it is wet, watercolour runs. For this reason, you cannot use an easel for watercolour painting in the same way as you would for oils. Unless you actually want the paint to run to create a special effect, the easel should be tilted back sufficiently so that the paint remains where you apply it, but not so flat that it is difficult for you to see your work. Several easel designs have a tilt facility that allows you to adjust your board to a horizontal or nearhorizontal angle for working, then adjust it back up to vertical for viewing. If you want to splash out, there are even easels specifically designed just for watercolour work.

Drawing board

A board is important for supporting your paper. It needs to be firm - the wood should not be less than 4-ply and it should be unstained and unpolished. (If it is stained, the stain sometimes comes off on the back of the paper; if it is polished, the gummed paper will not stick when you are stretching your paper.)

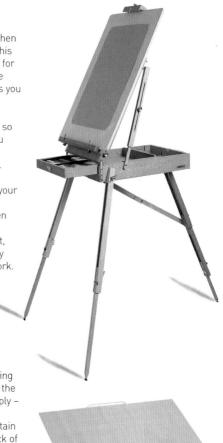

Salt This is a great way to add texture (see pages 76–77).

Paper towels

Always have these on hand to mop up extra paint or water in a hurry.

Bar of soap For quick cleaning of brushes after masking.

Cotton buds For lifting out paint.

Hair dryer Useful for speeding the drying process.

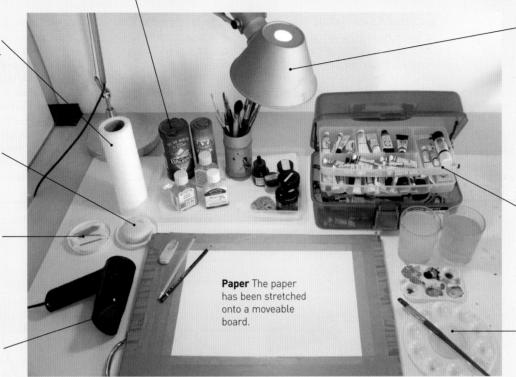

Light source Good lighting is essential for any form of painting. The direction of the light source is important too. If you are right-handed, the light should come from the left (and from the right if you are left-handed), or your working hand will throw a shadow on your work.

Organization Keep loose paints in a large box – buy one larger then you need, as you will probably buy more paints as your skills improve.

Palettes and water pots Keep water pots next to palettes to prevent water dripping on painting.

▲ A working surface

It may seem obvious, but having an adequate work surface often gets overlooked when setting up a painting space. It must be big enough to take water jars, paints, palette, brushes and any other materials and aids that you need - watercolour is a fast-drying medium so you need everything to hand. Your work surface may have to accommodate your painting board, too. If you are painting at an easel, the work surface should be sited close by and be the appropriate height, so that all your materials and tools are easily within reach. If you are lucky enough to have a studio or designated painting corner, you can have a large table solely for this purpose. If not, a kitchen or even dining table will do, covered with newspaper to protect it.

TIPS Storage solutions

- If you don't have a room or corner set aside just for painting, storing tools and materials can be a problem. One solution is to use one of those storage units on wheels, with drawers in which you can stash items away. The unit can be tucked into a corner or under a table when not in use and if the top is big enough and the right height it can double as a work surface when in use.
 - To remain in pristine condition, sheets of paper, pads and card

ideally need to be stored flat.
Those lucky enough to have their own studios may have space for a plan chest in which to keep such items. If you do not have this luxury, you can use large portfolios for storage. Propped up vertically on their spines, portfolios take up little space and can be tucked out of sight until needed. Available from art shops, they come in a range of types and sizes, from the inexpensive to the pricey. Choose according to your needs and pocket.

 Cardboard cylinders or plastic tubes are fine for storing thinner papers. However, heavierweight watercolour papers might crease if rolled, and are best stored flat.

Working Outdoors

Working outdoors, en plein air, can be a real pleasure. However, whether you're doing quick sketches or a complete painting, it needs more organization than indoor work, so plan your painting trips carefully.

If you like painting away from home, it might be worth keeping a special kit ready for just this purpose, with all the tools and

equipment you will need. Then all you'll need to grab before you go are paints, paper and brushes. Bear in mind, too, that you are going to have to carry the lot, so avoid anything that weighs too much. And a final word of warning: Be prepared for a little audience - of children especially - to gather to watch you at work. Most will be too impressed by your artistic skills to spot the odd 'mistake', so don't let this put you off what you are doing.

Choosing a location

Since you won't want to traipse around with your painting equipment looking for a good place to paint from, it's best to plan this in advance. You could explore the area the day before and choose your spot so that you go straight to it. If you're intending to complete an entire picture rather than making sketches, you might also consider doing the drawing on one day and painting on another. One of the difficulties of location

work is coping with changing light; you may think you have the whole day to paint in, but the scene will have changed completely between morning and evening, so you'll have to work fast - remember Monet's haystack series of paintings and how the colours and tones changed depending on the time of day? If you've already done the drawing the day before, you can start on the painting immediately without wasting valuable time.

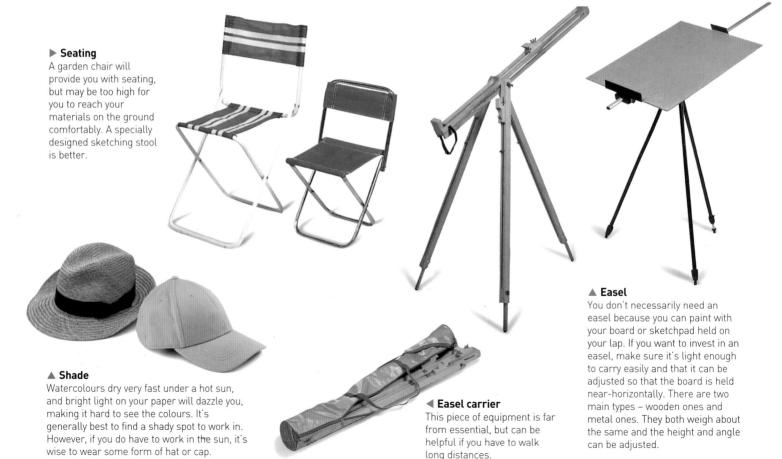

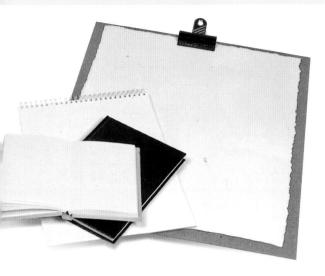

◀ Paper

For small, quick sketches you don't need to stretch paper. Use a watercolour pad or paper attached to a light piece of plywood or hardboard.

Equipment

You will also need the following pieces of equipment:

- Water container any plastic bottle will do.
- Water pot the non-spill ones (red top) are ideal.
- Brush holder this is not essential but will protect your brushes.
- · Paper towels, for wiping brushes, mopping up excess paint and cleaning up.
- · Large plastic bags, to protect your work if it rains.

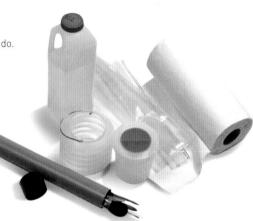

Checklist

When painting outdoors, you won't be able to pop to the cupboard or kitchen to collect something you've forgotten, so you need to be extra-organized. Before you set off, check that you have the following:

- · Brushes (you won't need many)
- Paintbox or tubes
- Mixing pans
- · Sketching block or light drawing board and sheets of paper
- Drawing pins, masking tape or bulldog clips for securing sheets of paper (if using)
- · Bottle for carrying water
- · Jar or plastic pot for paint water
- · Pencil and eraser for preliminary drawing
- · Knife or sharpener for sharpening pencils
- Sponges and paper towels, for applying paint, lifting out, and mopping up
- · Plastic bag to protect your work from rain
- · Sketching stool, or folding chair
- Easel and easel carrier (optional)
- Viewfinder (optional)

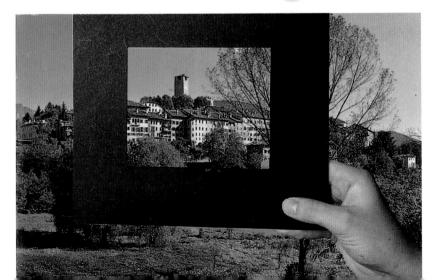

◀ Using a viewfinder

When you're faced with a large expanse of scenery, it can be very difficult to decide which bit to concentrate on. This is where a viewfinder, made from two L-shaped pieces of card, or a viewing frame - a rectangular window cut in a piece of cardboard - comes in. Hold it up at arm's length to isolate parts of the view, moving it around until you see the makings of a composition. Most artists use a viewfinder; some even take a picture frame out with them to assess how their painting will look when completed and framed!

Priming Paper

Understanding how your paper reacts to and absorbs water and pigment is critical to your success with the techniques shown in this book.

Think of it like this: if you prime wood before painting it, the top coat will go on more smoothly and successfully. It's the same with watercolour. Watercolour can be guite an unforgiving and temperamental medium. Once it is dry, it does not really like to be disturbed, or it will start to move around in ways you might not want. You need to control the flow of the paint by priming the paper first. Priming will not only help you to lay flatter washes or softer graded ones, but will also enable you to judge the receptivity of the paper more accurately.

You can apply this technique either to the whole of your painting - say, if you are going to lay down an overall pale, warm yellow wash for background warmth - or just to a selected area such as a sky.

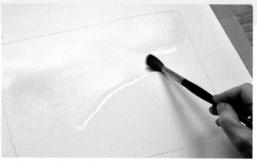

Laying a water wash

1 On heavy watercolour paper or stretched paper, a large brush is used to apply clean water, with guick, even strokes. Clean water is important in watercolour painting so that reserved highlights and colours remain clear and unpolluted.

2 The paper starts to absorb some of the water, and some sits on the surface. There should be an even, wet shine on top. If the water starts to puddle too much, you can absorb the excess by dabbing with a paper towel.

3 If too much water has been applied over a larger area, the excess wetness can be blotted away by carefully placing paper towel flat down onto the paper.

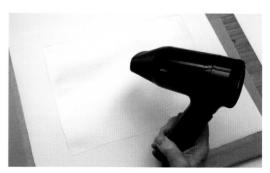

4 If it is a cold day or time is limited, a hairdryer can be used to remove some of the moisture.

5 judging the wetness The aim is to let the paper dry to a semi-gloss. almost silk finish. This finish is important as the paint will go down more smoothly. The other reason is that a very wet surface will buckle too much, making it impossible to get a flat wash because the pigment will run into the troughs. Here, some areas are still a bit wet and glossy, but others are at the perfect stage to receive paint.

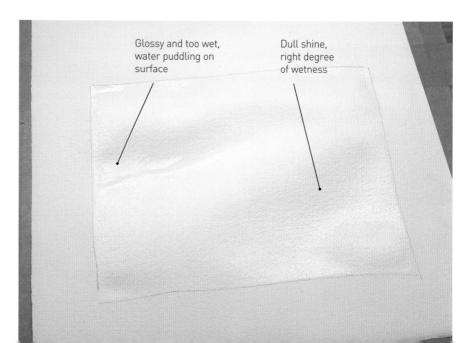

6 An adequate amount of the desired colour is mixed up, then applied as a flat wash. The damp paper surface allows the paint to flow more easily, and makes it easier to move around, than if it was going directly onto dry 'virgin' paper.

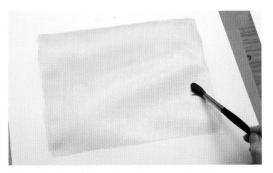

7 Not only does this produce flatter washes, but variegated washes will blend more smoothly, too.

Intricate edges

The technique is especially useful for painting a clear sky above a complex, detailed horizon. If the paper is dry, it's very hard to paint around the complex horizon line and cover the sky with a flat or even a graded wash before the paint dries.

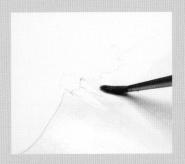

1 The artist draws in the horizon details, then turns the board upsidedown - it is easier to work into the complex outline from below - and paints clear water around the details and all the way to the top of the painting. The paper is left to absorb the water and reach the 'silk' stage.

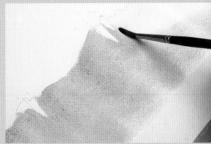

2 The artist lays a blue wash all over the sky, starting at the horizon. The paint flows over the damp area up to the dry edges, then stops. The artist takes care not to get grease from her hands on the paper as this will act as a barrier to water and paint.

Priming an area wet-on-dry

The technique can also be applied to areas of a picture that are already painted. A good sable brush pays off here, as it is so much gentler on the fragile pigment underneath.

1 The area that is to receive the secondary glaze is allowed to dry. Then, using a brush at an oblique angle so that it doesn't press too hard on the painted area, a layer of clear water is applied.

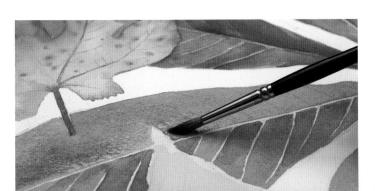

2 Care is taken to paint the water around and not across the details, or it will 'conduct' the paint into those parts.

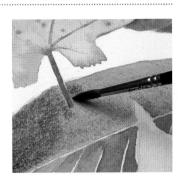

3 Colour is dropped or softly washed on. The wet, receptive paper allows the colour to flood evenly over the area and around (but not across) the details.

Flat Wash

The watercolour wash is one of the basic building blocks of watercolour painting, and the flat wash is the simplest of these. It is the easiest method for applying colour to the paper. and probably the very first exercise for the beginner in watercolour.

The term 'wash' is a rather confusing one, because it implies a relatively broad area

of paint applied flatly; however, it is also sometimes used by watercolour painters to describe each brushstroke of fluid paint. however small it may be. Here it refers only to paint laid over an area too large to be covered by one brushstroke.

Before applying a flat wash in watercolour, thinned gouache or acrylic, the paper is usually dampened to allow the paint to spread more easily. Tilt the board slightly, at an angle of no

more than 30°, to allow the brushstrokes to flow into each other - but not so steeply that the paint dribbles down the paper.

Load the brush with paint, sweep it horizontally across the paper, starting at the top and immediately lay another line below it, working in the opposite direction. Keep the brush loaded for each stroke and continue working in alternate directions until the area is covered.

Suggested applications

- Use for large, flat expanses of colour such as skies.
- Apply as a flat base colour to work into, wet-on-dry.

TIPS Painting the initial wash

- · Choose your brush carefully. A round brush forms a point when wet so should be at least a No.12: a flat brush. such as a hake, will make it easier to get an even result.
- Washes must be applied fast, so mix plenty of paint before you start - you always need more than you think.
 - Do not overpaint an area while wet or it will result in an uneven wash

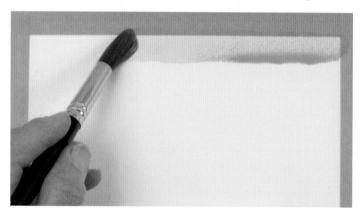

- 1 Starting with a wide brush, load enough diluted colour to make one stroke across the top of the paper. Tilting the board slightly towards you allows the paint to flow downwards.
- 2 Continue down the paper quickly, not allowing the paint to dry between strokes. Work back over uneven lines if necessary to even out any discrepancies in the wash

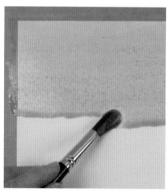

3 Continue down to the base of the paper, tilting the board to encourage even flow of the pigment before it settles.

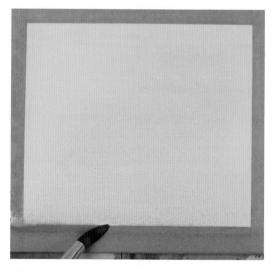

4 Here the paint has dried to a flat, even finish. Some pigments will granulate and produce a grainy effect. Get to know the paints in your palette before applying them to your painting.

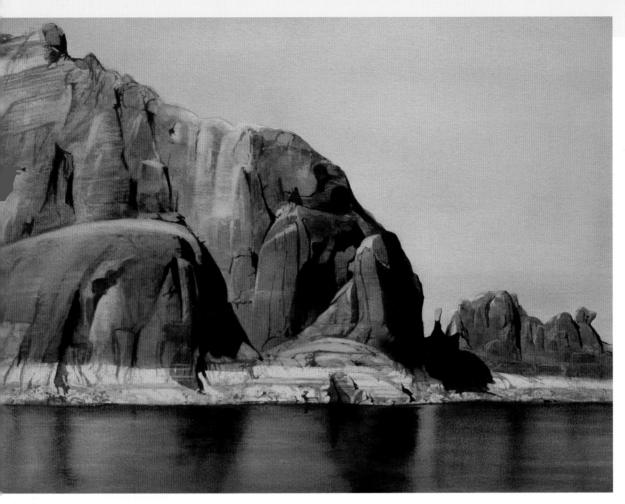

■ ROBERT HIGHSMITH

AT LAKE POWEL Painting skies Flat washes are often used for skies. Here the artist was concerned to achieve a totally even sky, so he masked the edges of the rock walls so that he could run the wash across the sky without being impeded. He used masking tape, masking fluid and paper and then proceeded to paint.

See Also

Stretching paper page 17 Toned ground pages 58-59 Masking pages 66-67

Using a sponge

Some artists prefer to use a sponge for laying washes. For the most even results, the paper is first dampened with a clean sponge. The sponge is then dipped into the paint before each stroke and dragged evenly from one side of the paper to the other, until the whole surface is covered. Slight streaks where one band of colour meets the next will merge as the paint dries. If applied with a sponge, the paint tends not to run down the paper as it can with a brush.

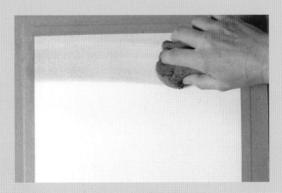

1 A sponge is a useful piece of equipment in watercolour painting. Some artists prefer it to a brush for laying washes. Dampening the paper first gives the best results.

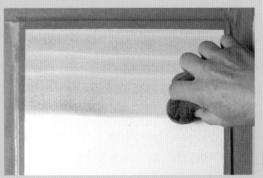

2 Place the board flat to dry. The bands of colour will flow together as the paint dries, and any streakiness will disappear.

Graded Wash

A graded wash is slightly more tricky to achieve than a flat wash, but is an ideal technique for conveying the subtle changes of colour and tone found in nature.

Colours in nature are seldom flat and uniform. A graded wash, that shifts in tone from dark to light, can give a more realistic effect than an area of flat tone or colour.

A graded wash is laid in the same way as a flat wash, the only difference being that more water is added to the pigment for each successive band of paint. It can be difficult to

TIPS Colour washes

- Because the paint has to become more and more diluted, you will need to have plenty of water on hand for this technique.
 - Remember that each wash should be only one step lighter than the previous one, so don't dilute too quickly.
- Don't rinse the brush between bands of colour, as this prevents a smooth progression of colour flow.
- It may be easier to apply a graded wash with a sponge. This gives greater control over the amount of water used in each successive band of colour, and thus can give better final results.

achieve a really even gradation, because too much water in one band or not enough in another will result in a striped effect.

When applying a graded wash, keep the paint as fluid as possible so that each brushstroke flows into the one below, and never be tempted to work back into the wash if it does not come out as you wished. If this happens, don't be discouraged – one of the great joys of the watercolour medium is its unpredictability; what may at first appear to be a mistake can become one of the defining qualities of the finished picture.

Suggested applications

• Use for large, flat expanses of colour such as sky (dark higher up, paler at the horizon) or sea (darker at the horizon, paler towards the shore).

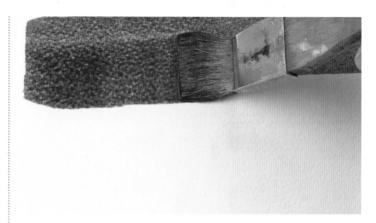

Applying the wash

1 A graded wash should be applied with a large brush, well loaded with plenty of water and paint. Starting at the top of the paper – where the colour will be most intense – a broad band of the paint is applied to the surface. The brush is drawn straight across a couple of times to apply one band of colour below the other, as with the flat wash technique. Each new stroke will lift any excess water from the previous stroke.

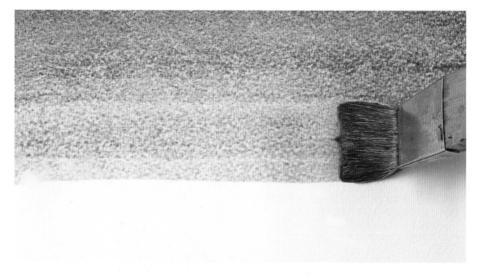

2 The brush is then dipped in clean water (rather than paint), and a band of diluted colour is applied below the still-wet previous band.

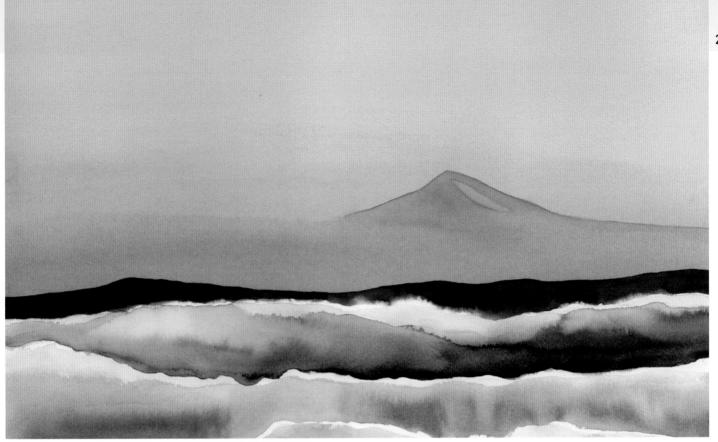

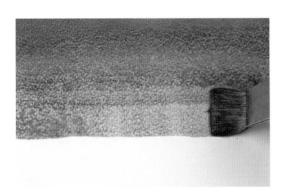

3 More water is added to the brush for each band of colour. Each band will be paler than the one before and will blend smoothly into it.

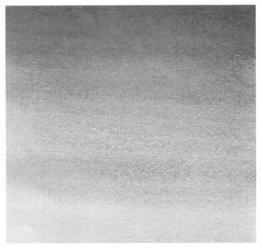

4 The wash is left to dry without working back into it and spoiling the even gradation.

A EVA BARTEL

MT JEEFFERSON FROM MT HOOD Blending tones To paint this glowing sky, the artist has skilfully blended cool tones along the horizon into the warmer pinks above. The even gradation contrasts with the more dramatic clouds below, painted wet-in-wet and allowed to 'blossom'.

See AlsoStretching paper page 17 Flat wash

pages 24–25

Variegated Wash

A variegated wash uses more than one colour and takes the wash technique one step further than either flat or graded washes.

The variegated wash technique is essentially the same as for the other types of wash, but - instead of the single colour of the flat wash or the variation in tone of a graded wash - it combines two or more colours. It is less predictable than either flat or graded, but you can achieve very exciting - if unexpected - results by allowing the colours to bleed into each other. Sunset skies are rendered especially well by a variegated wash, starting with blue at the top, blending down into yellow, with orange and red at the bottom.

To achieve the effect, sufficient quantities of the colours are mixed on the palette, then applied in bands, one below the other, onto dampened paper. The dampness of the paper does the rest by causing the different colours to bleed into each other.

Suggested applications

• Use for dramatic skies or, using different blues and greens, for expanses of sea.

Mixing paint

Have sufficient of each paint colour mixed and ready before you begin – the essence of a successful wash is to work quickly so you won't want to have to stop halfway to mix up more paint.

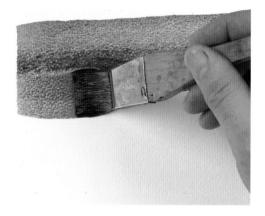

Applying the wash

1 A large brush is used to apply several bands of a rich Ultramarine to the paper. The colour is brushed on wet-in-wet to achieve even coverage.

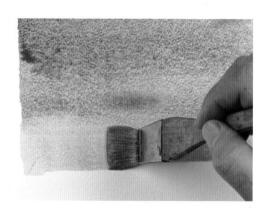

3 The same process is used to lay the third colour of the variegated wash. The paint is then left to dry.

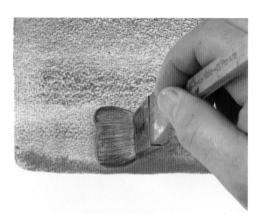

2 Working quickly wet-in-wet and using a cleaned brush, a band of red is brushed on, overlapping the still-wet blue so that the two colours bleed into each other. Further bands of red are applied, still working wet-in-wet.

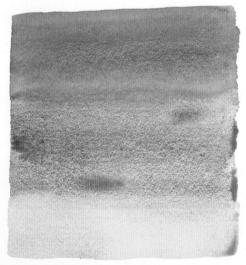

4 Three distinct bands of colour form this variegated wash, each blending softly into the adjacent colour. For a more subtle effect, the colours could be more closely related – for example, a yellow merging into an orange merging into a red.

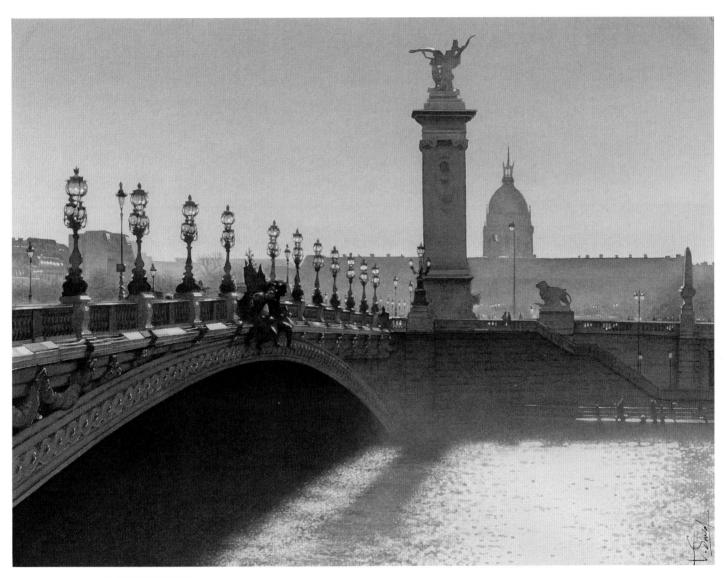

A THIERRY DUVAL

AGAINST THE LIGHT ON ALEXANDRE III BRIDGE

Working contre jour The challenge here was to convey the mistiness of the scene, contre jour (against the light). After applying masking fluid to protect the highlights, the artist began with the background, then added increasingly saturated washes across the painting until he achieved the correct tonal values.

See Also

Stretching paper page 17 Flat wash pages 24-25 Graded wash pages 26-27

Wet-on-Dry

Laying new, wet washes over earlier, dry ones is the classic way of building up a watercolour painting.

Because it is difficult to achieve great depth of colour with a preliminary wash, the darker and richer areas of painting are achieved by overlaying colours in successive layers – a technique known as 'wet-on-dry'. The danger with wet-on-dry is that you can allow too many layers to accumulate and muddy the colours, so if you are working mainly in flat washes, always try to make the first one really positive. It is, of course, equally permissible to paint some parts of a picture wet-on-dry and others wet-inwet - indeed some of the most exciting effects are achieved by combining the two methods.

In acrylic, wet-on-dry is the most natural way to work since acrylic paints dry very quickly, but gouache – although also fast-drying – presents more of a problem. To work wet-on-dry in gouache, begin by using the paint like watercolour (with water but no white) and gradually build up to thicker layers. One thick layer over another will result in a dull, muddy effect.

Suggested applications

- Work wet-on-dry where you want to build up richer tones.
- Use where you want to bring greater definition and sharpness to parts of a painting.

Painting the Washes

1 A bright yellow wash is laid down over the outline of the bird. While still wet, the edges of the painted area are feathered with a damp brush, pulling the paint to create varying degrees of transparency. When completely dry, washes of translucent orange are laid over the yellow.

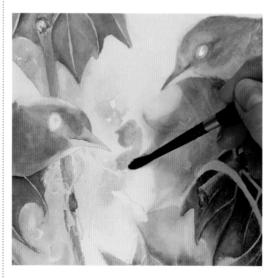

3 The blue sky background is created by applying irregularly shaped dabs of Cerulean Blue: some edges of the blue dabs are pulled with a clean damp brush, leaving a few hard edges and some unpainted areas. Note how the graded washes and areas of unpainted white paper create depth.

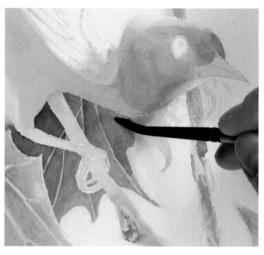

Adding shapes

2 The spaces between the leaf veins are painted with a combination of green, translucent orange and Lemon Yellow. The hard edges that define the leaf shape are retained, but the edges along the veins are lightly feathered.

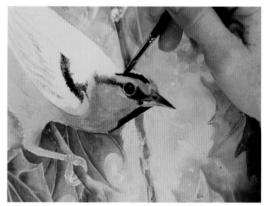

Adding fine details and textures

4 To maintain crisp edges, black and other deep-value colours should be painted onto a dry surface to prevent them from bleeding into adjacent colours. Small areas of colour and fine details are worked with a short-bristled, flat brush. Here, black mixed from green and crimson was brushed on with short strokes to depict the fine texture of the bird's feathers.

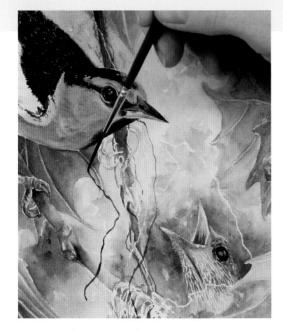

5 Fine strands of grass, string and horsehair make up the nesting material. A long, flexible rigger brush is ideal for applying wet paint in fine lines and squiggles. Any masking fluid that was applied in the nest area before the painting was begun is removed at this stage.

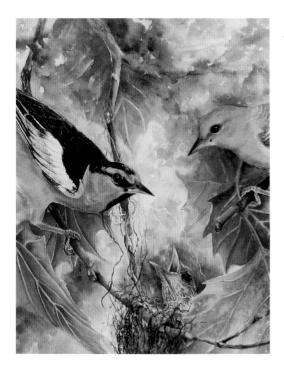

6 A rigger and a No.2 round brush are used to further define the strands of nesting material. The versatility of wet-on-dry technique allows the artist to obtain saturated colours next to thin washes. Sharp edges bring the subjects forward while softened edges retreat into the background.

MOIRA CLINCH

MALAGA

Leading the eye In a sensitive response to the watercolour medium, Moira Clinch has cleverly combined wet-in-wet with wet-ondry. To lead the eye to the top third of the painting, with the brilliant blue and red of the pot and geraniums, and the light, spiky foliage, she has created crisp edges, while the lower part of the picture has been painted selectively wet-in-wet.

See Also

Wet-in-wet pages 32-33 Brushwork pages 52-53

Wet-in-Wet

This is a technique that is only partially controllable, but it is a very enjoyable and challenging one for precisely this reason, allowing the watercolour artist to take advantage of the 'happy accidents' that result.

Working wet-in-wet means exactly what its name implies applying each new colour without waiting for earlier ones to dry, so that they run together with no hard edges or sharp transitions. Any of the waterbased media can be used, providing no opaque pigment is added, but in the case of acrylic, it is helpful to add retarding

medium to the paint to prolong drying time.

The paper must first be well dampened and must not be allowed to dry completely at any time. This means, first, that you must stretch the paper (unless it is a really heavy one of at least 400gsm/270lb); and second, that you must work fast. An alternative method is to drop colour into a wash that is still very wet so that the wetness of the paint itself allows the new colour to spread.

Paradoxically, when you keep all the colours wet, they will not actually mix, although they will bleed into one another. Placing a loaded brush of wet paint on

top of a wet wash of a different colour is a little like dropping a pebble into water: the weight of the water in the new brushstroke causes the first colour to pull away.

The danger with painting a whole picture wet-in-wet is that it may look altogether too formless and undefined. The technique is most effective when it is offset by edges and linear definition, so when you feel you have gone as far as you can let the painting dry, then take a long, hard look at it and decide where you might need to sharpen it up.

Suggested applications

- Use the soft, loose forms to suggest flowers, foliage and tree shapes.
- Wet-in-wet also works well for billowing cumulonimbus cloudscapes.

⋖ TIM WILMOT

MARINA AT SUNRISE

Painting moving water To suggest gently undulating waves, this artist worked wet-in-wet, applying strokes of a darker wash to a still-damp base colour. The darker strokes spread out to create soft shadows that resemble waves. The crisper reflections of the boats were later painted wet-on-dry.

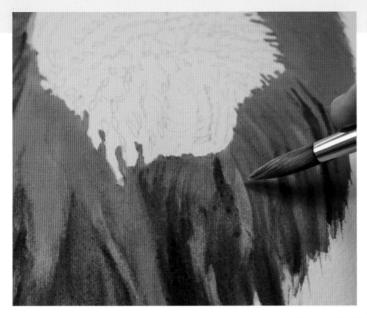

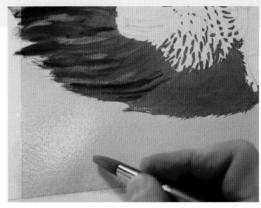

2 A wash of yellow-green is flowed in over the background. The artist works quickly to achieve an even effect. This process needs care as the more paint there is on the brush, the more will transfer to a wet surface, leading to some large, unwanted patches of colour. When a narrower area is to be painted, dabbing the brush onto a paper towel first will remove some of the excess paint and make it possible to work more precisely.

Applying the first wash

1 Having completed a detailed drawing showing the patterning of the plumage, and with the board tilted at approximately a 30° angle, the artist applies a wash to the head of the parrot, then adds shading and definition, working wet-in-wet so that the colours blend and blur. The brighter colour is applied with a repeating side-to-side, top-tobottom brushstroke. The remaining plumage is painted in the same way.

3 The shadows and outlines of the feathers need to be soft and blurry. not hard-edged. Even if the underlying wash has already dried, it is possible to re-wet the surface and work wet-in-wet, as here, to achieve the required effect.

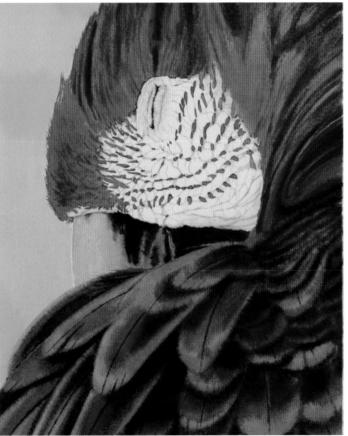

4 The artist continues working over the painting to complete the details. Note how the wet-in-wet technique gives a beautifully soft effect on the breast feathers.

> TIP **Excess** paint

If the colour runs too much, or bleeds into an area where you don't want it, you can gently lift out the excess colour with a dry brush, cotton bud or tissue (see Lifting Out, pages 44-45).

> See Also Lifting out pages 44-45

Blending

To achieve a soft, gradual transition from one colour or tone to another, the watercolour artist can choose from a number of different techniques.

Blending colours or tones is a slightly trickier process with water-based paints than with oil paints or pastel, because watercolour paint dries more quickly. One option is to work wet-in-wet, keeping the whole area damp so that the colours flow into one another. This a lovely method for rendering amorphous shapes such as clouds, but is less suitable for precise effects, such as those you might need in portraits, because you cannot control the

medium sufficiently – you might find, for example, that a shadow that is intended to define a nose spreads haphazardly out across the cheek.

To avoid the hard edges where a wash ends or meets another wash, brush or sponge the edge lightly with water before it is dry. To convey the roundness of a piece of fruit, for example, use the paint fairly dry, applying it in small strokes rather than broad washes. If unwanted hard edges do form, they can be softened by 'painting' along them with a small sponge or cotton bud dipped in a little water.

The best method for blending acrylics is to keep them fluid by adding retarding medium. This

allows for very subtle effects, as the paint can be moved around on the paper.

Opaque gouache colours can be laid over one another to create soft effects, though too much overlaying of wet colour may muddy the earlier layers. One way to avoid this is to use the dry-brush technique, applying the paint thickly with the minimum of water.

Suggested applications

- Use to create soft effects in amorphous shapes such as clouds.
- Use to create a sense of three-dimensional form and definition, for example, in portraits or still lifes.

Wetting the paper

1 First, an entire petal area is wetted with clear water.

2 While the paper is wet, yellow is painted on the interior of the petal and allowed to bleed out towards the edges. Gold is then added to indicate the shadowed centre of the petal.

Tilting the paper

3 The paper is tilted downwards so that the colours can further blend into each other, while flowing to the outside.

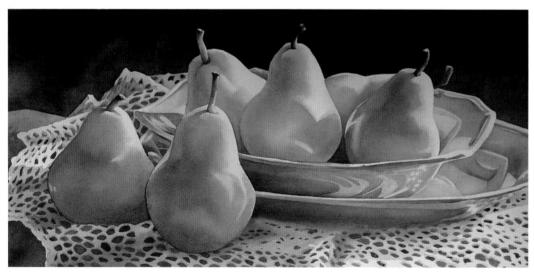

▲ BARBARA FOX

JEWELS

Subtle blends The artist has applied many glazes and a number of different colours so that they blend

subtly into each other to convey the rich and complex colouring of the pears and their rounded shapes.

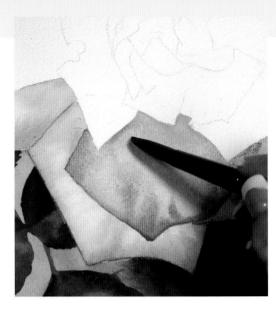

4 While still wet, deep pink is added to the outside edges of the petals. The paper is turned around to let the pink bleed into the petal interior, pulling the colour into the clear water that was initially laid onto the paper.

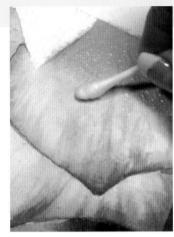

6 The petal is nearly finished. Final touches include lifting out colour with a cotton bud where highlights are needed.

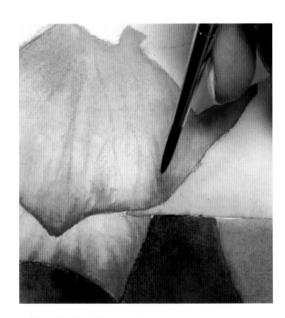

Adding the finishing touches

5 Once the paint is dry, the edges of the petal are re-wet and then once again saturated with deep pink. As the new layer of paint dries, petal lines are very lightly painted in using a fine brush.

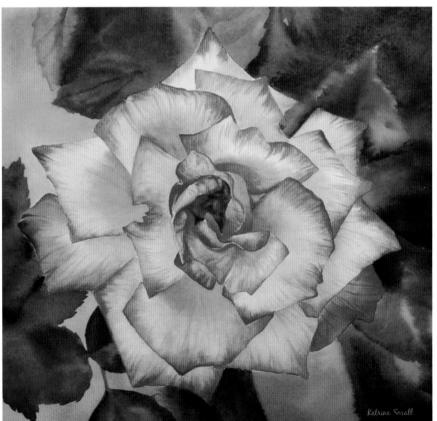

7 The remaining petals are worked in the same way. The hard edges of the petals contrasting with the soft blending on their inner surfaces, along with the blurry background, really make the rose stand out.

See Also

Wet-in-wet pages 32-33 Dry-brush pages 56-57

Hard Edges

One of the definitive qualities of watercolour is its tendency to form a hard edge, rather like a tidemark, wherever it meets a dry surface. This quality is one of the charms of the medium.

A wet watercolour wash laid on dry paper forms a shallow pool of colour that, if left undisturbed, will form hard edges as it dries. This can be alarming to the novice, but it is one of the characteristics of the medium that can be used to great advantage. By laying smaller, looser washes over previous dry ones, you can build up a fascinating network of fluid, broken lines and shapes that not only help to define form but give a sparkling quality to the work. This is an excellent method for building up irregular, natural forms such as clouds, rocks or ripples on water.

You will not necessarily want to use the same technique in every part of the painting. A combination of hard and soft edges describes the subject more successfully and gives more variety. Soft edges can be created by working wet-in-wet; using a sponge, paintbrush or cotton bud dipped in clean water to remove excess paint; or by dragging or pulling a wash over dry paper with either a brush or sponge, which will prevent the paint from pooling and drying to a hard edge.

Suggested applications

• Use for foliage, clouds, ripples on water or wherever a strongly textural effect is required.

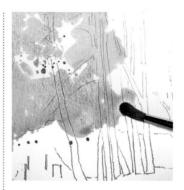

Painting the foliage

1 The artist starts with a light pencil drawing to act as a guide for a painting of a forest. He then begins to drop in colour for the foliage, applying wet washes to dry paper and leaving the paint to dry naturally and form hard, ragged edges.

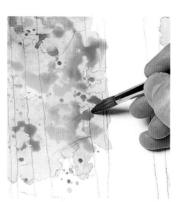

2 Drops of additional colour are applied on top, and again left to dry to create a patchy texture reminiscent of foliage.

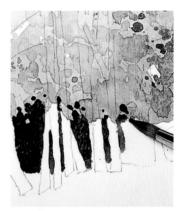

Background and foreground

3 When the foliage is dry, the artist carefully paints in the background, using the pencil outlines as a quide.

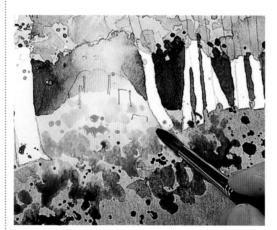

4 After painting in a base colour for the foreground and leaving this to dry, the same technique used for the foliage is applied. Spots of different browns are dropped in and left to form hard edges suggestive of the leafy woodland floor.

Adding the final touches

5 When the other parts of the painting are dry, the artist fills in the trunks and branches with a solid, dark colour that contrasts well with the filtered-light effect of the foliage.

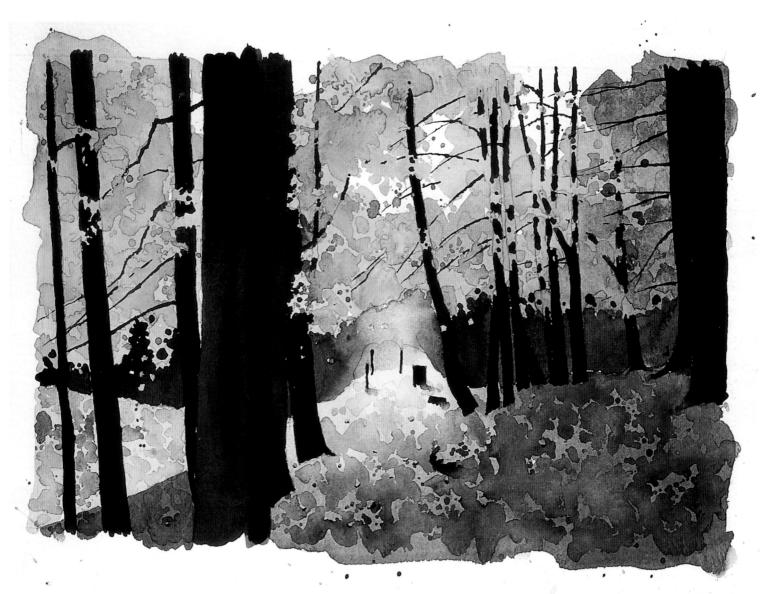

6 The finished picture demonstrates how effective this simple technique can be in conveying the texture of leaves. The solid trunks offer a contrast and accentuate the foliage effect.

See Also Back runs and blossoms pages 40-41

Glazing

Building up colour and tone by overlaying transparent watercolour washes is sometimes referred to as 'glazing', as if it were a special technique – in fact, it is the normal way of working with this medium.

Glazing is a technique that was perfected by the early painters using oils. They would lay thin skins of transparent pigment one over the other to create colours of incredible richness and luminosity.

Watercolour is noted for its transparency and this makes it highly suited to glazing. Layers of transparent washes allow the white paper underneath to 'shine' through, and it is this that gives watercolour its characteristic luminosity. The effects created by the technique are quite different than those of colour applied opaquely, because light seems to reflect

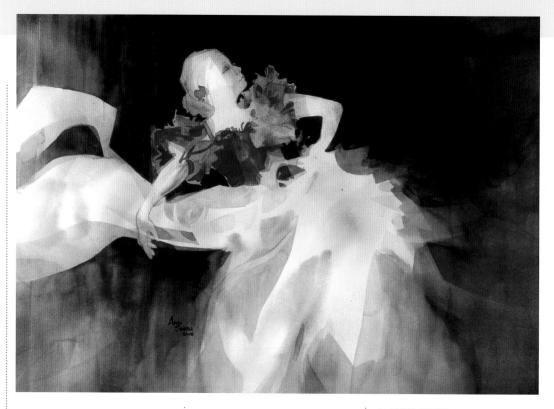

through each layer, creating the illusion that the painting is almost lit from within.

As well as traditional watercolour, acrylic paint is perfectly suited to the glazing

technique. When glazing, each layer must be thoroughly dry before the next one is applied and acrylic has the advantage of drying fast.

Special media are sold for acrylic glazing – available in both gloss and matt – and these can be used either alone or in conjunction with water. A whole painting can be built up layer by layer in this way.

Suggested applications

- Apply glazes wherever you want to build up colour and tone without obscuring the brightness of the paper underneath.
- Use to 'mix' colour directly on the paper – think of your glazes as a tissue paper collage where each new layer alters the colour of the underlying layer.

A ANNE SMITH

DANCER

Layering colour Smith's lovely image owes much of its impact to the combination of wet-in-wet and overlays of glazed colour, which give depth to each area. It was begun more or less as an abstract, with splashes of transparent colour, but once the figure of the dancer began to emerge the artist 'drew in' her face and arms more carefully.

TIP Glazing over impasto

Thin glazes can also be laid over an area of thick paint ("impasto") to great effect. The glaze will tend to slide off the raised areas and sink into the lower ones – a useful technique for suggesting textures, such as those of weathered stones or tree bark.

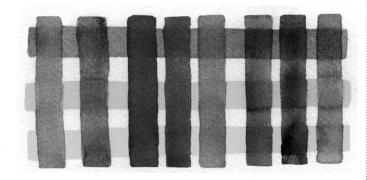

Colour preparation Transparency is the key characteristic to bear in mind when glazing so it is advisable to do some colour preparation on a separate piece of paper before starting a painting. Judge the transparency of your chosen colours by layering them over one another in a test strip.

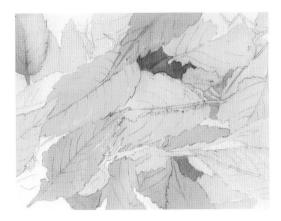

Working light to dark

1 Glazing relies on the application of layers of watercolour to develop colour, tone and intensity. It should be done slowly, and gradual changes made until the desired effect is achieved. A smooth, cold-pressed paper will hold many layers of paint satisfactorily but a soft brush and a light hand is required to avoid disturbing previous layers of paint. It is important to work from light to dark so that the highlights and lightest tones are first established.

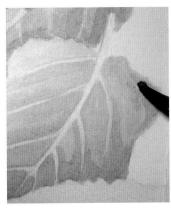

2 Colour is built up on the paper by applying thin washes of transparent colour. Here, layers of blue and yellow are applied to a green leaf until the desired tonal values of green are reached.

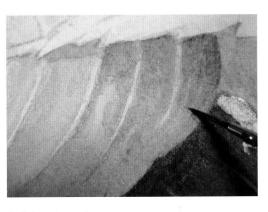

Staining pigments

3 Another property that may be considered when glazing is staining quality. Synthetically produced dye pigments such as Quinacridones will generally stain the paper while those made from metallic oxides and salts such as the Cadmiums will sit in a layer on the surface. Using diluted staining pigments initially may allow more layers to be added as they are less likely to be removed by subsequent applications.

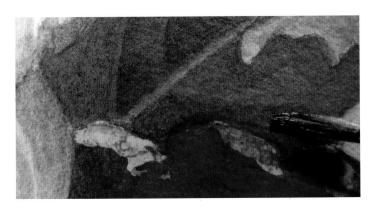

4 The shadowy areas between the leaves and on the darker coloured leaves are painted by layering blue and violet over maroon, gold and yellow to produce rich, dark areas of colour.

Achieving muted tones

5 Applying light, bright layers initially allowed the white paper to glow through the paint producing vibrant colours, which add a jewel-like quality to the subject. Muted tones can be achieved by glazing complementary colours over one another, such as yellow over violet, or by layering more opaque colours for a flatter finish.

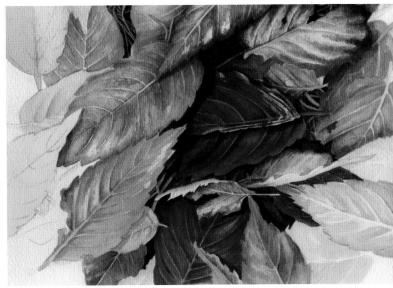

See Also Wet-on-dry pages 30-31

Back Runs and Blossoms

Back runs form naturally and are a quirky characteristic of the watercolour medium. Both a nuisance and a delight to painters, they can be treated as mistakes or exploited to the artist's advantage.

If you lay a wash and apply more colour into it before it is completely dry, the chances are that the new paint will seep into the old, creating strangely shaped blotches with hard, jagged edges. These 'back runs' are also sometimes called 'cauliflowers' or 'blossoms' because of their organic, flowerlike appearance. They do not always occur, however; the more absorbent or roughtextured papers are less conducive to the formation of back runs than smoother, highly sized ones.

If you don't want a back run and one does form, the only remedy is to wash off the entire area and start again. With practice it is possible to avoid them completely. However, many watercolour painters create back runs deliberately, both in large areas such as skies or water, or in small ones such as the petals of flowers, since the effects they create are unlike those achieved by conventional brushwork. For example, a realistic approximation of reflections in gently moving water can be achieved by lightly working wet colour or clear water into a still-damp wash. The paint or water will flow

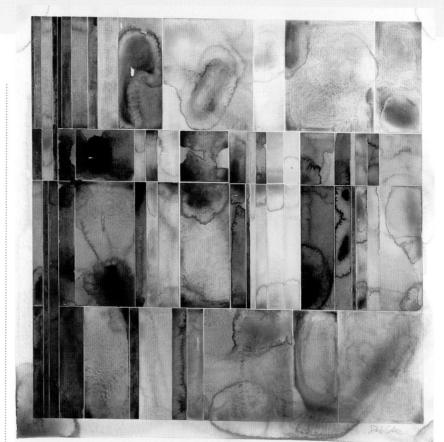

■ DAVID CASTLE

ELEMENTALS NO. 18

Abstract shapes

Based on a geometric framework, each shape is measured and drawn with a pencil and ruler, then painted wet-on-dry. Next, varying amounts of paint and water were dropped in to form 'blooms' or back runs. While still wet. additional colours were dropped in to give more depth and interest.

outwards, giving an area of soft colour with the irregular, jagged outlines so typical of reflections.

Suggested applications

- Use to suggest organic forms, such as blocks of foliage, flower shapes or cumulus clouds.
- Back runs also work well for irregular, hard-edged shapes, such as reflections in water.

When to add paint

It takes a little practice to be able to judge how wet or dry the first wash should be before adding more paint or water to create a back run. As a general quide, if there is still a sheen on the wash it is too wet and the colours will merge together without forming a back run, as they do when working wet-in-wet.

Granulation Certain colours have a tendency to granulate - separate on the paper to create a spotty, grainy texture, rather like the mottling you might see in certain kinds of stone. Using these pigments when creating back runs can add further surface interest and texture.

See Also

Wet-in-wet pages 32-33 Hard edges pages 36-37 Granulation pages 47-49

Dropping in water and colour

2 While the colour is still wet, the artist drops clear water from a clean brush into the paint. The water carries the pigment to the edge of the droplet as it continues to spread.

Applying initial washes

1 The artist drops Rose Madder, Dioxazine Violet, Naples Yellow and Winsor Blue onto wet paper and allows the colours to blend.

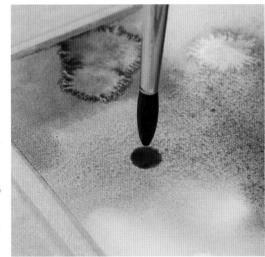

3 Continuing the method, the artist drops some Dioxazine Violet into the still-damp Rose Madder and the Winsor Blue, and then sits back and watches the paint spread.

4 Once dry, the painting shows the blossoms and florets with the concentration of pigment around the edges. Smaller splashes have made smaller blossoms.

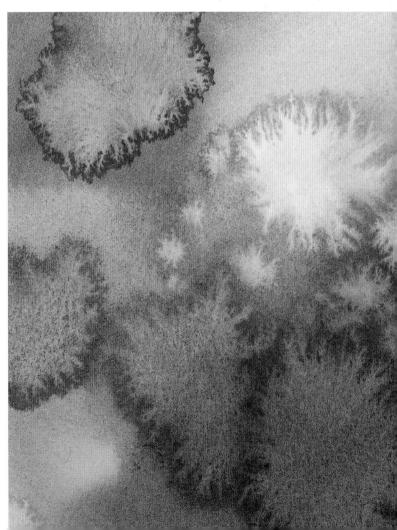

Feathering and Mottling

Both feathering and mottling exploit watercolour's inherent tendency to bleed if the surrounding surface is damp but with different results.

Working wet-in-wet is a classic watercolour technique but the feathering and mottling methods take this one step further. Instead of washing an entire area with water or paint and allowing the next wash to flow into it before the first wash is dry, these two techniques wet only certain areas, so the paint bleeds in a much more controlled way only where the artist wants it to.

In the case of feathering, bands of clean water are painted across a dry surface either unpainted paper or a dry wash: then, while these are still wet, bands of a coloured wash are laid at right angles across the water. The paint bleeds with a feather-like effect where it touches the water, but dries in hard-edged lines in the gaps in between. This can be a useful technique for rendering linear patterns, such as reflections in water.

The mottling technique is similar, except that the water is added afterwards, flicked onto the paint while it is still wet. Because the water is applied in a more random way, the final result is less predictable. But, as with all watercolour techniques, unpredictability is part of the charm and fascination of the medium.

Suggested applications

- Use to convey a stand of pine trees or tracery of branches in a forest canopy.
- Feathering can also work well for reflections in water.
- Mottling is an immensely useful technique for painting woodland trees and branches. It seems to present the labyrinth of tiny twigs exactly as they appear. It would be impossible to paint every little mark, but this creates instant tree texture.

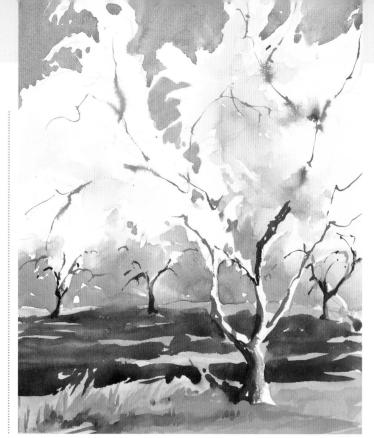

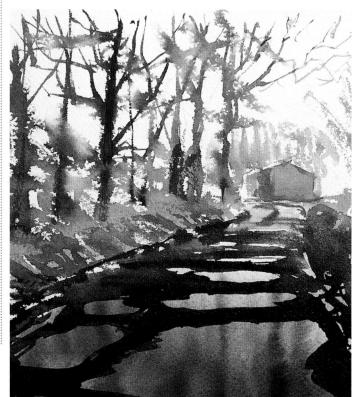

A JAN HART

SPRING BALLET

Softened colours Washes of delicate colour have been loosely applied to the foliage of the tree in the foreground, leaving large areas white. A few quick lines have been sketched in for the framework of branches and allowed to bleed in parts to soften them. The whole effect is one of light and movement.

■ JOE DOWDEN

COUNTRY LANE

Mottled branches In this painting, the artist demonstrates a deft application of the mottling technique. Rather than attempting to paint every branch in a tight and controlled way, he merely suggests the delicate tracery. The result is loose and lively. The soft, feathery shapes are counterbalanced by the bold, hard-edged shadows in the water below.

Feathering

1 First, several strokes of clean water are dragged loosely across the paper. The strokes are spaced out so that there are gaps between them. Pressing too hard will make the water soak into the paper, so care is needed. The brush needs to be dragged gently but firmly along the surface so that the tooth of the paper 'grabs' some of the moisture, while many of the tiny pits and dimples in the surface texture are left dry.

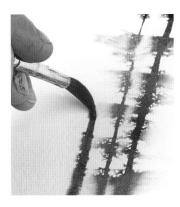

2 While still wet, parallel lines of colour are applied at right angles to the strokes of water. As the lines of paint pass across the lines of water, they diffuse sideways, creating a feather-like effect.

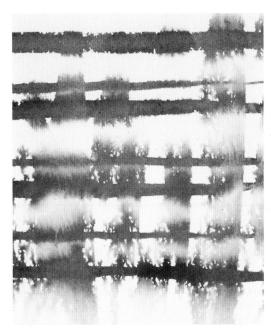

See Also

Wet-in-wet pages 32-33 Back runs and blossoms pages 40-41 Spraying water page 46 Spattering pages 72-73

TIPS Finessing feathering

- · You can vary the feathering technique by applying the strokes of water loosely at different angles, still leaving plenty of dry paper, to achieve a more random effect.
- When feathering, you need to have your colours mixed in sufficient quantity before you begin because the paint needs to be applied quickly before the water dries, or it will not 'feather'.
- · It's important to use a wet, freeflowing mix and rich colour for this technique. This will ensure that the original framework of lines remains strong, and does not lose its impact where it is diffused by water.

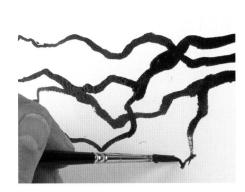

Mottling

▲ 1 The artist paints squiggly lines in a strong colour.

2 Before the lines of paint are dry, he spatters clean water over them by firmly tapping it over his hand and fingers, and letting droplets fly off onto the paper. Where the water hits the paint, the colour diffuses outwards.

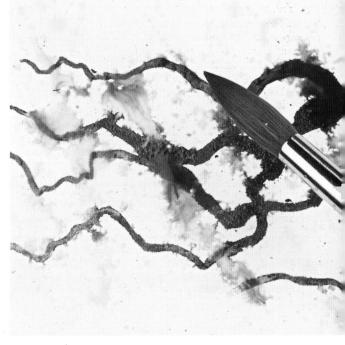

Lifting Out

Lifting out is not only a method of correction that allows the artist to remove excess colour from parts of a painting, but is also a useful and adaptable watercolour technique in its own right.

A number of different tools may be used to lift out paint. For instance, the effect of streaked wind clouds in a blue sky is quickly and easily created by laying a blue wash and wiping a dry sponge, paintbrush or paper towel across it while it is still wet. The white tops of cumulus clouds can be suggested by dabbing the wet paint with a sponge or some blotting paper.

Another useful aid to lifting out is gum arabic, which binds watercolour pigments and is also used as a medium. Add it in small quantities to the colour you intend to remove partially.

Paint can also be lifted out when dry by using a dampened

sponge or other such tool, but the success of the method depends both on the colour to be lifted and the type of paper used. Certain colours, such as Sap Green and Phthalocyanine Blue, act rather like dyes, staining the paper, while some papers absorb the paint, making it hard to move it around. Heavier-weight cold-pressed and rough papers are more robust and can take more punishment, and are excellent for lifting out in this way.

Suggested applications

- Use to soften edges, diffuse and modify colour, and create those highlights that cannot be reserved.
- Use to blur background areas so that they appear to recede, thus creating the illusion of three-dimensional depth.

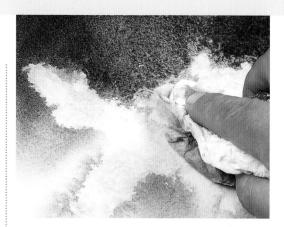

Initial lifting out

1 A loose, uneven wash is laid down for the sky. While the paint is still wet, cloud shapes are lifted out by pressing firmly with paper towel.

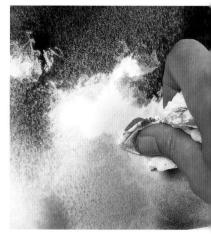

2 By varying the pressure applied, different amounts of colour can be removed. The paper towel can also be rolled to a point to lift out fine detail, as shown here.

Choosing tools

When lifting out large areas of dry paint, a dampened sponge works well. However, for smaller areas or more intricate work, a more precise tool is needed. Choose your tool for lifting off with your subject in mind.

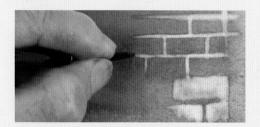

A clean No.6 brush can be used to lift out lines and here, it is used to suggest the shape of bricks in a wall.

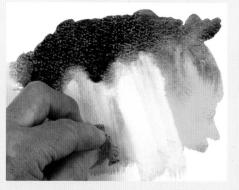

Use a natural sponge and wipe downwards with a strong movement to make rays of light.

A clean, wet brush is used to lift off paint and create soft highlights.

Creating tone and form

3 A pale wash is applied for the sea. A piece of paper towel is then dragged across the damp wash to create varying bands of tone and colour. The paint is left to dry.

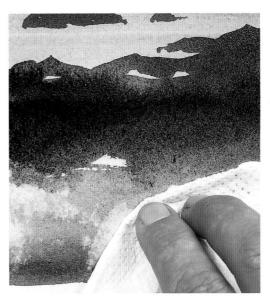

See Also

Reserving highlights pages 62-63 Sponging pages 70-71 Correcting mistakes pages 88-89 Perspective pages 110-111

- 5 While the paint is still damp, a clean, dry brush is used to lift out colour in the middle distance to suggest a flat area between the hills.
 - **6** By restricting the palette to sombre blues and greens, the artist has given the painting an overall unity. When seen as a whole, it does not lack drama however, due to the powerful contrasts in tone and texture that lifting out can produce.

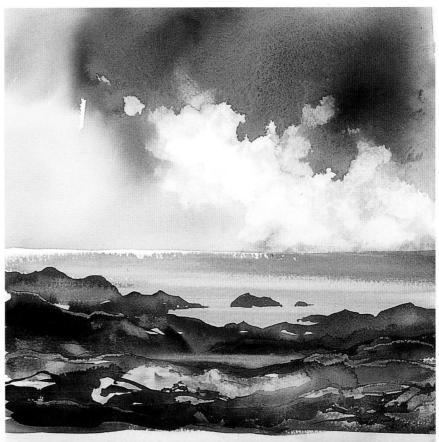

Spraying Water

This technique is similar to dropping in clear water to create back runs, but involves using a spray bottle or diffuser to achieve a much more subtle speckled effect.

Watercolour is a highly flexible medium, allowing the artist to create a wide range of effects. All depend on the way in which the paint interacts with water - as well as how much or how little water is involved. Spraying a wash with water is another way of manipulating the medium and taking advantage of its natural tendency to spread when wet. However, because the drops of water are small the effect is much more understated than with, say, back runs or other similar techniques - it is effectively a way of distressing the surface to produce a texture.

Timing is crucial with this technique – spray when the paint is still damp but has lost its surface sheen. If you spray while the area is still too wet, the water droplets will merge into the paint without leaving a mark.

Laying washes

1 Working wet-in-wet, the artist adds washes of several different colours to the paper and lets the colours blend together.

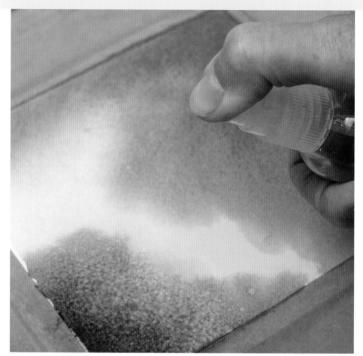

Spraying the damp paint

2 While the paint is still damp, water is sprayed onto it in short bursts from a bottle.

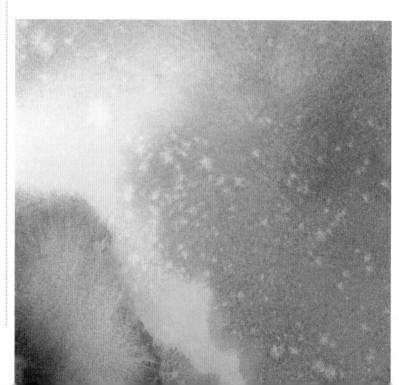

3 When the paint is dry, a random pattern of tiny watermarks is visible.

Granulation

Although it is not strictly a technique in its own right but part of the way in which certain colours behave, granulation can be used by the watercolour artist to great effect.

With some colours, pigment particles attract each other to produce a grainy effect known as granulation. What may look like an alarming mistake to a novice – and one that must be corrected immediately – is appreciated by the more experienced painter as one of

the delights unique to this medium, to be preserved and enjoyed. The texture produced by granulation is often very beautiful and can greatly enhance a painting.

Granulating colours include several of the blues – Cobalt, Ultramarine, Manganese and Cerulean – as well as Viridian, Raw Sienna and Raw Umber. However, if the name on the paint label is followed by the word 'hue', that colour may not granulate as well.

As an experiment that will produce an interesting two-tone

texture, a granulating colour may be mixed with one that does not granulate well – for example, granulating Manganese Blue with nongranulating Alizarin Crimson.

Suggested applications

- Exploit granulation to convey organic textures, such as those of masonry or stone.
- Use areas of granulation as a counterpoint and contrast with flat paint.

W ROGER PICKETT

BRITTANY SKYLINE

Exploiting different techniques

To build up the textures, Pickett has given himself a start by working on rough paper. The foreground was worked over a high-toned wash, and when dry, more paint was applied, mixed with granulation fluid, and the board was tilted to channel the granulation in various directions. Darker details were added first with a brush and then with a sharpened twig, used to draw lines into the wet paint.

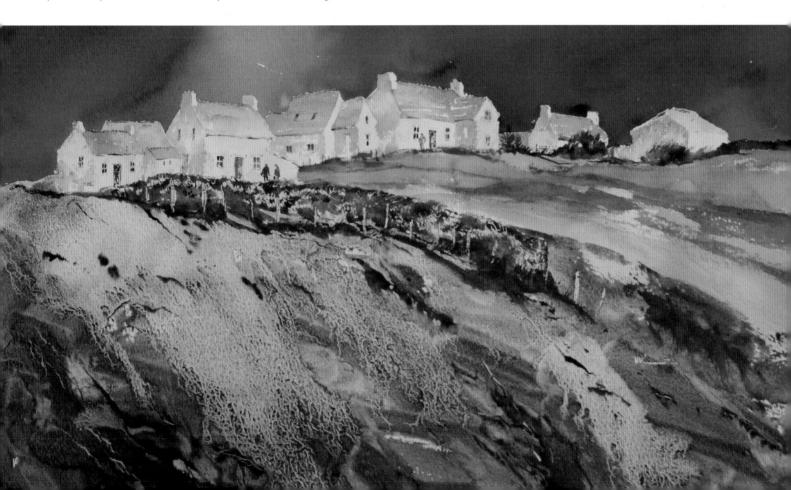

Granulation fluid

Granulation fluid is a watercolour medium developed to make all colours granulate, if wished. It may be used straight or diluted with water, then mixed with the paint.

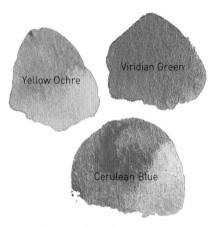

Granulating colours

This selection of granulating paints shows how the pigments settle on the watercolour paper. Don't be alarmed by this uneven appearance; it is normal and can be used to great effect in your painting.

Brushing in the first washes

1 The artist starts by brushing in a pool of Alizarin Crimson, followed by an overlapping pool of Manganese Blue (right).

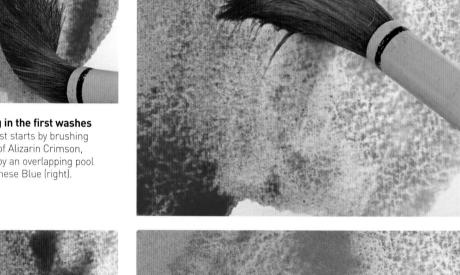

Applying a granulating mix

2 He then flows in an Alizarin-Manganese mix in the middle.

For the best effect and maximum granulation, use a rough paper.

3 When the paint is dry, the effect is clearly visible. The Alizarin to the left has not granulated but the mixed violet in the middle and the Manganese to the right have clearly granulated, producing that distinctive texture.

Increasing granulation

The amount of granulation you can expect to see varies according to the texture of the paper, the amount (and type) of water used and the nature of the pigment itself. Although some pigments granulate on smooth, hotpressed papers, the effect is increased if you use textured paper, as shown here. Mixing a particular colour with distilled water can also increase its granulation.

With distilled water

With granulation medium

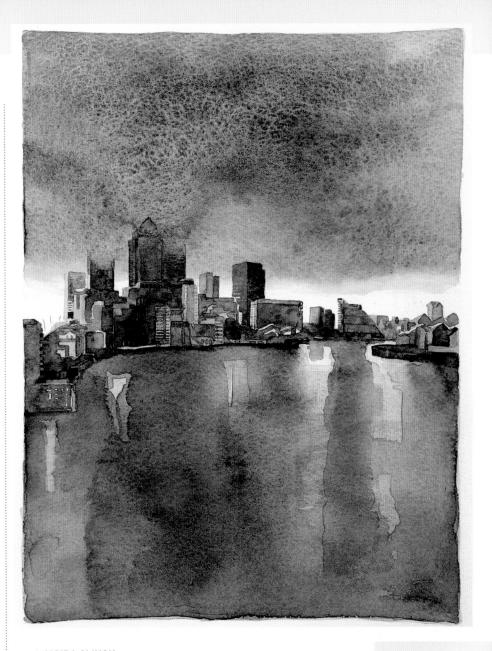

MOIRA CLINCH

THE SKY AND THE WATER

Exploiting granulation In this wonderfully atmospheric painting, granulation has been deliberately induced in the sky area so that it has an almost solid presence. The water has been treated more smoothly, with carefully reserved highlights linking it to the sky and buildings above.

See Also

Spattering pages 72–73

Back runs and blossoms pages 40-41 Feathering and mottling pages 42-43 Running in pages 50-51

Running In

This is a similar technique to creating back runs, but this time the board is deliberately tilted to allow gravity to act on the paint.

The difference between back runs and running in is that, in the case of back runs, the wet paint is allowed to spread in whatever direction it naturally wants to go, carrying a 'tidemark' of pigment with it; with running in, the artist controls the direction in which the water or wet paint runs by lifting the board so that it runs downwards.

Running in has a limited number of applications compared with other watercolour techniques, but it's worth knowing nevertheless watercolour is an incredibly flexible medium, offering a wider range of effects than perhaps any other painting medium, so it's good to be aware of every option. If this technique is controlled carefully and the wetness of the wash judged correctly when the water is dropped in, the final effect can be subtle and pleasing.

The soft, vertical forms created by running in are

suggestive of reflections in water, and could also be used to convey wet surfaces such as pavements. Carefully controlled, it could express the highlights on a shiny, cylindrical object.

Suggested applications

• Use the running-in technique wherever you want soft, vertical forms – for example, to convey reflections in water or the highlights on straight-sided, cylindrical objects such as vases.

Laying a wash

1 A flat wash is laid down on the paper.

Running in water

2 While the wash is still wet, the board is held upright and a brush holding clean water is touched to the top. The water runs down, carrying the pigment with it.

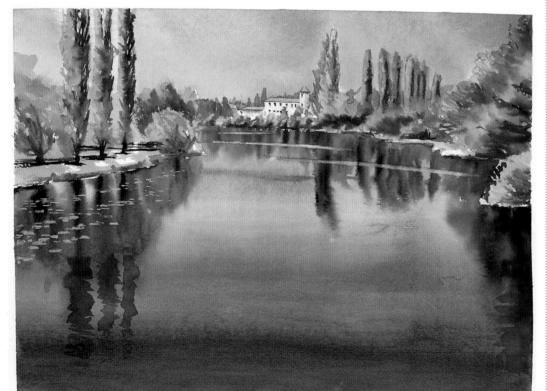

■ JOE FRANCIS DOWDEN

BROAD SUNLIT RIVER

Flowing in colour To convey the reflections of the trees in the water, the artist needed to flow colour, rather than water, into the painted surface of the river. Working wet-in-wet and using Cadmium Lemon, Burnt Sienna, Payne's Grey and other pigments, he allowed the lines of colour to diffuse and spread to create the blurry reflections.

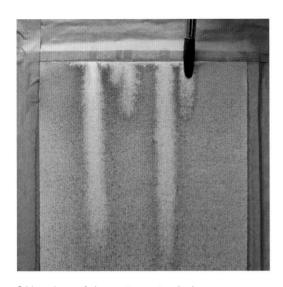

3 More drops of clear water are touched to the top of the still-wet paint.

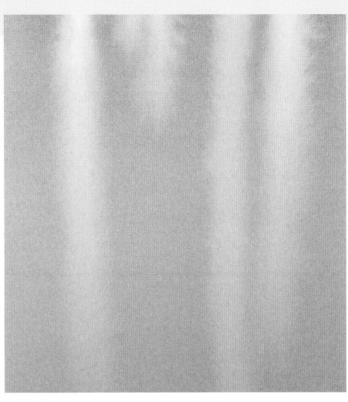

4 After the paint has dried, softedged passages of lighter colour are left within the wash.

Dropping in colour

Drop a colour into a wet area and allow it to react as its nature determines. It may diffuse, feather, bleed, creep, drop or shoot, depending on the introduced pigment and the density of the receiving wash. In these examples, Carbazole Violet (Dioxazine), a concentrated, dark organic pigment, receives inorganic and organic pigments very differently. Because of this unpredictability, experiment first on scrap paper before committing dropped-in colour to your painting.

Nickel Azo If Nickel Azo is introduced into a lighterweight wash, it shoots wildly. If the receiving wash is not wet enough, it drops to the paper.

Perylene Maroon This pigment appears to fuse with the wash it enters.

Cobalt Violet This granulating pigment dives for the paper.

Ultramarine Blue This pigment displays a ghostly, soft infiltration.

Cadmium Orange This heavy pigment dives in and spreads out into the lower layers of the wash, altering the colour.

Quinacridone Gold This displays a feathery edge in the Carbazole wash.

Running in colour

Instead of running in clear water, you could run in a wash of another colour, wet-in-wet, tilting the board so that the colour runs downwards and diffuses into the underlying wash.

See Also

Back runs and blossoms pages 40-41 Feathering and mottling pages 42-43

Brushwork

Knowing which brush to choose for the task in hand, and how to handle it, can make the watercolourist's job that much easier - and ensure greater success in the finished work.

There's a common belief that brushwork is important only in oil painting. Watercolours are painted in gentle, flat washes. aren't they, with no obvious brushmarks? Well, ves and no.

You can paint entirely in washes, as with wet-in-wet, where you certainly can't see any marks. But the marks a brush makes can be quite expressive, so it seems a pity not to make use of this resource. Some watercolourists build entire paintings by drawing with their brushes, using few, if any, flat washes, as in classical Chinese

painting with its almost calligraphic brushstrokes.

Watercolour brushes come in all shapes and sizes and it is worth exploring the wide variety available, as well as learning what kinds of marks individual brushes can make. Wide, flat brushes are designed to make wide, flat marks, and are good for laying washes. Round brushes are perhaps more versatile, depending on how they are used. A fine to medium round brush can make broader marks if you apply more

point is lightly touched to the paper, a fine line will be produced.

Always have more than one brush on hand, and when making marks be sensitive to what you are trying to convey short, criss-crossing marks can suggest the texture of foliage; fine, zig-zagging strokes are perfect for the reflections of trees in water

Suggested applications

• Let the shape of the brushmarks suggest their use. For example, dry-brush done with a flat brush creates a texture reminiscent of the textured surfaces of wood and rocks. 'Dancing' brushstrokes are good for foliage and vegetation.

MARY ANN ROGERS

MATADOR

Responding to the subject This painting demonstrates the artist's superb command of the watercolour medium. Her sensitivity to her subject is seen in the way in which she has varied her brushstrokes in response to the patterning and movement of the bird's plumage.

DAVID BOYS

SKETCHBOOK STUDY

Conveying subjects Here the artist has developed a 'language' of brushmarks to describe this bird's feathers. The marks follow the direction of the feathers, and vary in shape and in length from long to short - short, curling brushmarks convey the patterns on the long feathers, and dots and dashes the shorter breast feathers.

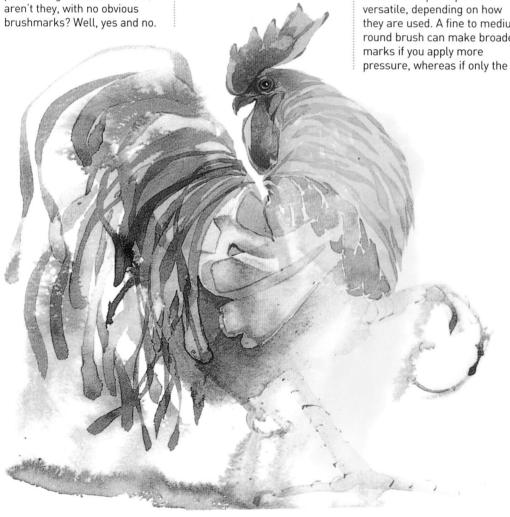

Dry-brush

1 To work the dry-brush technique with a flat brush, a very lightly loaded brush is held nearly parallel to the surface and moved quickly across the paper. Some paint is released onto the raised areas, creating a scumbled effect.

2 A round brush works as well as a flat one for dry-brush.

Two-colour strokes

This technique is possible only with a flat brush. Load one edge of a flat brush with one colour, then load the other edge with a different colour, and make dancing brushstrokes.

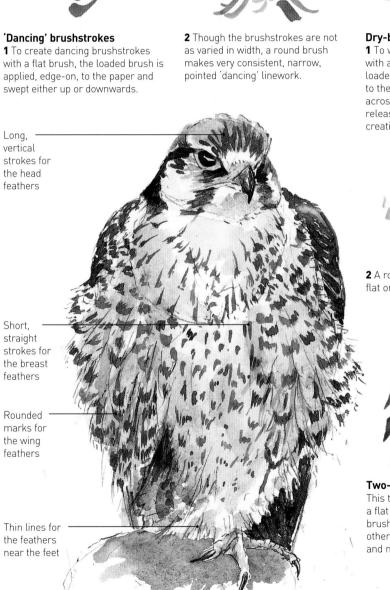

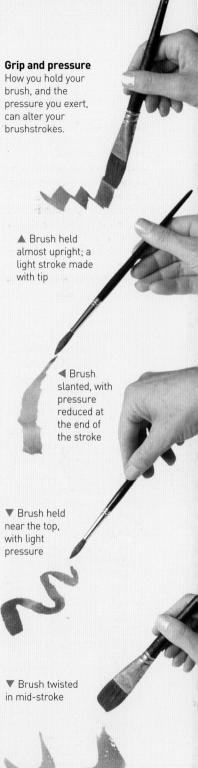

Brush Drawing

Drawing with a brush is an excellent way to loosen your technique, requiring no underdrawing in pencil.

Opaque water-based paints are not suitable for brush drawing because they produce too solid a mark – the marks and lines you make must be fluid and must flow easily from brush to paper, so use ordinary watercolour, watercolour ink or even acrylic paint, diluted with water to a wash.

With practice you will learn how much pressure to apply to your brush to make the line thicker, thinner, lighter or darker. Light pressure with the tip of a medium-sized, pointed brush will give a precise. delicate line. A little more pressure will thicken the line. while increasing it still further will produce a shaped brushmark rather than a line. It is even possible to produce a line of great sensitivity that is thick in places and thin in others, a highly pleasing effect.

Suggested applications

 Brush drawing is especially useful whenever you want your work to appear free and spontaneous.

 The technique is also good for conveying movement in a variety of subject matter.

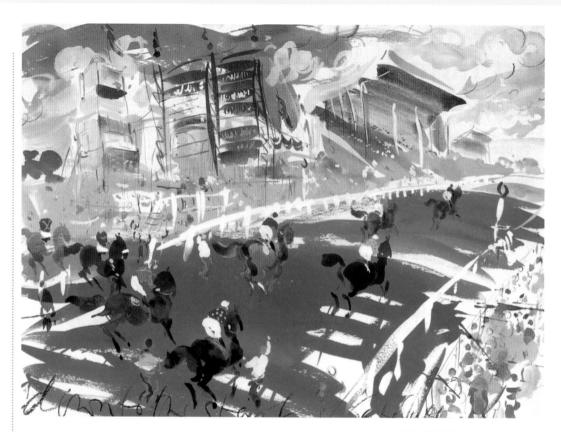

▲ JAKE SUTTON

DOWN TO THE START

Spontaneous drawing Drawing spontaneously with the brush is an excellent way to convey movement, which forms the main theme of this sparkling picture. Movement is expressed in every area, from the scribbled clouds to the blobs and splashes of paint used for awnings and foreground figures.

◀ JULIE CASSELS

MAD MARCH HARES

Using different brushes As well as applying different degrees of pressure to your brush to vary the lines and marks that you make, try using a selection of brushes, including broad, flat-ended ones; your mark-making repertoire will be almost limitless. This will give a sense of spontenaneity and movement to your paintings.

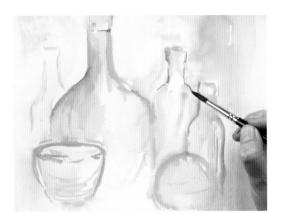

Drawing in the outlines

1 Using a fine brush and working on dry paper for a crisp effect, the artist draws in the main outlines of the bottles, making the lines in the foreground darker than those behind. The lines are then washed over with water to soften them – this will also allow the artist to erase and rework any errors. Loose washes of the same colour are applied within the outlines, and to the surrounding area.

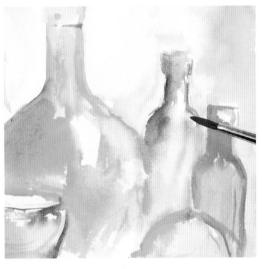

Adding definition

2 When the paint is slightly dry, washes of darker colours are applied to define the shapes of the bottles, and to add shadows and depth to the surrounding area.

- Vary the weight of your lines to suggest three-dimensional form. Thin lines suggest delicacy and lightness, while thicker lines convey greater solidity and weight, as can be seen in the bottles here.
- Wherever the underpainting is still wet, any marks or lines you make will bleed so if you want crispness make sure that the underpainting is dry first.

- **3** White or pale patches are left unpainted, for highlights. The artist continues building up the picture in this way.
- **4** The finished painting has sufficient definition for the objects in it to be clearly recognizable, but the looseness of the technique ensures that the whole retains its impressionistic approach.

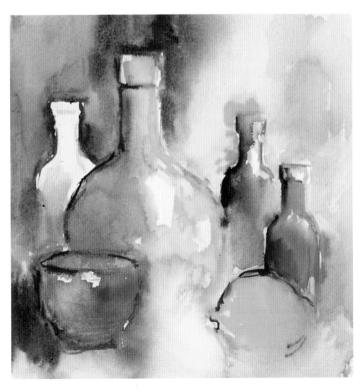

Chinese brushes

In Chinese brush painting, brushmarks are pared down to a minimum to capture the essence of a subject. Here, the flower petals are achieved by applying heavy pressure.

> **See Also** Brushwork pages 52–53

Dry-Brush

This technique is just what its name implies – painting with the bare minimum of paint on the brush so that the colour only partially covers the paper.

The dry-brush method is one of the most common ways of creating texture and broken colour in watercolour. It needs practice: if there is too little paint, it will not cover the paper at all, but if there is too much, it will simply create a rather blotchy wash.

As a general principle, the technique should not be used all over a painting, since this can look monotonous. Texture-making methods work best in combination with others, such as flat or broken washes

Opaque gouache and acrylic are also well suited to the drybrush technique. In both cases the paint should be used with only just enough water to make it malleable – or even none at all. Cold-pressed or rough papers lend themselves best to this technique; as the dry paint is skimmed across the coarse surface, it adheres to the raised spots but does not sink into the indentations, automatically creating a textured effect.

Suggested applications

- Use in landscapes for foliage and grass.
- Apply in seascapes to suggest the texture of the waves or highlights on the water.
- Use in portraits or animal painting to indicate the linear texture of hair or fur.

Establishing the main areas

1 Having pressed out excess moisture from the brush, the artist drags grey-blue watercolour across the paper for the sea. Since the paint is fairly dry, it does not spread evenly over the paper like a fluid wash, but produces a patchy finish suggestive of sparkling water.

2 While this is drying, she adds washes for the sky and an uneven wash of light ochre for the beach.

Bristle brushes

The best dry-brush effects are obtained with bristle, not soft sable or synthetichair, brushes (these are, in any case, quickly spoiled by such treatment).

▶ TONY BELOBRADJIC

VENEZIA 2014

Direct application This artist likes to work spontaneously, without a pencil sketch. Instead he prefers to apply colour directly with a brush, allowing the paint to catch on the rough surface of the paper to create texture and highlights.

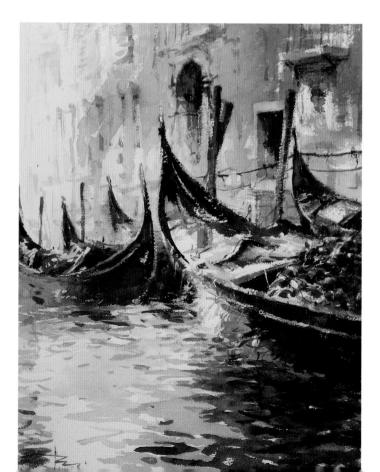

Working the foreground

3 Using a flat, broad brush and ochre, she begins to dry-brush the marram grass on the shore.

4 When the first layer of grass is dry, she builds up subsequent layers in the same way, dry-brushing progressively darker colours over the lighter tones. She also adds a small figure, partially hidden by the grass.

5 When the sea is completely dry, she dry-brushes streaks of Indigo mixed with Cerulean Blue over it. She also paints in the headland, overlaying a wash of greyblue on top of the semi-dry sky so that the two blend a little to create a softer effect.

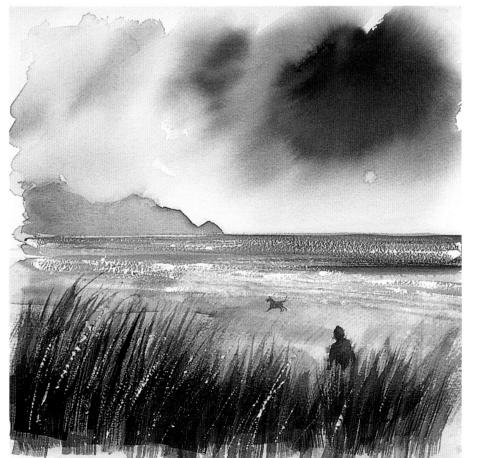

Adding highlights

6 The picture is completed with the addition of a little white gouache for extra highlights on the sea. Highlights are also scratched into the grass with a craft knife, and – as a final touch – the small figure of a dog running along the sand is placed in the middle ground.

See Also Using salt pages 76-7

pages 76–77 Creating texture pages 80–81

Toned Ground

Pre-tinting watercolour paper to create a toned ground offers several advantages to the watercolour artist.

Although most watercolourists work on white paper, there are times when you might want to work on a lightly coloured ground. The advantages of a toned ground are two-fold. First, it helps you to achieve unity of colour because the ground shows through the applied colours to some extent, particularly if you leave small patches uncovered. Second, it allows you to build up deep colours with fewer washes, thus avoiding the risk of muddying. This is especially well suited to

opaque gouache work where muddying occurs very easily.

It is possible to buy heavy coloured papers for watercolour work, but these may not always be easy to find, in which case you will need to colour your own paper. You do this by laying an overall wash of thinned acrylic, or an overall watercolour wash. For any but the heaviest weights of paper, it is necessary to stretch the paper first.

The main problem with pretinting is deciding what colour to use. Some artists like to paint a cool picture, such as a snow scene, on a warm, Yellow Ochre ground so that the blues, bluewhites and greys are heightened by small amounts of yellow showing through. Others prefer

cool grounds for cool paintings and warm grounds for warm ones. Think carefully about the overall colour key of your painting before pre-tinting; it can be helpful to try out one or two ground colours first.

Suggested applications

- Apply a toned ground wherever you want to create a unified, coherent effect.
- A toned ground is also useful if you want to concentrate most of your marks in one part of the painting the toned ground will 'fill' the rest of the space so that the picture still works as a whole, without looking unfinished.

TIPS Painting grounds

- Before you begin your painting, experiment with different-coloured toned grounds on some spare paper. When the paint is dry, roughly brush on some of the colours you will be using in your final picture, to see what effect you get. Watercolour is translucent, so the toned ground will affect the colours applied on top.
- Remember that if you apply an overall toned ground, you will not be able to reserve highlights because there will be no white paper left.

Tinting the paper

1 First, the artist lightly sketches in the subject matter. He then tints the paper with a wash of Raw Umber acrylic paint. The paint is initially applied with a brush and then rubbed with tissue to create a slightly uneven, patchy finish.

Working wet-in-wet

2 When the initial wash is thoroughly dry, the artist re-wets the paper and begins to deepen the colour in parts. Re-wetting the paper allows the paint to spread so that no hard edges form and the effect remains soft and blurry.

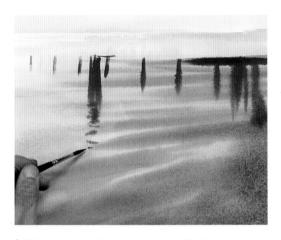

3 Maintaining a limited palette and continuing to work wet-in-wet, the artist builds up the tones and paints in the softer details, such as the reflections of the pier supports.

Working wet-on-dry

4 Once the atmosphere and colour have been established, the painting is allowed to dry. Working wet-on-dry, crisper details can then be added.

5 Further details are added wet-on-dry, such as the building at the top right, the pier supports running across the top of the picture, the dark, wooden breakwaters and the birds in the sky.

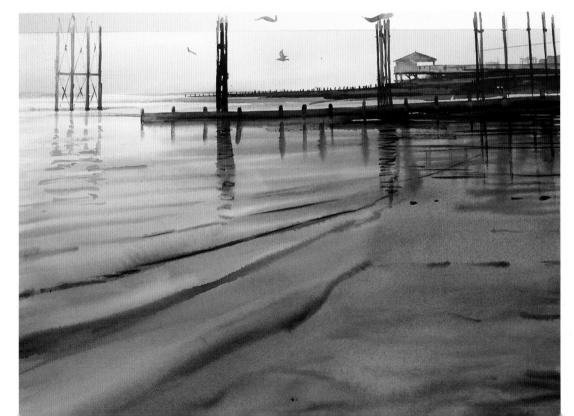

6 The toned ground and the disciplined palette bring together all the elements of the picture, giving unity and coherence. The tones become deeper towards the foreground increasing the sense of space and light.

See Also

Stretching paper page 17 Flat wash pages 24-25 Wet-on-dry pages 30-31

Line and Wash

Line and wash is a type of visual shorthand – combining line to indicate form with colour from the brush is a rapid and economical way to convey a great deal of information.

This technique has a long history and is still much used today, particularly for illustrative work. Before the eighteenth century, line and wash was

used mainly to put pale, flat tints over pen drawings – a practice that itself continued the tradition of the pen-and-ink wash drawings that were often made by artists as preliminary studies for paintings.

The traditional method is to begin with a pen drawing, leave it to dry, and then lay in fluid, light colour with a brush. One of the difficulties of using this method is to integrate the

drawing and the colour in such a way that the washes do not look like a 'colouring in' exercise, so it is often more satisfactory to develop both line and wash at the same time, beginning with some lines and colour and then adding to and strengthening both as necessary.

Alternatively, you can work 'back to front', as it were, laying down the washes first to establish the main tones and

then drawing on top. In this case, you will need to begin by making a light pencil sketch as a guideline.

The inks used may be either waterproof or non-waterproof. Non-waterproof inks will run and this will add to the loose expressiveness of the medium. Loose-flowing lines and washes do not have to be completely precise.

Suggested applications

- Line and wash is particularly well suited to small, delicate subjects, such as botanical plant drawings, or where you want to express precision of form, as with architectural subjects.
- The technique also works well for quick figure studies, where you want to convey a sense of movement.

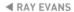

STREET IN KIEV

Architectural subjects Line and wash is an excellent technique for architectural subjects, as can be seen here. The artist has used watercolour sparingly, reinforcing his fresh, clean washes with lively pen lines supplying the finer detail. Responding to different elements within the scene, he has varied his line accordingly straight lines for the timber cladding, spidery lines for the branches and circles for the stones and pebbles in the walls and road surface - so that the line adds interest to the picture as well as providing information.

Initial linework

1 A few short strokes, lines and markings are made with an Indian ink pen, by first dipping it in the ink pot and then drawing directly on the paper.

Laying washes

2 When the ink lines are dry, a loose wash is brushed over them. Waterproof ink, which does not run, has been used here.

3 The artist continues to build up the colour over the ink drawing. Even though the colour is quite intense it is transparent, allowing the linework to show through - this is the essence of line and wash.

TIPS Drawing lines

- Tone can be built up by drawing numerous fine lines close together, in a technique known as 'hatching'. If the lines cross, it is referred to as 'cross-hatching'. The tone created by hatched lines can be supplemented with dark washes, perhaps for windows or doorways on a building.
- You need not limit yourself to a dip pen for drawing the lines. Many different instruments can be used, including ballpoint pens, or even an old broken twig dipped in ink to create scratchy lines with their own spontaneity.

Leaving unpainted areas

4 Some of the linework is left unpainted so that it remains sharp and focused. As with all art, the trick is knowing when to stop and not to overwork a piece - it can be a real advantage to stop short of completing a very detailed image.

See Also

Brush drawing pages 54-55

Reserving Highlights

Although you can create white highlights by applying opaque white paint (gouache), the purest highlights in watercolour work are made by 'reserving' that is, leaving the paper free of paint.

The light reflecting off white paper is an integral part of watercolour painting, giving good watercolours their lovely, translucent quality. For this

reason, the most effective way of creating pure, sparkling highlights is to reserve areas that are to be white by painting around them. This means that when you begin a painting, you must have a clear idea of where the highlights are to be, so some judicious advance planning is necessary.

When you lay a wash around an area to be reserved, it will dry with a hard edge. This can be very effective but it may not be what you want - for example, on a rounded object such as a

piece of fruit. In such cases, you can achieve a gentler transition by softening the edge with a brush, small sponge or cotton bud dipped in water.

Small highlights, such as the points of light in eyes or the tiny sparkles seen on sunlit, rippling water, which are virtually impossible to reserve because of their size, can be achieved either by masking or by applying white gouache as a final stage. Highlights can also be created by removing paint, by lifting out or scraping back.

Soft highlights

To create a soft. coloured highlight, apply slightly diluted Chinese white or white gouache on top of the colour. The white will sink slightly into the colour below to produce a gentle, soft-edged highlight, perfect for matt surfaces.

Suggested applications

- Use highlights to create tonal contrast and give the illusion of three-dimensional form.
- Reserve crisp highlights on shiny objects and softer highlights on more matt surfaces.

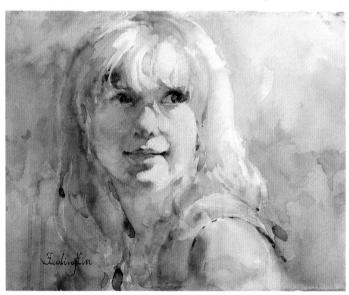

▲ FEALING LIN HER SMILE

Tinted highlights This spontaneous portrait captures a fleeting moment as the girl turns and smiles. The reserved highlights - on the hair, nose, upper lip, chin and shoulder - are lightly tinted rather than pure white paper. Darker tones have been built up progressively to add shading and form.

► CAROLINE LINSCOTT

CATCHING THE LAST LIGHT II

Bold contrasts Reserved whites on the tips of the petals and glazes of transparent colour convey the luminosity of these night-blooming cactus flowers. The crisp edges of the petals against the dark background throw the blooms into greater relief, making them appear even more translucent.

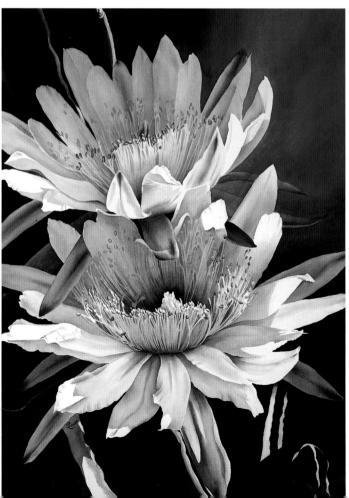

Coloured highlights

Not all highlights are pure white; in paintings where all the tones are dark, too many whites could be over-emphatic. In this instance, you will need to wait until some colour has already been applied, and then either reserve areas of an initial pale wash or build up really dark tones around a later, mid-toned one. If you want to work wet-in-wet, you will have to wait until the initial wash has dried completely before re-wetting the paper.

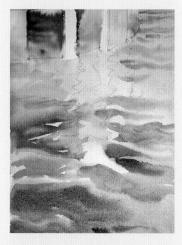

1 Soft tones are built up, wet-in-wet, on an underwash of pale blue.

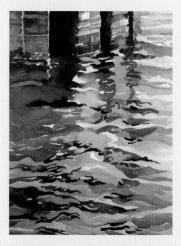

2 Crisper shapes are added wet-on-dry for definition and form.

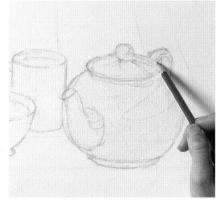

Making an initial sketch

1 The artist makes a preliminary drawing, lightly sketching in the shapes of the highlights so that they will be easy to reserve.

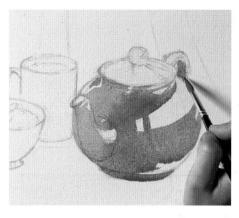

Applying the washes

2 The highlight is to be an important feature of the painting, so the teapot is painted first. Because the pot has a reflective surface, the edges of the highlights are crisp, an effect the artist wants to exploit fully.

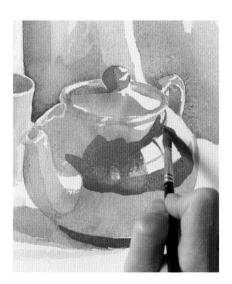

3 The background and the other objects are painted with all the highlights reserved as white paper or a pale colour. The artist now begins to build the darker tones.

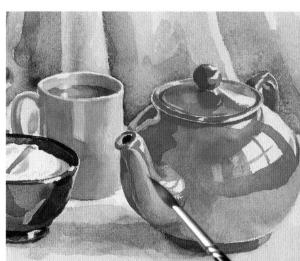

4 The softer highlight on the spout of the teapot is made by reserving the lighter colour, that is, painting darker washes around the original light pinkish-brown.

See Also

Lifting out pages 44-45 Scraping back pages 64-65 Masking pages 66-67 Body colour pages 82-83

Scraping Back

Sometimes called sgraffito, this technique simply involves removing dry paint so that the white paper is revealed. It is most often used to create small, fine highlights that cannot be reserved, such as light catching blades of grass or small points of light on the surface of rippled water. It is a more satisfactory technique than applying opaque white highlights with a brush, because this can look clumsy and, if laid over a dark colour, does not cover it very well.

Scraping is done with a sharp knife, such as a craft knife, or with a razor blade. For the finest lines, use the point of the knife, but avoid digging it into the paper. A more diffused highlight over a wider area can be made by scraping gently with the side of the knife or with a razor blade, which will remove some of the paint but not all of it. The method should only be used in the final stages of a painting because it scuffs the paper and makes it impossible to apply more paint on top; in addition the paint must be completely dry.

The same technique can be used for gouache or acrylic, but the surface must be one that can withstand this treatment.

Suggested applications

• Use for tiny highlights that cannot be achieved either by masking or reserving; for example, delicate surface textures, blades of grass or sparkles on water.

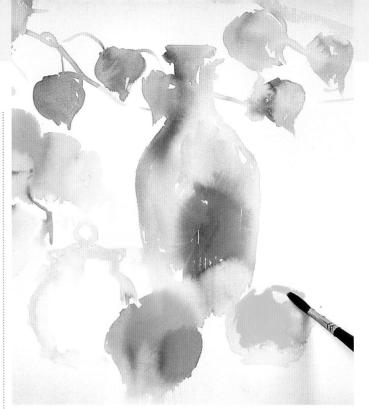

Laying a wash

1 Layers of watercolour are first built up in the usual way. This kind of light underpainting will allow for scraping back later.

Improvising tools

3 Other tools can be used for scraping back. Here, a credit card provides a useful edge for scraping away bands of just-damp colour.

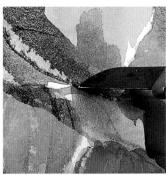

Scraping back damp paint

2 Using a round-bladed craft knife, the artist scrapes away the plant stems. This is done while the paint is just damp so that it is easier to remove. Working in this way requires careful judgement. If the paint is too wet, the colour will simply flow back into the space it previously filled; the paper surface will also be wetter and so more easily torn. If the paint is left to dry completely, however, it can be more difficult to scrape away.

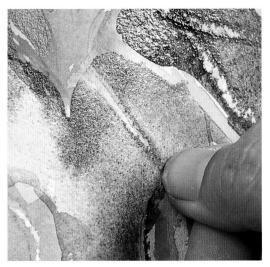

4 A fingernail provides another ready tool for scraping back.

Additional highlights

5 If more highlights are required, the surface may be gently rubbed with sandpaper. This must only be done when the paint is completely dry - sandpaper will rip the surface of damp paper.

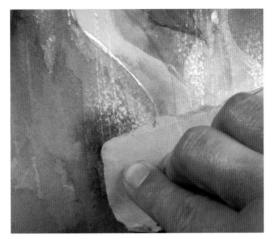

Drawing with a blade

You can use the blade of a scalpel or craft knife like a pen or pencil to 'draw' linear highlights or texture, as on the inner surface of this mushroom - but take care to judge the wetness of the surface correctly before you start.

6 To create shafts of light, the sandpaper can be folded to create a sharp knife-edge.

Paper quality

This method will not be successful unless you have a good-quality, reasonably heavy paper - it should be no lighter than 300gsm (202lb). On a flimsier paper, you could easily make holes or spoil the surface.

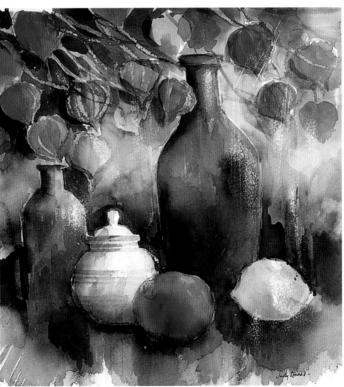

7 Translucent watercolour washes and scraped-back areas give the finished still life a luminous quality.

TIP Choosing scraping tools

Almost anything sharp enough to scratch away the surface of the paint can be used for scraping back, but consider first the kind of shape you want to make and choose your tool accordingly. For example, sandpaper gives an overall sparkle or, folded and used on edge, it creates more concentrated linear highlights. Blades also produce linear highlights, while a credit card pulls back' colour for a more diffused area of brightness.

See Also

Reserving highlights pages 62-63 Masking pages 66-67

Masking

The two main purposes of masking are to create highlights by reserving certain areas of a painting, and to protect one part of a picture from accidental paint splashes while you work on another.

If over-used, masking can detract from the spontaneity that we associate with watercolour, but it is a method that can be used creatively, giving exciting effects that cannot be obtained by using the more classic watercolour techniques. Liquid masking fluid or masking tape may be used.

The liquid is applied with a brush and comes in two forms. One has a slight yellow tint, allowing you to see the brushstrokes as you apply them. The disadvantage is that the yellow patches are visible as you paint and tend to give a false idea of the colour values. There is also a colourless type, which does not distort colour perception but can be hard to see. Fluid-filled pens are also available, allowing you to 'draw' with the fluid.

Once the fluid is completely dry, washes are painted over it. When the paint is dry, the mask is removed by gently rubbing with a finger or an eraser. The beauty of liquid mask is that it is a form of painting in negative – the brushstrokes you use can be as varied in shape as you like, and you can create lovely effects by using thick and thin lines, splodges and little dots.

Sometimes a painting needs to be approached methodically

and dealt with in separate parts, and this is where the second main function of masking comes in. Liquid mask or masking tape (ideal for straight lines) can be used as a temporary stop for certain areas of the painting. Covering the whole area of the building with liquid mask or putting strips of masking tape along the edges will allow you to paint freely without the constant worry of paint spilling over to spoil the sharp, clean lines. Once the background is finished, the mask can be removed, and the rest of the painting carried out as a separate stage. It may be mechanical, but it is a liberating method for anyone who wishes to have complete control over paint.

Suggested applications

- Reserve small, intricate highlights with liquid mask –for example, a pattern of leaves and twigs catching the sunlight in a woodland scene.
- Use to protect one area of a picture while painting freely on another.

Applying initial colour

1 Using a light pencil outline as a guide, the artist begins painting in the petals of the flowers with washes of blue and purple watercolour. She also washes Raw Umber and Burnt Sienna over the stems. Patches of deeper blue are applied for the sky. The paint is then left to dry completely.

Masking out

2 She then masks the flowers and stems with liquid mask and leaves it to dry.

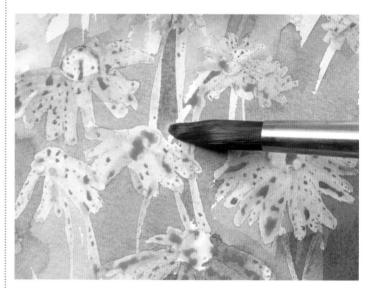

Painting over the mask

3 The artist paints a green wash all over the flowers, using directional strokes for the grasses. The paint is left to dry, then a few more stems in the foreground are masked out with fluid.

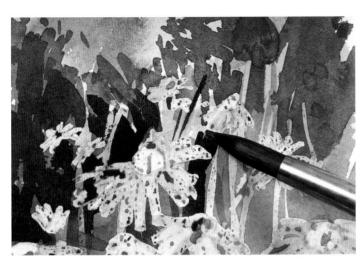

4 When the second coat of mask is dry, she paints darker green over the grasses and on the trees in the background. All the paint is now left to dry fully before the masking is removed.

TIPS Best practice

- If the paper is too rough or too smooth, masking will either be impossible to remove or will spoil the paper - the best surface is a medium one (known as 'NOT' or cold-pressed).
- Rubbing the paintbrush in wet soap before dipping it in the fluid makes it easier to clean later. The brush should also be cleaned immediately after use.

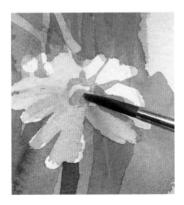

5 Final details, such as the orange hearts of the flowers, are added with a fine brush.

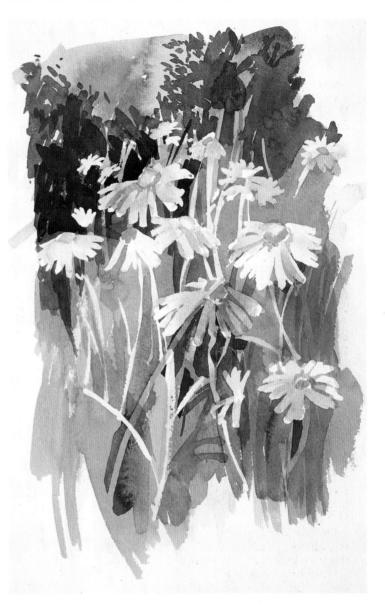

6 Masking has allowed the artist to work in a spontaneous way, and has produced an effect impossible with any other technique. When the mask is removed the results can be a little unpredictable but any 'happy accidents' become key elements of the style.

See Also

Reserving highlights pages 62-63 Scraping back pages 64-65 Wax resist pages 68-69

Wax Resist

This simple technique, based on the antipathy between oil and water, can yield magical results.

Wax resist is a valuable addition to the watercolourist's repertoire and involves deliberately repelling paint from certain areas of the paper while allowing it to settle on others. If you draw over paper with wax or an oily medium and then overlay this with watercolour, the paint will slide off the waxed or greasy areas. You can use either an ordinary household candle or inexpensive wax crayons for this technique. The British sculptor, Henry Moore (1898-1986), who was also a draughtsman of great imagination, used crayons and watercolour for his series of drawings of sleeping figures in the London Underground during World War II.

The wax underdrawing can be as simple or as complex as you like. You can suggest a hint of pattern on wallpaper in a portrait by means of a few lines, dots or blobs made with a candle, or create an intricate drawing using crayons with sharp points.

Wax beneath watercolour gives a delightfully unpredictable speckled effect which varies according to the pressure you apply and the type of paper you use. It is one of the best methods for imitating

natural textures, such as those of rocks, cliffs or tree trunks.

Suggested applications

• Use to create natural patterns and textures, such as the bark of trees, dappled sunlight or light through foliage.

Applying wax and oil pastel

1 Having first lightly pencilled in the outlines of the figures, the artist roughly scribbles over the sunlit background and trees using a white wax candle and green and yellow oil pastels.

▼ CHARLES KNIGHT RWS. ROL

techniques are used to create the frothy waves in this picture which create a feeling of movement and add drama to the composition.

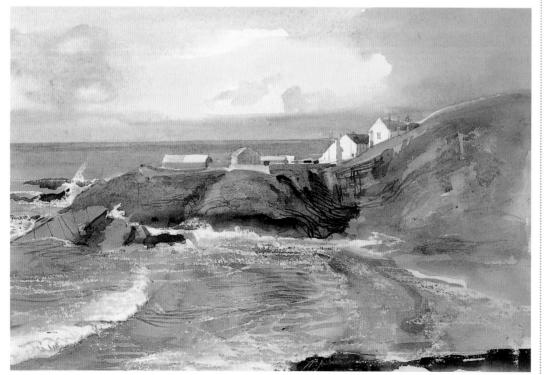

Painting over the resist

2 Dark shades of watercolour are then flooded over the whole area. The waxy parts reject the watercolour, but where there are tiny gaps in the waxy surface the colour adheres, creating broken shapes and the speckled effect that is so characteristic of the waxresist technique.

3 It is difficult to achieve even coverage of the surface using a waxy medium, as seen here in close-up. However, the relative unpredictability of this technique is part of its charm, and adds valuable surface texture to the finished painting.

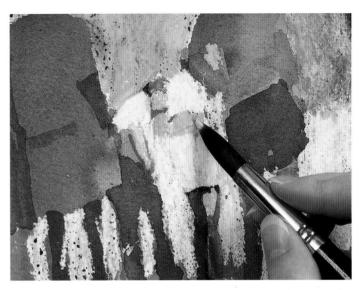

Adding definition 4 When the initial washes are dry, additional tones are added to define the forms without overworking them.

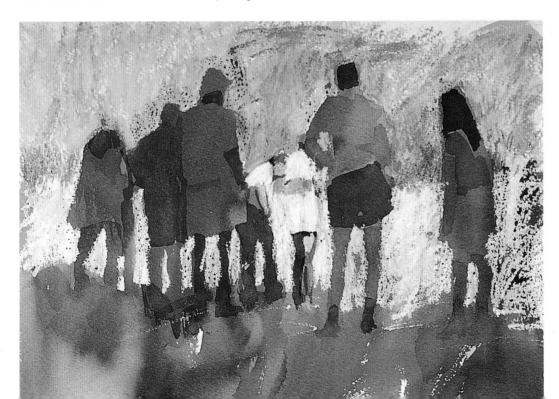

5 The finished piece shows just how effective the wax-resist technique can be. The sunlit background and the shadowy forms in the foreground are suggested with just enough tone and detail in the lightest, most impressionistic way. The trick here, as always, is knowing when to stop, to avoid overworking and ruining the painting. Notice, too, the clever contrast between the bright, acid tones of the background and the cooler, deeper tones of the figures.

See Also Masking pages 66-67 Creating texture pages 80-81

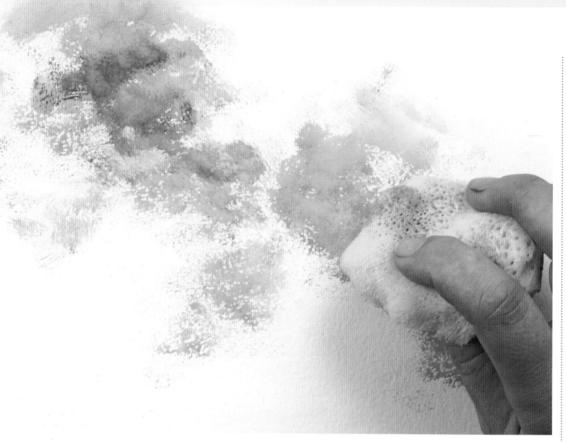

Sponging

Dabbing paint onto paper with a natural sponge gives an attractive, mottled effect, and is an excellent way technique for describing texture.

A sponge is an important part of the artist's toolkit. It can be used both to blot up excess colour and to apply colour when a textured effect is required. It can even be used to apply overall washes. Small artists' sponges are available, but you can improvise and cut a piece off a larger sponge.

Use a different sponge for different colours (or wash your

sponge out thoroughly between applications). Where you want a drier application, it's easy to reduce the amount of paint you are applying simply by squeezing the sponge slightly to expel the excess. By applying denser paint in shadowed areas, you can suggest form as well as texture. If you've used too much paint - perhaps obscuring the highlights - remove some by dipping the sponge in clean water, squeezing out the surplus and dabbing back into the paint. You can do this even when the paint is dry.

There is no reason why whole paintings should not be worked using this method, but sponging

does have its limitations. The marks made by a sponge are not precise enough for intricate work or fine detail, so in the later stages of a painting brushes are usually brought into play to create fine lines and details.

Suggested applications

 Sponging is a useful way of creating a large mass of texture

 for example, to simulate a profusion of ragged plants in a garden, undergrowth in the wild or perhaps the masonry in an old building or the rough appearance of rocky crags.

Initial sponging

1 The artist begins by sponging on yellow, orange and green for the sunlit areas of the foliage. To preserve the crispness of the marks and to prevent them spreading and softening, he sponges onto dry paper. He continues to add colour until the desired shape for the canopy of each tree is achieved. The paint is left to dry so that there is no muddying of subsequent colours.

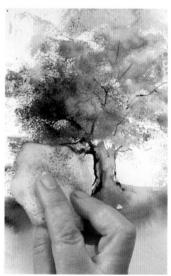

Varying the tones

2 The trunks and branches are painted in, using a brush. A loose band of colour is added along the bottom to indicate the ground. Darker, cooler tones are added with a sponge to indicate the shadowed foliage, and left to dry slightly.

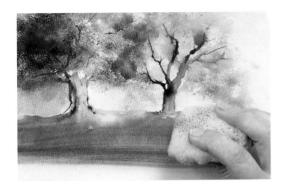

3 A pale yellow wash is applied to the background, working from right to left and light to dark and allowing the wash to pick up some of the sponged colour in the foliage. This will have a softening effect on the sponging, so that the technique does not dominate the picture. The sponge is then used to apply a thin band of French Ultramarine across the foreground.

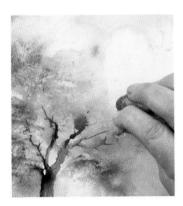

Adding highlights 5 Finally white body colour is sponged on for the lightest foliage on the left.

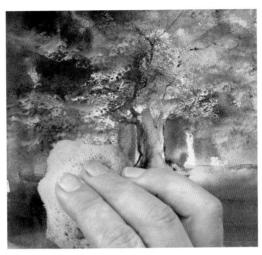

4 For extra definition, more dark tones are dabbed on with the sponge. Where the sponge is too unwieldy, a brush may be used to apply these darks.

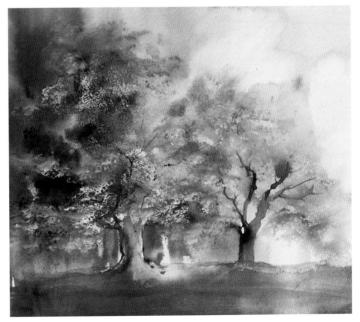

6 The limited palette of yellow, orange, brown and blue gives the finished piece overall cohesion. Note, too, the careful balance between shadows on the left and highlights on the right, which avoids a confused mass of tones.

Wet or dry?

The crispest effects are achieved by sponging onto a dry surface. For a softer sponged effect, try dabbing the colour onto a slightly damp surface. Or work both wet and dry in different parts of the painting to create varying texture and definition.

TIPS Choosing a sponge

- Always use natural sponge for painting as it is more absorbent and pliable and – with its irregularly spaced holes - produces a more pleasing, organic pattern than harsh, synthetic sponge.
- Small natural sponges vary from coarse to very fine, and this affects the texture they produce. Experiment with different kinds to see which you like.

See Also

Spattering pages 72-73 Using salt pages 76-77 Scumbling pages 78-79 Creating texture pages 80-81

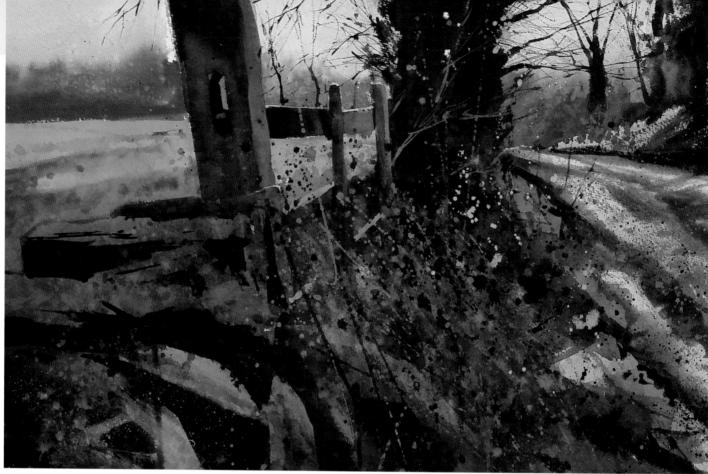

Spattering

Spraying or flicking paint onto the paper, once regarded as unorthodox and 'tricksy', is now accepted by most artists as an excellent means of enlivening an area of flat colour or suggesting texture.

Any medium can be used, but the paint must not be too thick or it will cling to the brush. To make a fine spatter, load a toothbrush with fairly thick paint, hold it horizontally above the paper, bristle side down, and run your index finger over the bristles. For a coarser effect, use a bristle brush, loaded with paint of the same consistency,

and tap it sharply with the handle of another brush. The bristle brush method can also be used for watery paint, but will give much larger drops. Some artists like to use a paintbrush, flicking paint off it by tapping the metal part of the handle against the finger, to release a spray of paint.

The main problem with the method is judging the tone and depth of colour of the spattered paint against that of the colour beneath. If you apply dark paint – and thick watercolour will of necessity be quite dark – over a very pale tint, it may be too obtrusive. The best effects are created when the tonal values are close together.

▲ PAUL TALBOT-GREAVES

WINTER SUN LIGHTS UP THE PASTURE

Textured foreground Multiple layers of spattered paint create the texture of the brambles in the foreground. The artist allowed the paint to dry between each layer and used different-sized brushes for different effects – a size 8 round, a size 6 round and an old toothbrush for the finest texture

Suggested applications

• Apply to evoke natural textures, such as foliage, shingle or sand.

TIPS For successful spattering

- Practise first. Spattering is a somewhat unpredictable method and it takes some practice before you can be sure of the effect it will create, so it is wise to try it out on some spare paper first.
- If you need to spatter one pale colour over another for example, to express the texture of a pebbled or sandy beach, for which the technique is ideal the best implement to use is a mouth diffuser of the kind sold for spraying fixative.

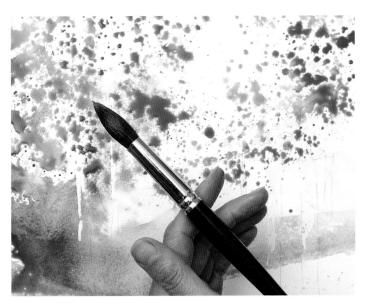

See Also Sponging pages 70-71 Using salt pages 76-77 Creating texture pages 80-81

2 Tissue paper protects the foreground and sky from successive layers of spattering. More pigment is added at each stage to bring shadow and depth to the image.

Building up texture

1 Sap Green is gently spattered over a loose drawing of tree trunks, sections of which have been masked out to suggest dappled light.

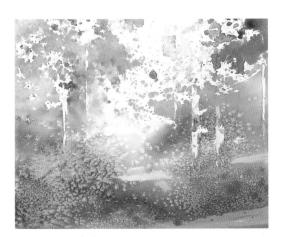

- **3** The same Sap Green is brushed loosely over the foreground, with areas of blue and violet flooded in to suggest a carpet of bluebells. Salt is sprinkled in to add further texture.
- 4 After all the spattered paint has dried, the tree trunks are painted with Burnt Umber and Sap Green.

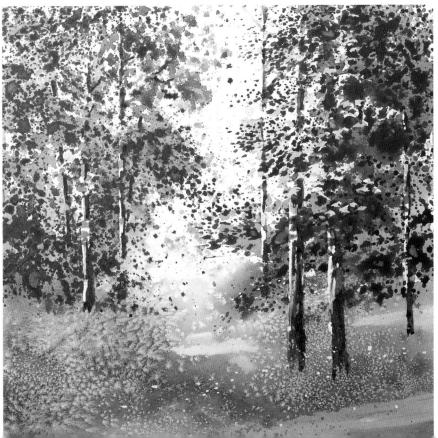

Blots and Drops

Flicking blots of paint onto dry paper or dropping spots of paint into a wet wash are relatively random ways of adding colour, texture and interest – and can produce some pleasing and surprising results.

Blot painting is a technique most often associated with monochrome ink drawing, but now that watercolours are available in liquid (ink) form this technique has become more popular with watercolour artists. The other reason for its inclusion is that it is an excellent way of loosening up technique and providing new visual ideas. Like back runs, blots are never entirely predictable and the shapes they make will sometimes suggest a painting or a particular treatment of a subject quite unlike the one that was planned. Allowing the painting to evolve in this way can have a liberating effect and may suggest a new way of working in the future.

The shapes the blots make depend on the height from which they are dropped, the consistency of the paint or ink and the angle of the paper. Tilting the board will make the blot run downhill; flicking the paint or ink will create small spatters; wetting the paper will produce a diffused, soft-edged blot. Dropping a blot onto the paper and then blowing it will send 'tendrils' of paint shooting out in various directions.

An associated technique

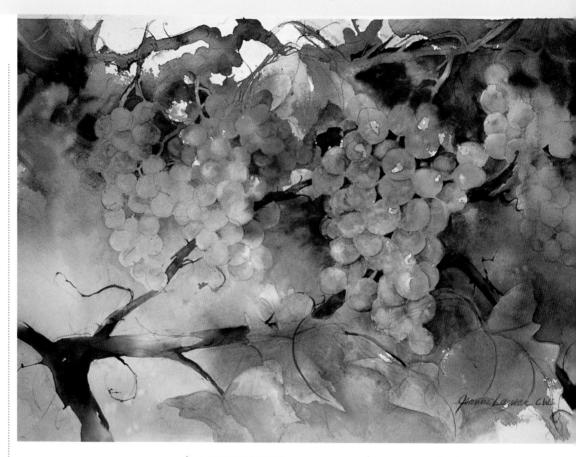

exploits watercolour's tendency to spread when applied wet-in-wet. The method involves dropping small amounts of wet paint from a brush into a wet wash. The drops spread and feather out on their edges, rather like back runs, but because they are small and are applied in a more controlled way, the effect is different.

Suggested applications

- Blots can be used to suggest the textures of a tree, flowers or pebbles.
- Blown 'tendrils' of colour may suggest stems and branches.

A JEANNE LAMAR

TIME TO CRUSH

Working on wet paper In her painting, the artist has dropped paint onto wet paper in places, producing subtle colour mixes and soft edges. Certain areas were then sharpened up, but with care taken to preserve the spontaneous effect.

Dropping colour wet-on-dry

1 The artist flicks a loaded brush onto paper to produce these random paint blots.

TIP Choosing pigments

Different pigments have different qualities and thus behave in different ways. Some are opaque, some more translucent, some granulate, some dry flat. Experiment by dropping different colours into wet washes and observe how they interact, then choose the combinations that you like best and that produce the effects you want.

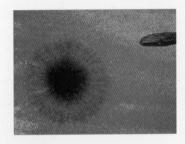

Dropping colour wet-in-wet

• A dense wash of a deep pink is brushed onto the paper. While the wash is still wet, Ultramarine is dropped in. The brush can be touched to the surface, or droplets can be allowed to fall off the brush from above. Larger droplets are made by using more paint, smaller ones by using less.

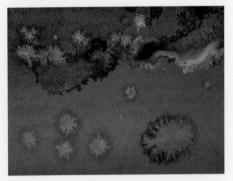

 As a variation, a wash of indigo was laid down and opaque colours were dropped onto it.
 Cadmium Lemon and Cobalt Turquoise Light are both lighter than indigo but because of their opacity they make an impression on the darker wash and push the indigo colour out to form darker ringlets. See Also
Back runs and
blossoms
pages 40–41
Spattering
pages 72–73

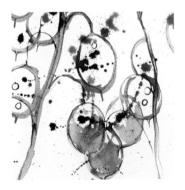

Building up the image

2 The blots suggest honesty seeds to the artist, so she builds up the picture by drawing in the paper-thin petals and stems of the plant, using a fine brush.

3 Washes of colour are added where necessary, and additional spots of colour are dabbed on with a finger.

4 The artist completes the work by adding in just enough definition to allow the image to be read figuratively, while taking care to retain the original spontaneity.

Using Salt

There are numerous ways to break up an area of watercolour and add texture. One of the most interesting and unexpected is to sprinkle a wet wash with crystals of salt.

It is one of the paradoxes of painting that a large area of flat colour seldom appears as colourful, or as realistic, as one that is textured or broken up in some way. The Impressionists, working mainly in oils, discovered that they could best describe the shimmering effects of light on foliage or grass by placing small dabs of various greens, blues and yellows side by side instead of using just one green

Dropping table or sea salt into the wet paint can produce some interesting textures. Being water-retentive, the grains of salt soak up the wetness of the paint from the immediate area, speeding up the drying process there. As the paint dries, little star shapes appear as the water floods out of the crystals and pushes the colour away to create feathered edges.

Suggested applications

• The effects you achieve can be translated into different textures depending on the context in which they are used - snow, lichen, rocks, leaves, flowers and so on

Different-sized grains

Salt grains of different sizes produce shapes and textures of different kinds. Experiment to see what you can create.

 Using larger salt grains produces more distinct star-like shapes with feathered edges.

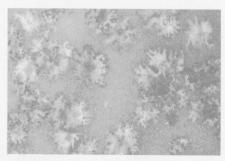

• Smaller-grained salt produces a finer texture.

⋖ KATRINA SMALL

FLEUR DE FETE

Background interest In her painting, the artist has used salt spatter for the background alone. This contrasts nicely with the sharp delineation and careful blends used for the feet and sandals.

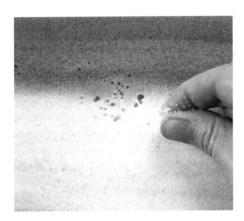

Creating patterns with salt

1 Initial washes establish the areas of sky, mountains and lake. While the washes are still wet, salt is sprinkled into selected areas - in this case, the sky, to create a cloud-like effect.

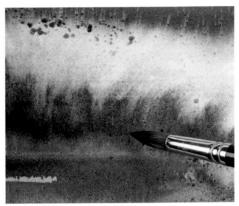

2 The salt is left to work. Meanwhile more colour is added wet-in-wet to achieve the required density in different parts of the picture, and the colours are allowed to bleed into each other.

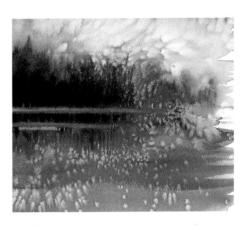

3 The colours are deepened, still wet-in-wet, to strengthen the impression of the mountains and lake. Salt is sprinkled onto the lake to create a speckled pattern, like that of sparkling water.

See Also

Dry-brush pages 56-57 Scumbling pages 78-79

TIPS Choosing a finish

- The wetness of the wash will determine the final result, so judge the wetness carefully to achieve the effect you want.
- Breaking up colour with salt is most effective in areas with an even finish, as this provides the greatest contrast.

Varying the wetness

One of the tricks in creating salt textures lies in judging the wetness of the paint, as this will affect the pattern you achieve, as shown in the examples below.

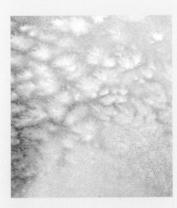

· Here salt is added to very wet paint, giving a softer and more diffuse effect.

• In this example, the salt is added after the paint has dried a little - still damp, but not running.

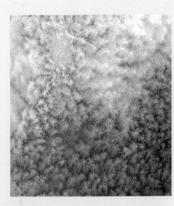

· Here the paint has almost dried; the effect is smaller and tighter.

Scumbling

Usually done with a short-haired brush (the older the better). scumbling involves scrubbing dry paint unevenly over another layer of dry colour so that the underlying layer shows through in parts.

This is one of the best-known of all techniques for creating texture and broken colour effects. Scumbling can give amazing richness to colours, creating a lovely glowing effect

rather akin to that of a semitransparent fabric with another. solidly coloured one beneath. There is no standard set of rules for the technique because it is fundamentally an improvisational one.

Scumbling is most frequently used in oil painting, but is in many ways even better suited to acrylic and gouache because they dry so much faster - the oil painter has to wait some time for the first layer to dry. The

for gouache is that it allows colours to be overlaid without becoming muddy and deadlooking - always a danger with this medium.

Because of the relatively thin consistency of watercolour, the technique is less well suited to this medium than to gouache and acrylic. Whatever medium you are using, the trick is to apply dry paint as thickly as possible - if it is too wet, it will simply spread out across the paper. If you are scumbling with watercolour, it is more effective if you are using tubes, as you can then apply the paint undiluted, straight from the tube.

Use a rough paper, too, rather than a smooth, hot-pressed one. As with the dry-brush technique. the dry, scrubbed-on paint will not be fluid enough to sink into the hollows but it will adhere to the raised tooth of the paper. which will accentuate the scumbled texture.

Suggested applications

• Use wherever you want to evoke a natural texture - for rocks, masonry, fur and so on.

◀ TRACY HALL

LUCKY COCKEREL

Scumbled watercolour For her painting, the artist has cleverly adapted the scumbling method to watercolour to build up the textures of the stonework and barn door. She has used the paint with the minimum of water and glazed over the scumbled areas when dry.

- A bristle brush is ideal for scumbling, but other possibilities include stencilling brushes, sponges, crumpled tissue paper or even your fingers. If you do use a softer brush, make sure it is an old one that can take some rough treatment - a good brush will soon be ruined.
- Practise your technique on some spare paper. Load the brush well with dry paint, then, with a twisting, dabbing motion of the brush head, 'grind' the paint into the paper. Repeat the process for a delightfully varied texture.
- Like other texture-creating techniques, scumbling works best in contrast with smoother, less textured area, so keep it localized to small areas of your painting an all-over scumbled texture will lose impact.

Planning the layers

Experiment with scumbling to see the effects you can get. Try applying light colours over dark, dark over light or a vivid colour over a contrasting one.

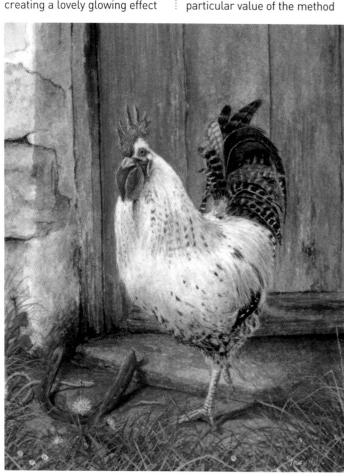

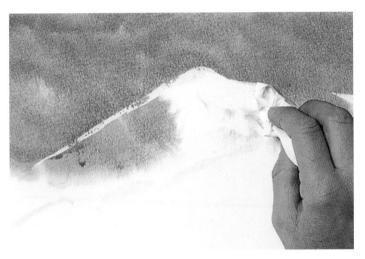

Applying initial colours

1 The edge of the mountain is covered with masking fluid and left to dry. The paper is dampened, and a wash of Antwerp Blue with a touch of Payne's Gray is laid. The colour is lifted out where it floods over the mountain top.

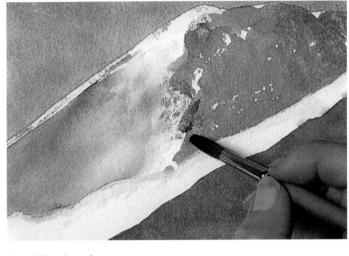

Scumbling dry colour

2 The shadows on the mountain are painted with a darker, greyer mix of the two colours used previously. When the paint is dry, dry sepia is scumbled on the exposed rock edges and used to pepper snow in the centre.

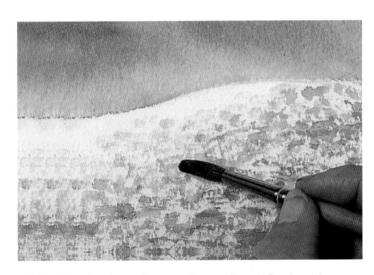

3 A diluted but dry mixture of Antwerp Blue and Payne's Gray is used to scumble the trampled snow in the foreground. Tone is built up by further scumbling.

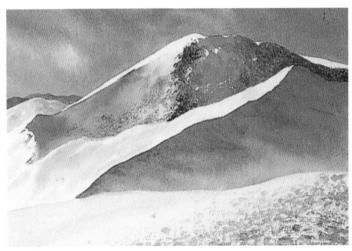

4 The masking fluid is carefully rubbed off and the white areas are dampened. A pale wash of Antwerp Blue is applied for the shadows in the undulating snow. The crispness of the edge of the snow-covered mountain provides a pleasing contrast to the scumbled marks in the foreground.

See Also Sponging pages 70-71

Creating texture

There are two main kinds of texture in painting: surface texture, in which the paint itself is built up or manipulated in some way to create what is known as surface interest; and imitative texture, in which a certain technique is employed to provide the pictorial equivalent of a texture seen in nature.

Surface texture is sometimes seen as an end in itself, but in many cases it is a welcome by-product of the attempt to turn the three-dimensional world into a convincing two-dimensional image. Since watercolours are applied in thin layers, they cannot be built up to form surface texture in the same ways as impasto oils or acrylics can, but this can be provided instead by the grain of the paper. There are a great many watercolour papers on the market, some of which particularly the handmade varieties - are so rough that they appear almost to be embossed. Rough papers can give exciting effects, because the paint will settle unevenly (and not always predictably), breaking up each area of colour and leaving flecks of white showing through.

Acrylic paints are ideal for creating surface interest because they can be used both thickly and thinly in the same painting, providing a lively contrast. You can vary the brushmarks, using fine, delicate strokes in some places and large, sweeping ones in others.

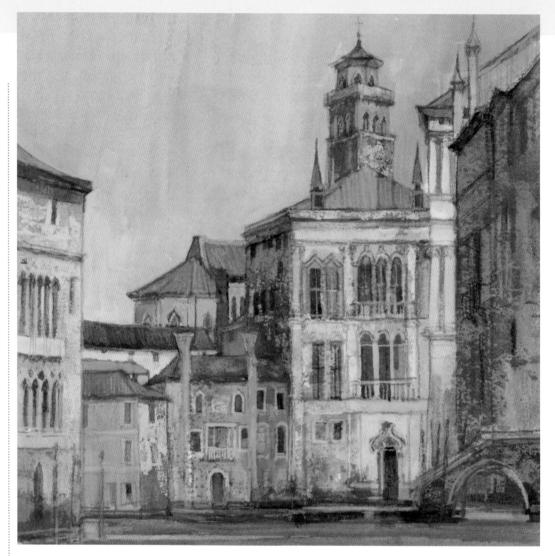

Several of the best-known textural techniques are described in other entries, but there are some other tricks of the trade. One unconventional but effective method is to mix watercolour paint with soap. The soap thickens the paint without destroying its translucency. Soapy paint stays where you put it instead of flowing outwards, allowing you to use inventive brushwork to describe both textures and forms.

Intriguingly unpredictable effects can be obtained by a variation of the resist technique. If you lay down some turpentine or paint thinner on the paper and then paint over it, the paint and the oil will separate to give a marbled appearance.

Suggested applications

• Study the texture you wish to evoke, then choose an applicator that will reproduce that texture.

▲ MOIRA HUNTLY

VENICE

Applying paint with paper To suggest the beautiful crumbling plaster walls of the buildings, the artist brushed watercolour onto a thick piece of paper, then pressed it firmly onto the working surface. The effect of this technique will vary depending on the texture of the paper and the thickness of the paint.

Initial drawing and painting

1 First, the artist draws the basket in lightly. and then applies washes to the background, foreground and to the basket itself. The paint is left to dry completely.

Building texture

2 Shadowed areas are painted in, and, while the paint is still wet, the textured side of a piece of paper towel is pressed into it to lift off some of the paint and leave an imprint of the paper behind. The paint is then left to dry.

4 When this is dry, a strip of corrugated cardboard is used to apply paint for the woven border along the top edge of the basket.

5 An imaginative application of paint, using the kind of scrap materials that most people have in their homes, has resulted in the almost tactile surface texture of this basket.

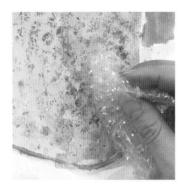

3 Spots of darker colour are then dabbed onto the basket using bubble wrap, bubble-side out, to suggest the mottled, textured weave of the basket.

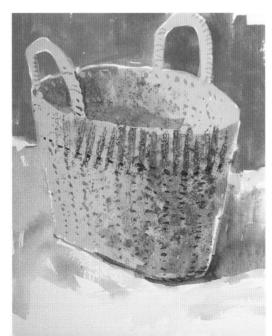

Aluminium foil and clingfilm

Striking effects to create a range of features twisting ridges and edges, a texture of sharp lines and dark-and-light patches - can be achieved with aluminium foil. Try this experiment. Have a crumpled sheet of aluminium foil at the ready. Apply three broad bands of colour wet-on-dry, allowing them to blend. Press the sheet of aluminium foil onto the paint. Press it gently all over so that the crumpled surface is in contact with the still-damp watercolour. When the paint has dried, remove the foil and see its texture imprinted onto the paper. Try the same technique with clinafilm.

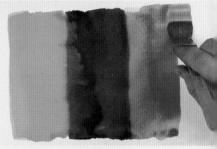

Pressing on the foil

The final effect

See Also

Back runs and blossoms pages 40-41 Feathering and mottling pages 42-43

Body Colour

This slightly confusing term simply means opaque water-based paint. It can be used to great effect with the more conventional translucent watercolour.

In the past the term 'body colour' was generally used to describe Chinese White mixed with transparent watercolour and applied to parts of a painting, or the same white used straight from the tube for highlights. Today, however, it is often employed as an alternative term for opaque gouache paint.

Some watercolour painters avoid the use of body colour completely, priding themselves

on achieving all the highlights in a painting by reserving areas of white paper. There are good reasons for this, because the lovely translucency of watercolour can be destroyed by the addition of body colour, but opaque watercolour is an attractive medium when it is used sensitively.

A watercolour that has gone wrong – perhaps one that has become overworked or too bright in one area – can often be saved by overlaying a semi-opaque wash or glaze, and untidy highlights can be cleaned up and strengthened in the same way.

Suggested applications

• Transparent watercolour mixed with either Chinese White or gouache Zinc (not Flake) White is particularly well suited to creating subtle weather effects in landscapes, such as mist-shrouded hills. The mixture gives a milky, translucent effect slightly different from that of gouache itself, which has a more chalky, pastel-like quality.

Being selective

Use body colour selectively – restricting it to parts of the painting so that it contrasts with the more translucent washes will have the greatest impact.

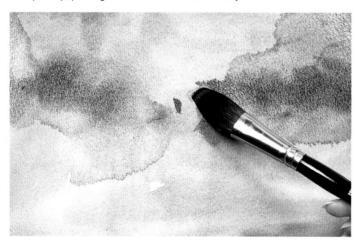

Laying a toned ground

1 First, a toned ground is laid down over the entire surface, using acrylic paint in a pale beige-cream. When this is dry, the buildings, trees and foreground are painted in with Ultramarine, Prussian Blue, Alizarin Crimson and Sap Green watercolour. Washes of these colours are painted wet-in-wet, using a large brush and loose brushstrokes. There is little form or definition at this stage of the painting.

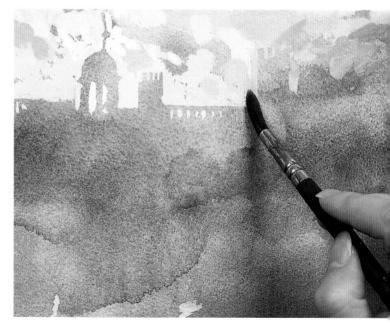

Building the sky and foreground

2 When the washes are dry, body colour is used to build up the sky. The artist uses gouache in white, Lemon Yellow, Indian Yellow and a neutral grey.

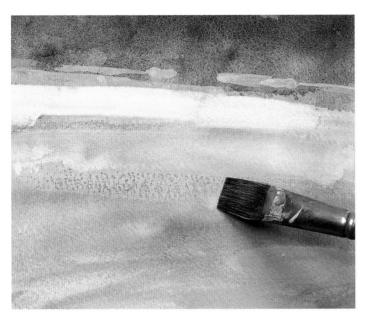

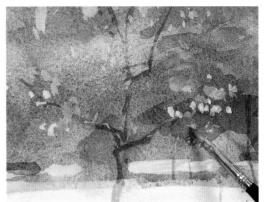

See Also Wet-in-wet pages 32-33 Toned ground pages 58-59 Reserving highlights pages 62-63

Adding final details

4 Further details, such as trunks and branches, are added to the trees, using Olive Green and Prussian Blue watercolour. The artist then dabs on touches of pale yellow gouache to highlight some of the leaves on the trees in the foreground.

3 White, Saffron Green and Indian Yellow gouache are applied to the grassy area in the foreground, deliberately echoing the colours of the sky. Patches of especially solid body colour here create the effect of dappled sunlight.

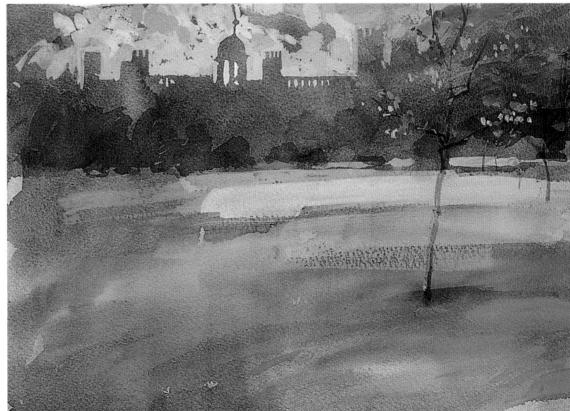

5 The mixture of misty, bluemauve watercolour and sharp, solid gouache creates a highly atmospheric scene, reminiscent of the colours on a sunny early morning.

Mixed Media

Although many artists know that they can create their best effects with pure watercolour, more and more are breaking away from convention, finding that they can create livelier and more expressive paintings by combining the attributes of several different media.

To some extent, mixing media is a matter of trial and error, and there is now such a diversity of artists' materials that there is no way of prescribing techniques for each one or for each possible combination. However, some mixtures are easier to manage than others. Watercolour and acrylic, for example, can be made to blend into one another almost imperceptibly because they have similar characteristics, but two or more physically dissimilar media, such as line and wash, will automatically set up a contrast. There is nothing wrong with this - it may even be the point of the exercise - but it can make it difficult to preserve an overall unity. The only way to explore the natures of the different materials and find out the most effective means of using them is to try out various combinations.

Suggested applications

• Develop a sensitivity to your subject matter and choose media accordingly, to evoke a corresponding impression, mood and texture.

Water-based media

Acrylic used thinly, diluted with water but without the addition of

often used together, and many artists scarcely differentiate between them. However, unless both are used thinly, it can be a more difficult combination to manage, since gouache paint, once mixed with white to make it opaque, has a matt surface, which can make it look dead and dull beside a watercolour wash.

Ink and watercolour are another successful combination, as demonstrated in the example on the facing page.

◄ PAUL DAWSON

THE PINK UMBRELLA

Capturing detail Every surface in this picture is treated with the same loving attention to detail to create its meticulously rendered realistic effects. These include dry-brush over preliminary wash to texture the floorboards, table and walls; the leaves were added with thick gouache on top. For the chair, a wash was laid, then the cane weave was defined with ink and finished with fine glazes of acrylic.

in more or less the same way as watercolour. There are two important differences between them, however. One is that acrylic has greater depth of colour so that a first wash can. if desired, be extremely vivid, and the other is that, once dry, the paint cannot be removed. This can be an advantage, as further washes, either in watercolour or acrylic, can be laid over an initial one without disturbing the pigment. The paint need not be applied in thin washes throughout: the combination of shimmering, translucent watercolour and thickly painted areas of acrylic can be very effective, particularly in landscapes with strong foreground interest, where you want to pick out small details such as individual flowers or grass heads (something that is very hard to

white or any medium, behaves

Gouache and watercolour are

do in watercolour).

TIPS 'Rescuing' work

- It is often possible to save an unsuccessful watercolour by turning to acrylic in the later stages.
- Try using a failed watercolour as a basis for experimentation; many successful mixed-media paintings are less the result of advance planning than of exploratory reworking.

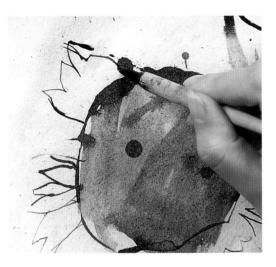

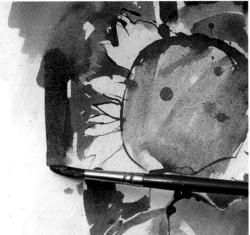

Building up with different media 2 She continues to build up the tones, using a mixture of ink and gum arabic.

Laying a toned ground

1 To create a toned ground that will unite the whole image, cyan acrylic ink is first dripped onto damp paper and spread and rubbed in with paper towel. Using an ink dropper, the artist then draws in some rough outlines with coloured ink. While the ink is still wet, she blocks in areas of darker tone with a paintbrush and ink mixed with gum arabic.

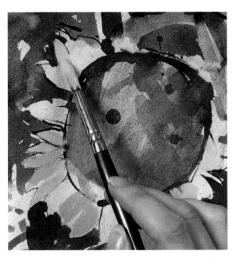

3 She paints the sunflower petals in yellow gouache, an opaque colour.

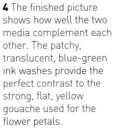

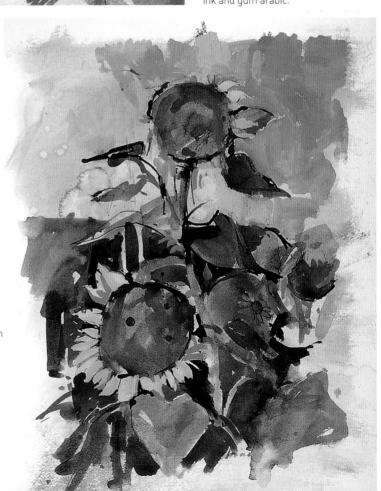

► CAROLYN WILSON

POLISH ROOSTER

Watercolour and collage This painting began with a watercolour underpainting on thick paper, which was then collaged with various textured oriental rice papers, using acrylic matt medium as the glue. The collaged pieces were torn, not cut. When the paper was dry, a further layer of colour was added.

Watercolour and pastel

Soft pastels can be used very successfully with watercolour and provide an excellent means of adding texture and surface interest to a painting.

Overlaying a watercolour wash with light strokes of pastel, particularly on a fairly rough paper, can create sparkling broken colours.

Oil pastels have a slightly different, but equally interesting effect. A light layer of oil pastel laid down under a watercolour wash will repel the water to a greater or lesser degree (some oil pastels are oilier than others) so that it sinks only into the troughs of the paper, resulting in a slightly mottled, granular area of colour.

Gouache and pastel

These two media have been used together since the eighteenth century when pastel was at the height of its popularity as an artist's medium. Some mixed-media techniques are based on the dissimilarity of the elements used, which creates its own kind of tension and dynamism; however. gouache and pastel are natural partners, having a similar matt, chalky quality.

Watercolour crayons

These are, in effect, mixed media in themselves. When dry, they are a drawing medium, but as soon as water is applied to them, they liquefy to become paint that can be spread with a brush. Highly varied effects can be created by using them in a linear manner in some parts of a painting and as paints in others. They can also be combined with traditional watercolours, felt-tipped pens or pen and ink.

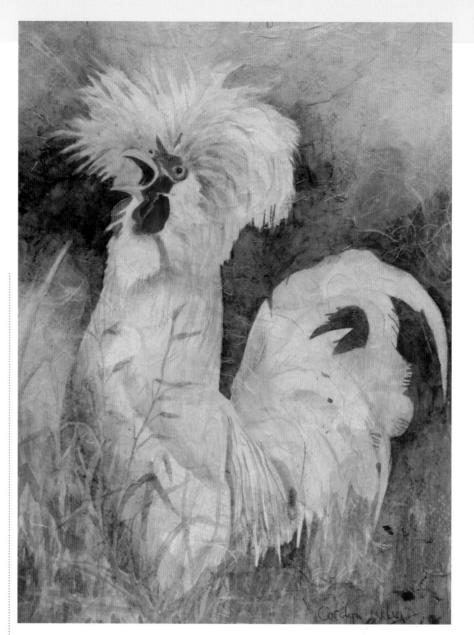

▶ CLARE BROOKS

APPLES IN A PAPIER MACHÉ BOWL

Touches of gold At first sight, this painting appears to be simply a watercolour, but the artist has been highly innovative and inventive, using gold powder added to aqua pasta for the patterns around the edges of the bowl, and employing the sgraffito technique for the markings inside the bowl. By mixing the colours for the apples with gum arabic, she was able to slow the drying time and thus make the paint more workable.

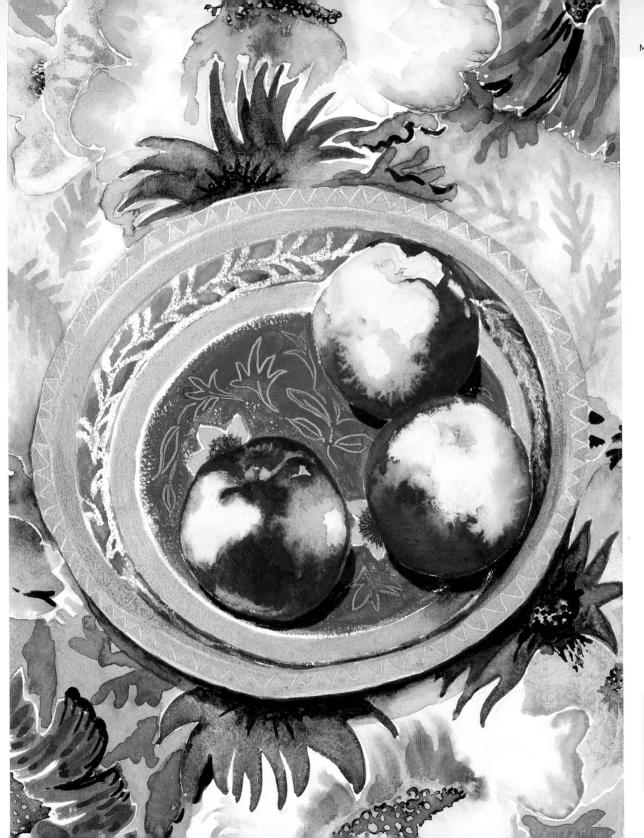

See Also

Line and wash pages 60-61 Wax resist pages 68-69

Correcting Mistakes

It is a common belief that watercolours cannot be corrected but, in fact, there are several ways of making changes, correcting or modifying parts of a painting.

Before painting complete pictures, you'll need to know how to correct mistakes. Every watercolourist may sometimes find that a wash has gone over an edge that was meant to be clean, or decide halfway through a picture that a colour isn't quite right. It is comforting to know that there are remedies.

The methods depend on how far you have progressed with your painting. Paint can be removed by lifting out with a sponge and clean water, but you can lift paint out more radically by actually washing it off. If you notice at an early

stage that something is badly awry – perhaps the proportions are wrong or an initial colour doesn't look right – put the entire painting under cold running water and gently sponge off the paint.

In the later stages of a picture, you may want to change a small area without disturbing the surrounding colours. In this case, dab off the paint with a dampened sponge, and let the paper dry before repainting. For tiny areas, you can use a dampened cotton bud or wet brush, which is also ideal if you want to add highlights or soften over-hard edges.

Sometimes you may find that a white area has been spoiled by small flecks and spatters of paint. You can touch these out with opaque white, but a better method is to remove them by scraping with the flat edge of a cutting or craft knife; don't use the point, which could dig into the paper and spoil the surface.

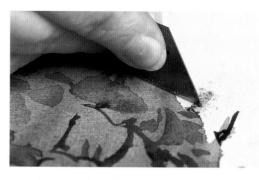

Scraping away blemishes

Small specks and spatters are easily removed by scraping with a knife or razor blade. This must be done with care, however, or the blade might tear holes in the paper.

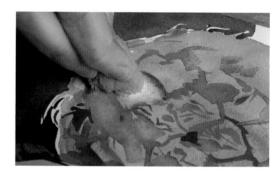

Sponging off excess colour

If there is too much colour in one area, some can be lifted out with a damp sponge.

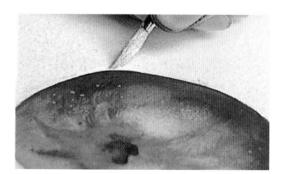

Cleaning up edges

Ragged edges can either be tidied up with a knife or blade, as in the top example, or with opaque white gouache paint, as here.

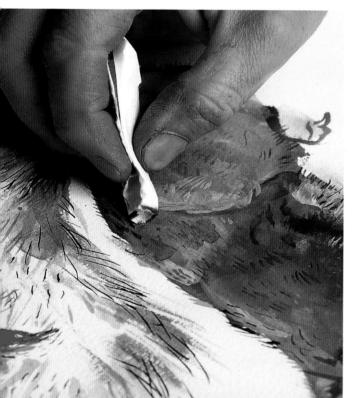

Correcting the spread of colour

If one colour floods into another to create an unwanted effect, the excess can be mopped up with a small sponge or piece of blotting paper.

Softening a shadow

1 A shadow in the foreground is too hard-edged. The artist washes away part of it with a sponge dipped in clean water.

2 The edges of the shadow are successfully softened but the divisions between the light and dark areas are now insufficiently defined. The aim is to give a crisp, dappled effect, similar to the shadow below the fountain.

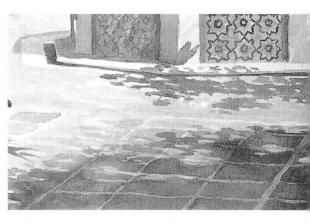

3 A little more of the mauve-blue watercolour is applied at the back of the shadow and left to dry. Then a mixture of red watercolour and white gouache, carefully matched to the pinks of the courtyard paving, is painted over the blue shadow.

Unexpected effects

Don't be in too much of a hurry to correct a 'mistake'. One of the charms of watercolour is its ability to produce unexpected effects. Allow yourself to be led by the medium to a certain extent, and see if you can work with those 'happy accidents', making them look like an intentional part of the finished piece.

Correcting a paint run

1 The artist is painting a background to a family portrait when the wash that he is applying bleeds onto one of the foreground figures.

2 If you experience accidental spills, use a tissue quickly to mop up any of the accidental colour.

3 It is easy to correct mistakes as you go along. Here some hair colour was spilt onto the cheek and was lifted off with a damp flat brush.

See Also

Lifting out pages 44-45 Reserving highlights pages 62-63 Scraping back pages 64-65

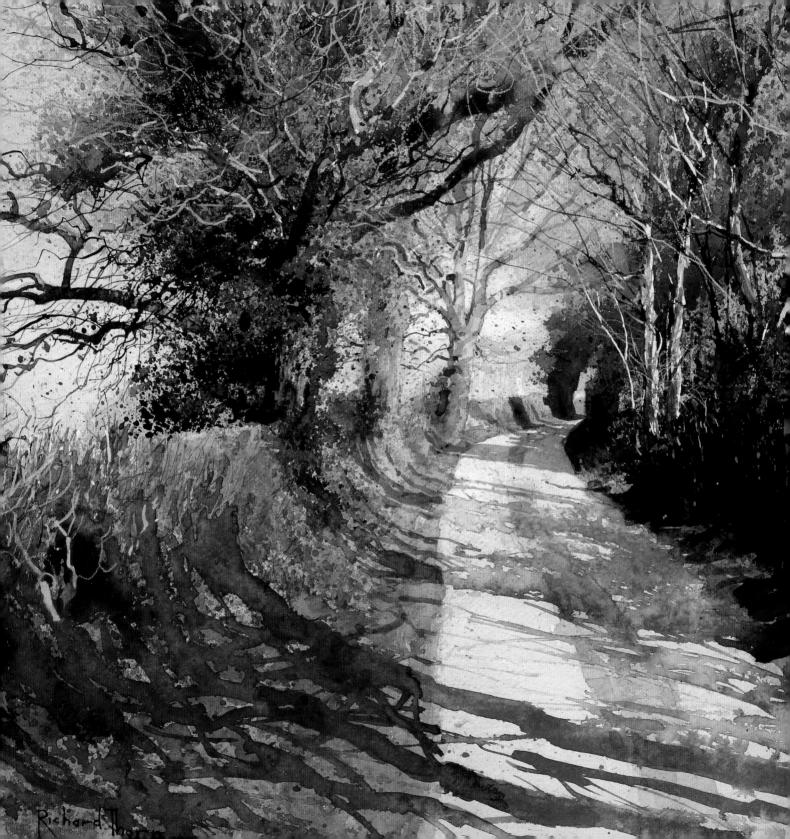

Picture making

Whatever the medium used, there are certain principles an artist needs to know, such as understanding tonal values and the optical illusions of perspective and three-dimensional form. Developing a personal language, maintaining the practice of sketching and knowing how to make a good composition are universal, too. But certain factors are more relevant just to watercolour. For example, the translucency of the medium means that you can't simply paint over a mistake, as you can in, say, oils, so planning your work ahead is essential. Similarly, a wash of one colour laid over another will alter the colour of both, so a knowledge of the way in which colours interact is especially important for the watercolourist. This section explains all the basic principles that allow the artist to translate three-dimensional reality onto the two-dimensional plane.

◀ RICHARD THORN

MARCHLIGHT

A great array of watercoloUr techniques are used to capture this sunlit lane. After the base washes have been applied, the strong shadows are painted using feathering techniques and the foliage is created with washes followed by spattering. The tracery of branches is painted using a dip pen with watercolour inks.

Choosing Paints

The primary colours are the three fundamental colours that are mixed to create all other colours in the painter's palette. There are two sets of primaries: additive and subtractive.

The colour wheel

The colour wheel shown below attempts to accommodate both the additive and the subractive system. It uses Quinacridone Magenta, Aureolin Yellow and Cobalt Blue as primary colours. Admittedly the Cobalt Blue is not a true cyan, but neither are Cerulean, Phthalo, Manganese or Ultramarine. Cobalt Blue mixes well with other pigments, which some would say partially makes up for its limitations.

Perhaps you remember learning at school about the three 'primary' colours - red, yellow and blue - from which all other colours can be mixed. But exactly

which particular red, which yellow and which blue does this refer to?

To complicate matters further, there is more than one kind of primary colour. There are the light or 'additive' colour primaries, that you see through light, as in a television or on a computer screen; and pigment or 'subtractive' colour primaries, that you see as paint pigments or inks. Artists need to consider both types when painting. Colours are mixed according to the subtractive pigment primaries, and then our eyes evaluate the colours we use through the additive light primaries.

Primaries mix to grey

The three pigment primaries mixed together make grey.

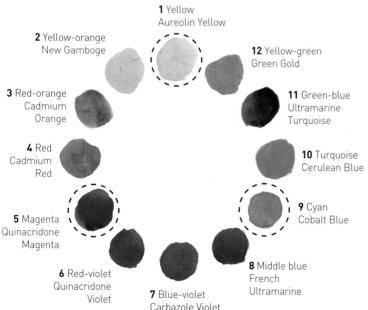

(Dioxazine)

Light or additive colour primaries

When we mix colours of light, the more we mix the brighter the colour gets. Colours add to each other. By mixing just three colours of light - red, green and blue we can make any colour we want. These are the primary colours used to make the millions of different colours we see on television and computer screens.

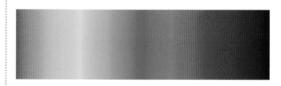

Pigment or subtractive colour primaries

Paints and pigments absorb different colours of light. subtracting from what you see. The more pigment is added, the more light is absorbed and the darker the combined colour becomes. It is nearly the opposite of mixing light. The primary colours for paint or pigments are cyan, magenta and yellow (these, along with black, are the four colours used in colour printing and to create the printed colours you see on this page). Mixing the three pigment primaries produces black or grey, as well as all other pigment colours.

Primaries mix to secondaries

Two pigment primaries mix together to make a secondary colour. Primaries with secondaries provide a full range of colours.

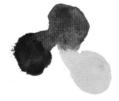

Magenta + vellow = orange

Yellow + cyan = green

Magenta + cyan = blue-violet

Choosing primary palettes

Because the pigment primaries mix to create all other colours, an artist can use just three pigments for a painting. These three studies of the same subject use only primary colours of different kinds of watercolour pigment. Why not try it out yourself: choose three primaries that have the characteristics you want – and go!

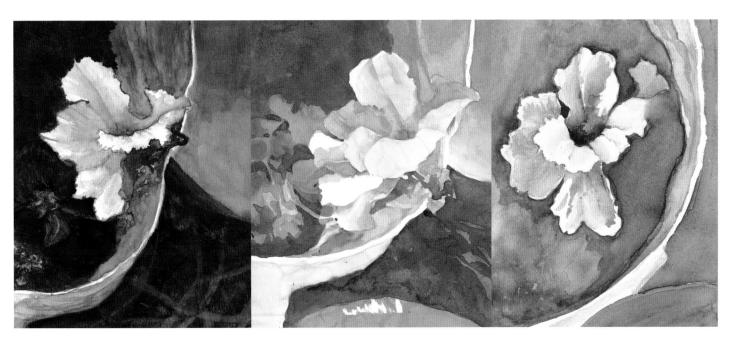

Permanent, staining pigments

John Deyloff selected three permanent, staining primaries for his study: Phthalo Blue, Holbein's Opera and Quinacridone Gold. Note the very dark darks that he was able to mix from these three pigments – as well as some lighter greys. Transparent washes are more difficult to obtain with these strong pigments.

Transparent, non-staining pigments

Jan Hart played with three of her favourite pigments, which demonstrate a bit of granulation (in the Cobalt Blue), transparency and nice variation in colours. Note that achieving very dark darks is not as easy with this palette of primaries. The colours chosen were: Cobalt Blue, Rose Madder and Genuine Aureolin Yellow.

Sedimentary or opaque pigments

Karen Norris chose three sedimentary or opaque pigments for her study. Her selection enabled her to create some interesting textures and pigment mixtures, as well as some sense of transparency. Quinacridone Burnt Scarlet is not a sedimentary pigment, but the artist chose to include it with the two that are – Ultramarine Blue and New Gamboge.

Complementary and Analogous Palettes

It is said that no colour is more beautiful, more exciting or more vibrant than when it is placed next to its complement – its partner – across the colour wheel.

On the colour wheel, the complement of a primary colour (magenta, cyan or yellow) is the combination of the other two primaries. So mixing a colour and its complement is the same as mixing all three primaries together. The complementary palette is a simple, easy-to-use colour scheme with potential for the strongest colour contrasts.

The analogous palette offers the artist adjacent, closely related pigments that combine in perfect harmony. Each pigment contains a part of its neighbour, which makes them all related. Many people who grew up in the 'dyed to match' culture of the 1950s, when orange and red were thought to clash, only learned years later to appreciate the rich harmony of the analogous hues. Choose a

minimum of three adjacent colours to explore the interesting ways in which this palette can be used to promote the desired feeling and mood.

The studies of a pink rose (opposite) demonstrate the effects that the analogous palette can produce. The close relationship between the colours results in great coherence in the finished painting. Some artists enjoy combining high-chroma (pure and vivid) pigments with low-chroma, more 'muddy' ones within an analogous colour scheme.

W ALLEN BROWN

BEYOND THE COYOTE FENCE

Using a complementary palette Allen Brown selected Cadmium Orange and Ultramarine Blue as complementary colours for his painting. His colour choices appear to be consistent with the pigment colour wheel. Although he used pure

Cadmium Orange very sparingly and pure Ultramarine Blue even more sparingly, his deft use of both for mixing colourful neutrals is quite apparent. He made a conscious choice to use more Ultramarine Blue than Cadmium Orange to give the cool bias his winter landscape needed.

TIPS Choosing complementary schemes

- For a complementary scheme, think 'contrast'.
- In a complementary scheme, the most striking colour choice is a warm and a cool. 'Warm' colours are reds, oranges and similar pigments; 'cool' colours are blues and greens.
- Consider using a warm, pure colour (red or orange) as an accent placed opposite unsaturated cool colours to emphasize the warms – or vice versa.
- For best results choose a dominant complementary that will appear directly and in mixes. Use the other complementary for accents.
- Avoid overuse of unsaturated warm colours such as brown or dull yellow. Overuse tends to create a deadening effect.

The complementary colour wheel

Yellow's complement, blue-violet, is a mix of magenta and cyan. Blue-violet plus yellow = dark grey or black.

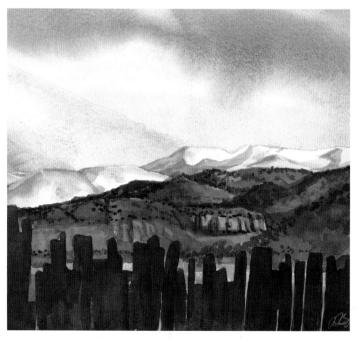

Cadmium Orange

Ultramarine Blue

Analogous colour wheels

The first pigment wheel (right) shows close analogous colour relationships; the second pigment wheel (far right) shows one step or looser relationships. Try both and see the different possibilities.

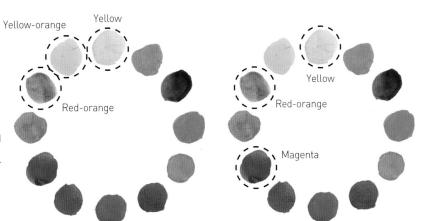

TIPS Choosing analogous schemes

- For an analogous colour scheme think 'co-ordination'; the analogous scheme is inherently harmonious.
- When using an analogous scheme, the choice of appropriate subject matter is all-important it too needs to have harmony of colour. In the case of greens, the analogous colour scheme is fully visible in nature: Remember this in your next summer landscape.

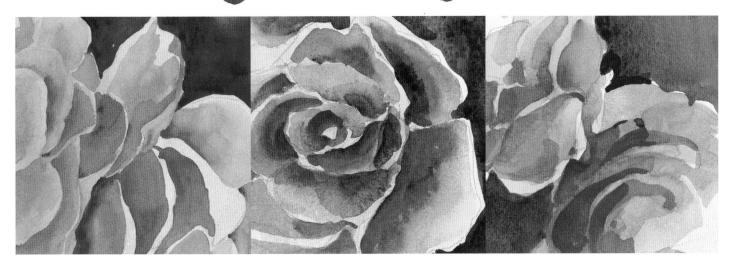

A Pure, high-chroma pigments

The use of three or four adjacent high-chroma pigments on the visual colour wheel certainly grabs attention with its sizzle. It can overwhelm the eye if the high-chroma pigments are used purely and at full strength. Even mixes of these intense pigments create a vibrant painting. Here the Quinacridone Magenta provides some relief in the background. Rose Madder Genuine was used as an underwash.

Opera Quinacridone (Holbein) Magenta

ne Rose Madder Genuine

▲ Low-chroma, semi-neutral

Each of these pigments is located away from the high chroma rim of the pigment map. Together they comprise 'neutralized' violet, red and red-orange, along with some wonderful granulations. A distinctive mood of mystery, or cloaked danger, is evoked by these semineutrals. Note the rich creeping and granulating in the mixes. An underwash of pale English Red Earth helped to set the sombre mood.

Red

Venetian Pur

Purpurite Genuine

English Napthamide Red Earth Maroon

A High- and low-chroma

You can combine two high-chroma pigments and one low-chroma, or two low and one high, as shown. A simple, elegant colour scheme can consist of three carefully selected analogous paints – two of low chroma and a single high-intensity pigment. Here the dusky Purpurite Genuine and smooth Venetian Red were selected as the red-violet and red-orange, respectively. The central magenta position was claimed by the vibrant Opera – a 'hot pink' that is really cool in temperature.

Venetian Red

Opera (Holbein)

Purpurite Genuine

Choosing a Palette

When you are starting a watercolour, it can be tempting simply to 'paint what you see' – that is, to use the whole range of colours that you perceive in the subject in front of you. For a more effective result, however, it is better to work with a unique colour palette.

When choosing a colour palette to work with, be aware

that the more colours you use in a painting, the more difficult it is to achieve colour harmony. Restraint and a considered use of colour will result in a more harmonious finished piece that will be more pleasing to the eye, as well as conveying mood and a sense of artistic authority.

An artist's 'palette' – the colour scheme he or she uses in a painting – is a specific choice of colours based on their relationship to each other on the colour wheel. Many artists resist

colour schemes – until they try one. Using a colour scheme is an effective way to extend your understanding of colours and colour relationships.

It's well worth investing some time experimenting with various palettes. As your understanding grows, you'll be better placed to choose the palette that is most sympathetic to your subject matter and that will produce the effect you want. Your command of colour scheming will contribute significantly to the

'mood' of your painting and the blending of all the elements into a coherent whole.

You may be surprised to discover the range of colours and tones you can achieve with just a limited number of pigments. The studies shown here all feature the same subject yet, because the same palette isn't used in each case, the final results look and feel different. As well as these options, there are others that you can explore.

TIPS Choosing colours

- For best results in an analogous scheme, avoid combining warm and cool colours.
- Use the monochromatic Velásquez and complementary palettes [see page 98] to learn about value/tone relationships and/or as value studies for another painting.
- To maintain control and restraint in your use of colours, try putting tape over the paints in your palette that you intend not to use.

▼ Monochromatic palette

Using a single colour in variations of lightness and saturation makes for easy viewing and can establish an overall mood. It also forces the artist to think in terms of tonal values (see pages 102–103). Here Manganese Violet, representing the red-violet in the colour wheel, was selected as much for its texture as for its colour. Note how the granulation provides additional interest. However, in a monochromatic scheme it can be difficult to distinguish the most important element of the painting, since all parts are rendered in different tonal values of a single colour.

Manganese Violet

Analogous palette

This colour scheme (see page 95) offers the strongest potential for creating unity and a particular mood. It is just as easy to use as the monochromatic scheme, but it looks richer. Using paint colours that are immediately adjacent to one another creates a singular boldness – there is no colour contrast. A painting done in an analogous scheme can encompass all cool colours for a sombre or night-time scene, or all warm colours for a lighter portrayal. It is possible to select immediately adjacent hues for a 'tight' study, or hues that are separated by one colour step for a 'loose' study. It also is possible to select analogous pigments that are located in more neutral positions on the colour wheel, such as greens or red-violets, for more neutral mood possibilities. Above all, this colour scheme encourages you to step out of your comfort zone.

Primary palette

Because this scheme uses the three primary colours (which produce all other colours), it may offer the widest range of colour possibilities. At the same time, the choice of just three pigments as the base helps produce unity and harmony in the painting. The primaries can be pigments that represent the magenta, yellow and cyan of the pigment colour wheel, or the red-orange, blue-violet and green of the light colour wheel (see 'Choosing primary palettes', page 93).

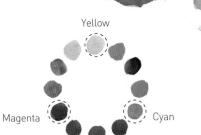

Magenta

Cobalt Blue

Cadmium Yellow

► The Velásquez palette

Named after Spanish artist Diego Velásquez, this is a subtle version of the primary pigment palette, using a limited selection of three to four pigments that were available to the old oil-painting masters. The Yellow Ochre, Burnt Sienna and Ultramarine Blue combine to create soft neutrals and glowing lights, as shown in the study. Modernize the palette by substituting Quinacridone Gold for Yellow Ochre and Quinacridone Burnt Orange for Burnt Sienna. Ultramarine Blue remains a long-time favourite of many artists and a staple of their palettes. You can achieve a wonderful glow with these pigments. The pale green is achieved by mixing Yellow Ochre and Ultramarine. Although Ultramarine and Burnt Sienna cannot create lavender, the neutral achieved is most useful.

Yellow Ochre

Ultramarine Blue

Burnt Sienna

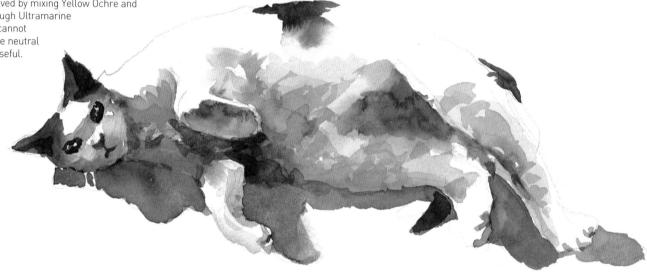

Paint a colour wheel

You can build your own colour wheel and take it with you when you paint. It is a good idea to keep any colour wheels that you create very simple. There should be a lot of room for individual interpretation and substitution of pigments when something new and exciting comes out. When a new pigment comes out, add it to your existing colour wheel to fill in the gaps or do a new colour wheel just to find out what your current thinking is.

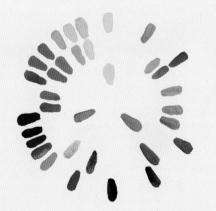

Aureolin

Yellow

Carbazole

Violet

(Dioxazine)

▶ Complementary palette

Using pure colour opposites (see 'The Colour Wheel', page 92) enables you to present a stronger contrast than in any other colour scheme, thus drawing maximum attention. For the best results, place cool colours against warm ones, or vice versa. The predominance in the amount of one colour over the other creates the intended mood. A night painting, for example, may start as a complementary colour scheme. Note the strong contrasts in this cat study.

Blue-violet

Four-colour complementary palette

TIPS **Getting the** most out of a palette

- Increase the richness of the complementary palette by using four colours in two complementary pairs for example, a blue-violet and a cyan complementing a yellow and a red-orange (see left).
 - Try the 'split-complementary' scheme that places a single warm colour - say, a yellow - against three oppositional colours, such as a warm blue, a blue-violet and a violet (see below left).
- Use a six-colour scheme, consisting of three sets of complements: a magenta and a green; a yellow and a blueviolet; a blue and an orange. These three sets will allow you to mix a range of neutrals, from brown to grey, and each can be 'pushed' towards the pure colour for accents.
- Try a tertiary palette, using 'tertiary' colours, which are are defined as those mixed from one primary and one secondary - for example, red and green, or blue and orange. The tertiary palette is useful for achieving complementary neutrals, with accents. A predominantly warm or cool bias works best with this scheme.

Colour Mixing and Overlaying

When mixing colours, remember that they always look darker wet, in the palette, than they will do on the paper.

As explained on pages 92-93, the pigment primaries - red, yellow and blue - cannot be mixed from other colours. The secondaries, made from two primaries, and the tertiaries. made from the three primaries or one primary and a secondary. are also all available ready made. However, you can achieve more variety through mixing and it's fun. When you start experimenting with colour mixing, you will quickly discover how dramatically the proportions of the pigments used affect the mixture and how much stronger some pigments are than others. The amount of water in the mix will affect the colour intensity, too.

If you don't achieve the colour you want when mixing wet, you can always adjust it by overlaying – in other words, 'mixing' colours on the paper rather than in the palette. This is comforting because it takes away the fear that nothing can be changed once it's down on paper. Don't rely too much on overpainting, though; it's still best to achieve the right colour first time.

Don't always go for the obvious mix of pigments – or even the obvious tube or pan colour. You can get richer and subtler effects by combining more unlikely pigments. Keep a note of successful mixes so that you can repeat them later.

TIPS Good colour mixing practice

- Keep the water in your jar clean: dirty water may taint your colours. Refresh it often or use two jars – one of clean water for diluting paints, one for rinsing brushes.
- As you progress with the colour mixing, don't rely on the look of the colour on the palette
 test it out on a spare piece of watercolour paper.
- Avoid mixing four or more colours together, or all you'll achieve is a characterless mud.

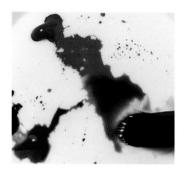

Rich darks

There are many ways of achieving a dark mix other than using black directly from the pan or tube. One way is to mix Ultramarine Blue and Light Red. This combination makes a beautiful grey, with a large range of subtle hues that can be mixed in any strength up to a virtual black. Ultramarine Blue and Indian Red produce a more intense dark. Here Ultramarine Blue and Light Red are mixed on the palette to create a dark grey.

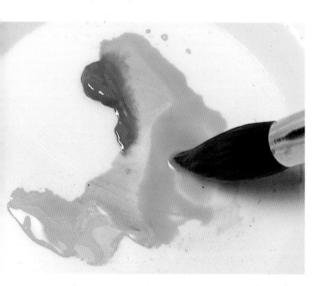

◀ The right green

Manufacturers greens are often very strong, and often too crude for the greens you see in nature. Rather than using a green straight from the tube or pan, start with a yellow such as Cadmium Lemon or New Gamboge. Add a smaller amount of a green, such as Phthalo Green or Hooker's Green, until the paint is the desired colour. Here Cobalt Teal was added to Permanent Yellow to get a bright green. Finally, add Burnt Umber or Burnt Sienna to the colour to tone it down and make it look more natural

Overlaying colours

Because watercolours are transparent, you can't make a colour lighter by putting another one on top; you can only make it darker. And because of this transparency, you can't achieve a really dark colour with a first wash, as the white paper always shows through to some extent. This is done by laying one colour over another. You can also change colours by overlaying one on top of another; however, aim for no more than four layers of colour, as too many will spoil the fresh sparkle that is one of the most attractive features of watercolour.

Wet versus dry

One of the trickiest aspects of watercolour painting is judging what the colour will look like when it's dry, so it's a good idea to do a test on a spare scrap of watercolour paper first. There can be considerable difference between a dry colour (top) and a wet one (bottom).

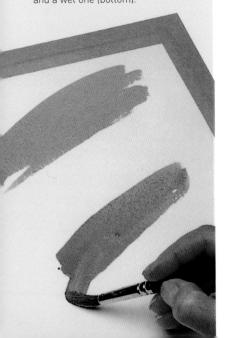

Raw Umber

French Ultramarine

Cadmium Yellow

Alizarin Crimson

French Ultramarine

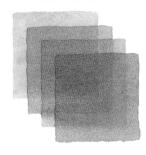

Payne's Gray

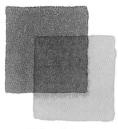

Yellow Ochre

Cadmium Yellow

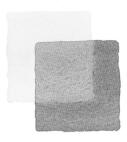

French Ultramarine

Overlaying to darken colour

Some pigments are more transparent than others; to achieve the desired density, it may be necessary to overlay further layers of the same colour. The first layer should be completely dry and it is necessary to work quickly so that each new layer does not stir up the one beneath.

Overlaying to lighten colour

A light colour applied over a dark one does not disappear. Although you can change the nature of an underlying colour in this way, you can't significantly change its tonal value [see pages 102–103] unless you paint over it with a more opaque pigment.

Overlaying to change colour

Although you can alter a colour by laying another on top, you can't obliterate the first one – the new colour will be a mixture of the two.

• Although you can add white to a watercolour mix to lighten it, you will alter its character totally, making it creamy and opaque. It is usually better to get paler tones by adding water rather than white paint.

 When painting a small area, use a small brush to add water to the colour on your mixing palette; a large brush would absorb too much colour and none would be left on the palette. Apply the colour to the paper with the same brush.

 When painting a large area, mix the water with the paint to form a reservoir on the palette, ensuring that sufficient paint is produced at the start to complete the wash without having to go back and mix more colour.

Analysing Tone

Tone, or colour value, indicates the darkness or lightness of a subject. Every colour, and every watercolour paint colour, has its own value.

All living beings use sight in practical ways; it is part of their basic 'survival kit'. Humans, for example, may use their sight to judge the distance between them and an oncoming car. However, humans' aesthetic use of sight is less well developed. As artists, we all need to cultivate this particular use of sight to look for relationships in the visual world - in colours, in shapes and in tones.

Tones - or 'tonal values' refer to the relative lights and darks that we perceive in everything we see. Even in the absence of line and colour, we still know what we are looking at simply from the way in which these tones interrelate. The relative pattern of lights and darks in a drawing or painting

helps to convey form and give an illusion of spatial depth, as well as contributing to its success as a composition. So it's not enough just to know about colour and colour mixing; for your paintings to succeed. you need to have a good awareness and ability to analyze tone, too.

TRANSLATING TONE TO COLOUR

Think of a black-and-white photograph, It contains no colour or lines, yet we can still 'read' the image perfectly well simply from the pattern of lights and darks and all the stages in-between. Doing studies like this one are a really good exercise and will heighten your awareness of tone.

■ Black-and-white photograph

The children in this photograph. together with their reflections, make strong vertical shapes. Crossing the picture, there are the horizontal shapes of the bank and the ripples in the water. The absence of colour makes it easier to see this pattern.

▲ Tonal sketch

In a linear drawing, edges are defined by lines – a pattern of lines is produced on the paper. In a tonal painting, edges are defined by areas of tone. The tonal pattern may overlap what would have been the line pattern; note how the children and their reflections make one continuous shape.

Colour sketch

In a coloured version of the same scene, the tones of the colours match those in the black-and-white tonal sketch.

IDENTIFYING TONAL CONTRASTS

When you are sketching outside, look for tonal contrasts. Which direction is the light coming from? On a sunny day this is easy to ascertain because shadows will be pronounced. Even though your logical mind may find it hard to believe, on a very bright day an intensely blue sky may actually be tonally darker than the buildings it illuminates. Conversely, on a dull day the land may be darker than the sea and sky.

Scottish sea scene

1 In this photograph of a Scottish scene on a damp, grey day the tonal contrast is between the sea, which reflects the sky, and the land.

2 In the resulting monochrome sketch (in which a yacht has been substituted for the boat), the land is much darker than the sky and water.

Mediterranean tonal sketch

- ▲ 1 In this monochrome sketch, a white building is set against a searingly blue sky. In relation to the sky, the building appears much lighter and this is reflected in the greys used. Even without the addition of colour, the drawing conveys a powerful illusion of bright sunlight.
- ▶ 2 In this coloured version, the sky has been painted a deep blue to emphasize the contrast in tone between sky and building and to convey the warm, sunny light that is so reminiscent of the Mediterranean.

Make a Tonal Panel

To help you understand tone. make some tonal panels. First make a panel with black and white paint. Then make others with neutral mixes, in various intensities.

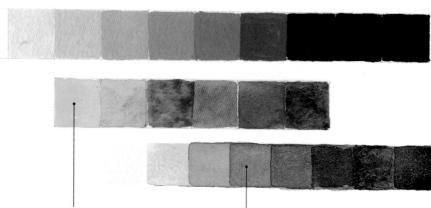

Benchmark strip

1 Mark out a strip of 10 squares on a sheet of paper. making the size of the squares about 2cm (%in). Now fill in the squares with paint, grading them from white to black - Chinese White and Ivory Black are good for this. (Usually, of course, it's not necessary to use black or white paint in watercolour.) Start with white in the first square and add a minimal amount of black to increase the darkness of each subsequent square until you reach pure black. This tonal panel will act as a 'benchmark strip' for the tones in your painting.

Colour strip

2 Make a colour strip to compare with the benchmark strip. Start with a yellow. See how close in tone it is to the white compared to the blue, which is tonally much darker.

Neutral strip

3 Make a third strip of squares. Mix a neutral grey from three primary colours, such as Cobalt Blue, Scarlet Lake and Aureolin Yellow. Use this mixture to make a panel that matches the benchmark strip in tonal value. Start with pure water in the first square to match the white paint, then use less water and more paint in the following squares. You will not achieve black, but you will be able to make a good dark tone. Now try the same procedure with others mixes of primary colours.

USING A TONAL PANEL

To practise recognizing tonal values, make a simple graded tonal panel of five 4-cm (11/2-in) squares. Leave the first square blank to match your paper. Grade the tones in even steps towards a dark that is not quite black. Move this panel around your painting. Note how the edge of the different squares in your strip will almost 'disappear' when they are matched with a part of your picture that is of the same tonal value.

Contrasting tonal values

1 In this bright, sunny painting, the tonal contrasts are very marked. The building - which is backlit by the sun and silhouetted - is a dark tone. The surrounding sky is much lighter.

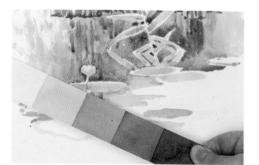

Soft tonal values

2 Playing down the tonal values between the reeds and the water - and emphasizing the contrast between the water lily and the water - focuses attention on the flower.

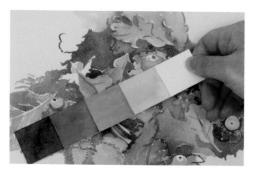

Close tonal values

3 The leaves and fungi on this shady woodland floor are all very close in tone. There is just enough contrast to define the shapes.

USING A TONAL VIEWER

Colour can confuse your perception of values. An intense colour can appear lighter in value than it really is. A red, transparent Plexiglas square can help here. You may be able to order a piece cut to 7.5 x 7.5cm (3 x 3in) through your local glass shop. Or you can attach a small piece of red plastic to a blank slide mount. When you look through the red plastic, all the colours will be visible as values of light red to dark red.

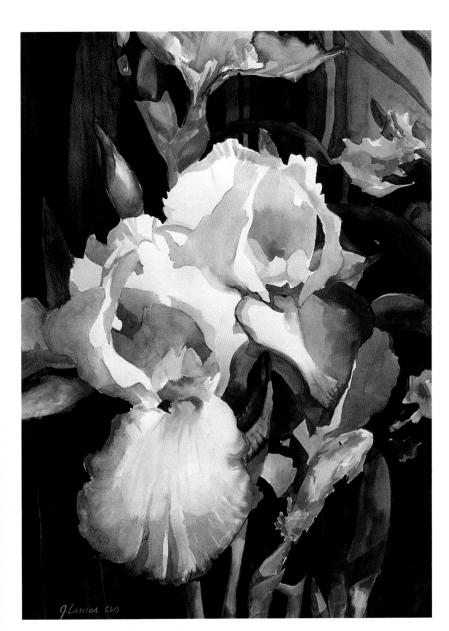

▲ JEANNE LAMAR CHARISMA

Light against dark In this painting, the pale flowers stand out against the dark background, but even here there is considerable variety of tone, suggesting leaves and stems without being too specific.

Light and Shadow

Painting is all about light, or the absence of light. It is through light and shadow that we understand and appreciate form, texture and colour.

Manipulation of the lighting in a painting also affects mood, so it is no wonder this aspect is one of the most essential in painting. One of the artistic movements

that demonstrates this is Impressionism. The French Impressionists were renowned for capturing the transient effects of atmosphere and light. painting outdoors in the French countryside with its clear air and warm light. There they expressed what they saw - the incredible colours of light, shade and shadow.

Creating shadow and light in watercolour is notoriously difficult, but can be made easier

by understanding the theory. Conversely, the beautiful translucency of the medium and its affinity with the glazing technique allows the artist to overlay areas of shadow that positively glow.

Colour in shadow

When asked what colour shadows are, most people reply, 'grey'. But shadows are never just grey. Conventional wisdom also suggests that the

colour of shade (the part of the object that is turned away from the sun) is a darker shade of the obiect's local colour. However, colours from the surroundings are also reflected into the shadow - and the time of day plays a part, too. Sunlight in early morning and late afternoon is warmer (more vellow) than direct light at noon. and so affects ambient colours and hence the colours that are reflected into the shadow.

TIPS A cast shadow...

- · ...is darkest, sharpest and coolest at its origin. It is always attached to the object that is casting it unless that object is in the air.
 - · ...is always transparent, allowing the underlying subject to show through.
- ... of a near or hard-edged object has hard edges. Shadows of distant or fuzzy objects have soft edges.
- ...changes as it passes over different surfaces. It may change in colour, direction and shape. For example, when the cast shadow of a roof overhang passes over a recessed area, such as a doorway or window frame, the shadow changes, usually dipping downwards.
- ... of foliage often produces 'sun pictures' on the ground. The sun filters through the numerous openings of foliage to create irregular patterns of light. This is what we call 'dappled light'.
- ...of a tree extending horizontally across the ground is linear and generally appears longer than it is wide. If you paint it very wide, it won't appear to lie flat on the ground. Shadows closest to the viewer are widest, warmest and darkest. Those further away become progressively thinner and cooler.
- · ...may have colours of adjacent objects and even light reflected from another surface within it.

CAST SHADOW

When a light source falls on an object, the cast shadow is the dark area that is caused by the object blocking the light source. The base colour of the cast shadow is the complement of the light source; here (above and right), the shadows are blueviolet with the complementary yellow-orange light source.

When a light ray bounces, its light waves become longer and the colour of the light becomes warmer. The shaded area receiving bounced light grows warm. This concept helps to explain why in bright sunlight we see orange in the shaded side of a building (left).

THE COLOUR OF SHADOWS

Under warm incandescent light, a tomato was placed on three different-coloured surfaces – pure white, dark green and yellow-gold. The direct yellow-orange light produces a blue cast shadow, which appears to our eyes as a combination of the shadow colour, surface colour and any reflected colour. The shadow's variable edge is due to other sources of light in the room.

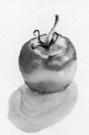

Tomato on white

On a pure white surface the cast shadow is blue. Within the cast shadow, closest to the base of the tomato, is some red reflected from the tomato creating an area of violet (red + blue). Note the band of reflected light from the white surface back onto the middle of the tomato.

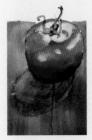

Tomato on dark green

The colour of the cast shadow is still blue but it appears darker on the dark green surface colour. As the surface colour is reflected back onto the tomato, the combination is a dark neutral (red + green).

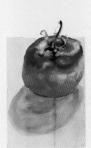

Tomato on yellow-gold

The cast shadow is the same blue – but now its visible colour is a mix of the blue and the yellow-gold surface – a pale greenish gold.

Because the shadow is light enough, some of the reflected tomato red can be seen in the shadow. Yellow colour from the surface reflects back onto the tomato to create orange (red + yellow).

These photographs and accompanying studies demonstrate choices in painting cast shadows.

Sunny wall

1 In the original photograph, the sun casts solid, hard-edged shadows of the rain spout and beam end (not shown) onto the sunny wall. Note the reflected light glow on the shaded left wall. A tree also casts its shadow onto the sunny wall in softened linear shapes and dappled sun pictures. The shadows change in colour as they fall over the white curtains.

2 First, an overall underwash of yellow is applied, leaving the window as it is. On the shaded left wall, a bright mix of Rose Madder Genuine and yellow is brushed into the reflected light corner and pulled across to the left edge. While still wet, a darker mix of Rose Madder Genuine and Napthamide Maroon is blended in, leaving the upper corner alone. On the sunny wall. Rose Madder Genuine is applied over the yellow underwash for a darker and drier shadow mix. Pure Cobalt Blue is applied to the window. Finally the harder-edged cast shadow from the left wall is added, using Cobalt Blue-Violet and taking care to paint the negative spaces around the sunlit grasses in the foreground.

Posts and mud wall

1 The sun shining from the upper left makes parallel beam shadows across the mud surface of the building in this photograph. When they reach the perpendicular light-coloured wall, the shadows change direction and colour. Note that the darkest, sharpest and coolest part of the shadow is at its origin the base of the beam.

2 The texture of the dried mud wall is achieved with granulating pigments, added directly into a still-wet base of Rose Madder Genuine. The undersides of the projecting beams are rendered warm and lighter, to suggest reflected light. The shadows are transparent Cobalt Blue, thinned and warmed up with Rose Madder Genuine as they move away from the beams.

Working with Light Sources

Whatever subject you are painting, the placement and direction of the light source or sources will be critical to its success. Be aware that shadows change shape and direction through the day - take photos for reference as you work.

As well as contributing to the overall mood of a painting, shadows serve various other important functions. For example, they act as an anchor, 'tying' an object to whatever

surface it is standing on. If you're painting a pitcher on a table, for instance, and you leave out the shadow below it. the pitcher will look as if it's floating in space. They also help to create an illusion of threedimensional space within the flat, two-dimensional surface of a painting, as well as introducing a sense of drama.

A shadow falls on the opposite side from which the light is coming - the object that casts it is blocking that light. You can vary the direction (and strength) of the shadow according to the effect you want to create, either by moving the object itself in

relation to the light source or by altering the direction from which the light is coming. This is easiest if you are using artificial light - it could be as simple as moving the table lamp that is lighting your still life. If you are painting a portrait, you could ask the sitter to move so that the light, and therefore the shadow, falls differently on them. To complicate matters a little, light often comes from more than one source, creating softer, secondary shadows in addition to the stronger main shadow. When observing your subject, you need to be alert for such subtleties.

TIPS Characteristics of shadows

- The shape of a shadow is related to the shape of the object that casts it.
- Shadows are darkest close to the object.
- The darkness and definition of a shadow depends on how close it is to the light source. A strong, directional light will cast stronger, more clearly defined shadows than more diffused light.

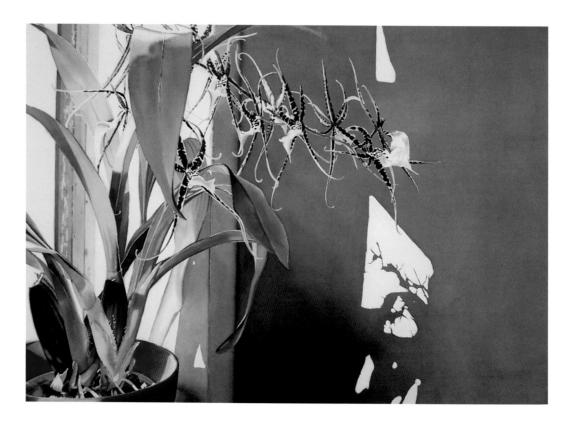

DENNY BOND

FRAILTY

Creating patterns with light and shadow In this highly realistic painting, the artist has focused on the patches of light and the silhouette of the foliage cast on the wall to the right. Highlights on the foliage bring the plant forward in space, and the shadowed wall glows with reflected colour.

How cast shadows work

In the original photograph, a strong, directional light is coming from the right of the vase, casting a strong shadow to the left. The lighting is simple and comes from a single source, so there are no secondary shadows. In the painting, the same colour is used for the cast shadow and the dark side of the vase. The yellowish cloth is painted around the shadow, overlapping it in the foreground just below the vase. Note how the shadow serves to 'anchor' the vase to the table – it is an essential part of the picture; without it the vase would float and there would be little sense of the space around it.

The colour of a shadow is affected by that of the surface on which it falls

The shape of the shadow is related to the shape of the object Light from the side casts strong, clear shadows Shadows are darkest close to the object

Flowerpots on a window ledge

Here, the strong directional light coming through the window casts diagonal shadows behind the flowerpots. In order to 'attach' the pots to the surface so that they don't appear to float, the artist has painted additional patches of shadow just behind the pots, right next to the base of each one. The strong shadows and highlights on petals, leaves and pots create a powerful sense of light flooding the whole scene.

Perspective

The perceived world is threedimensional, but as painters we must translate space and form in a way that makes sense on the flat, two-dimensional surface of a piece of paper. One of the optical tricks that artists have at their disposal is linear perspective.

Visual perception is the name for the way in which our brains interpret the messages received from our eyes. One of the peculiarities of visual perception is that objects appear to get smaller the further away from us they are. At the same time, parallel lines, such as train tracks or furrows in a ploughed field, appear to converge in the distance – although, of course, in reality they maintain the same parallel relationship. This optical illusion is known as linear perspective.

Discovered by Italian Renaissance artists, linear perspective became an obsession for some. Paulo Uccello (1397–1475), in particular, spent many hours experimenting with perspective and foreshortening (whereby the parts of an object appear to become compressed and smaller the further away they are from the viewer). The results can be seen in his famous painting The Battle of San Romano, painted in the 1450s and now hanging in the National Gallery in London. The fallen lances on the ground all point towards a common vanishing point (the point at which parallel lines appear to

converge) and the way in which a fallen figure on the ground is foreshortened is thought to have been the first time that this technique was used.

Understanding and mastering these simple principles of perspective will allow you to create a sense of distance and scale in your images, to show objects overlapping, getting smaller or converging in an understandable way.

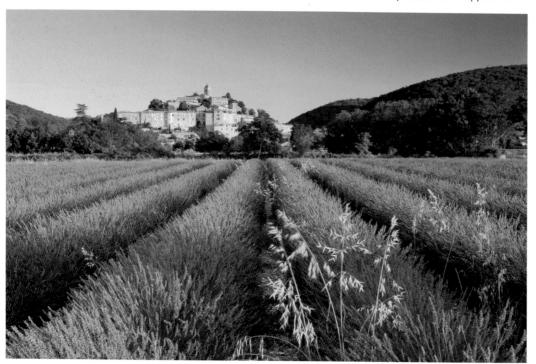

Converging lavender rows

1 This photo of a lavender field in the South of France clearly shows the effect of perspective, with the rows of lavender converging towards a vanishing point in the distance, leading the eye into the picture and towards the village in the background.

TIPS Assessing perspective

- When working with perspective, remember that angles converge towards a common vanishing point, and that this vanishing point relates to the onlooker's viewpoint. In the painting of a lavender field on the opposite page, for example, we know without thinking that the onlooker is standing just left of the centre of the picture space, because the lavender rows here are hardly slanted at all but point straight ahead. Conversely, the rows on either side become progressively more angled the further they are from the onlooker.
- When assessing the perspective of an angular object such as a wall or building, hold a viewfinder or L-shaped frame up to it so you can accurately measure the angles against the right angles of the frame.

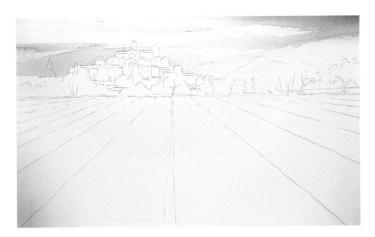

Doing a perspective drawing

2 The preliminary drawing shows the converging lines of the lavender rows. Some of the original details have been subtly altered for a more effective composition, and a few light initial washes have been laid.

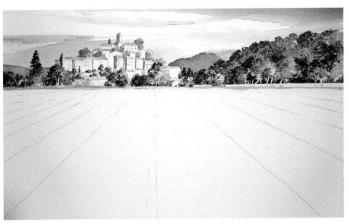

Building up colour and detail

3 Working from the back to the front, the artist begins adding colour and detail to the buildings in the village and the surrounding trees. The foreground lines are still visible.

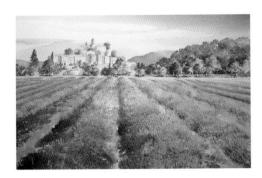

- 4 The rows of lavender are loosely painted in with a violet, crimson and indigo mix, working wet-in-wet and sprinkling the wet paint with salt to create texture. Shadows are added to give a sense of form.
- **5** In the finished picture, colours and details have been strengthened. The rows of lavender clearly demonstrate the principles of perspective and show how useful this visual tool can be in creating the illusion of three-dimensional space on a flat, twodimensional surface.

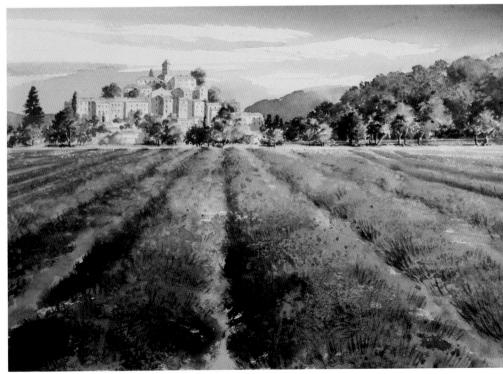

Order of Working

Because there are no rigid rules in watercolour painting, it can be hard to know how to begin. The diagrams on these two pages indicate a possible order of working, starting with the lightest areas and finishing with the darkest.

It isn't always easy to decide where and how to begin a painting. The standard advice about watercolour is that because the colours are transparent, you have to work 'from light to dark'. This means

that when you are putting colour on in layers, you must begin with the lightest ones, because you can only make colours darker by adding a layer. But it does not mean that you must always start by painting the palest bits of a picture.

Suppose you're painting a bunch of white flowers in a dark blue vase against a light blue background, for example. The conventional method would be to lay a light blue wash over the vase and background, reserving the flowers and any highlights as white paper, let this dry and then paint the vase on top. But you could begin with the vase,

and paint the background around it. Some artists even prefer to put down areas of dark colour first, because this gives them a point of reference for the tones in the rest of the picture.

Whichever method you choose, your first task is always to anaylse your subject in terms of light and dark blocks of colour. Look at the photographs shown on these pages and see whether you can figure out which colours you would put on first. Then compare this with the sequences in the numbered diagrams, which give a suggested order of work.

Painting buildings

- 1 First make a drawing, then lay a flat or graded blue wash for the sky and leave it to dry. Lay a very pale wash, perhaps Yellow Ochre with a touch of Alizarin Crimson, over the rest of the painting.
- 2 Paint the shadowed side of the building, then begin to darken the colours in the central area and foreground shadow. Paint the lamp post over the colours.
- **3** Add further dark washes to the central area and the foreground shadow, and then begin to build up detail on the buildings.
- **4** Continue to add detail and strengthen colours where necessary.

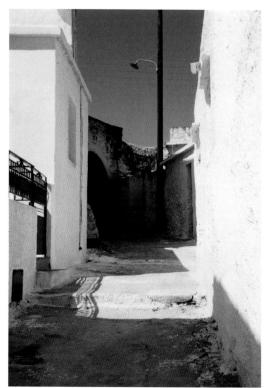

Painting a landscape

- 1 Draw the main shapes. Lay a pale wash for the sky and a slightly darker one for the distant hills. Lay ochre washes over the main areas of the painting, but not the river. If blue is painted over ochre it will turn green.
- 2 Paint the river with a mid-blue wash.
- **3** Start on all the green areas, painting over the ochre washes. Begin in the distance with pale washes, building to darker colour in the foreground.
- 4 With all areas blocked in, gradually add detail and strengthen colours, reserving ochre highlights in the foreground.

Painting a still life

- 1 Make an outline drawing, then lay a light yellow-brown wash over the background, reserving the white flowers, and leave to dry.
- 2 Lay separate washes for the vase and the blue pot.
- 3 Block in the checked cloth with blue, reserving white squares. Block in the main shapes of the leaves, painting individual leaves over the background wash.
- 4 Begin to add detail and continue to darken colour where necessary.

Themes

In the first two parts of the book I outlined the techniques most frequently used by watercolour painters as well as introducing some of the more unusual and unconventional ones. I hope that these will provide some food for thought and experiment, but it is important to remember also that painting techniques are no more than vehicles for the expression of ideas. My aim in this third part of the book is to show you, by means of finished paintings, how other artists have harnessed their technical skills and experience of the medium to their own vision.

A wide variety of techniques and different approaches are shown, together with some explanations of the particular difficulties associated with certain subjects. I hope that everyone will find something to inspire them in the selection of paintings – looking at the work of other artists is never time wasted, and analyzing their methods can often suggest a new direction.

◀ THIERRY DUVAL

LES ILLUMINATIONS DE LA PLACE FURSTENBERG

Night scenes can be difficult to achieve in watercolour because the artist must get the depth of tone right the first time – successive washes will only dull the colour. Here, the artist has reserved the halos of light with masking fluid, then softened the edges with clean water before applying a light Quinacridone Gold wash around each halo.

The animal world

The animal kingdom presents the most common of all problems to the wouldbe recorder of its glories: none of its members stay still long enough to be painted. You can usually bribe a friend to sit reasonably still for a portrait, but you cannot expect the same cooperation from a dog, cat or horse. If movement is the essence of a subject, however, why not learn to make a virtue of it?

Understanding the basics

Watch an animal carefully and you will notice that the movements it makes, although they may be rapid, are not random - they have certain patterns. If you train yourself to make quick sketches whenever possible and take photographs as an aid to understanding, you will find that painting a moving animal is far from impossible - and it is also deeply rewarding.

We in the twentieth century are lucky, because we benefit from the studies and observations of past generations. We know, for instance, that a horse moves its legs in a certain way in each of its four paces - walking, trotting, cantering and galloping - but when Edgar Degas (1834-1917) began to paint his marvellous racing scenes, he did not fully understand these movements. He painted horses galloping with all four legs outstretched, as they had appeared in English sporting prints. It was only when Eadweard Muybridge (1830-1904) published his series of photographs of animals in motion in 1888 that Degas saw his error and was quick to incorporate the newfound knowledge into his paintings. This confirms the value of the camera as a source of reference, but photographs should never be slavishly copied, because this will result in a static, unconvincing image.

Understanding the basics

Painters and illustrators who specialize in natural history acquire their knowledge in a wide variety of ways. Many take powerful binoculars and cameras into remote parts of the countryside to watch and record birds and animals in their natural habitats. but they also rely on photographs or study stuffed creatures in museums. All this research helps them to understand basic structures, such as the way a bird's wing and tail feathers lie or how a horse's or cow's legs are jointed.

Sketching from life

Although background knowledge is helpful because it will enable you to paint with more confidence, books and magazines are never a substitute for direct observation. When you are working outdoors, try to keep your sketches simple, concentrating on the main lines and shapes without worrying about details such as texture and colouring. If the animal moves while you are in mid-sketch, leave it and start another one - several small drawings on the same page can provide a surprising amount of information.

► LIZ CHADERTON SUNLIGHT

The spontaneous application of paint captures the spirit of this horse and gives the painting great immediacy. The reserved white areas play a huge part in this painting, with wet-in-wet passages giving contrast.

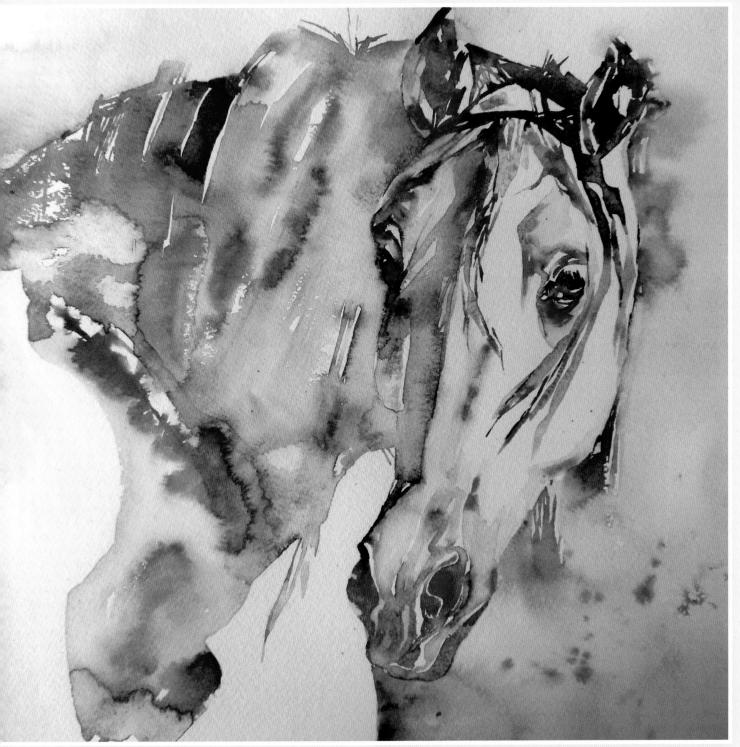

Birds

Birds are a perennially appealing subject, but they are also a complex one. The fur of a smooth-haired animal does not obscure the structure beneath. but the feathers of a bird do - if you look at a skeleton in a museum you may find it hard to relate it to the living, feathered reality. To portray a bird convincingly, it is important to understand the framework around which it is 'built', and the way the small feathers follow the contours of the body while those of the wing and tail extend beyond it. Never be ashamed to draw on the store of knowledge built up by others: look through natural history books and photographs in wildlife magazines as well as sketching birds whenever you can.

If you are painting birds in their natural habitat, for instance geese on a river or seagulls circling around a cliff top, you will need to concentrate on shape and movement rather than detail. Both the line and wash and the brush drawing methods are well suited to this kind of broad impression, but the two most exciting features of birds, particularly exotic ones, are colour and texture, so many bird painters employ a more precise technique.

You can practise painting feathers and discover ways of building up texture by working initially from a photograph or another artist's work, or even by painting a stuffed bird.

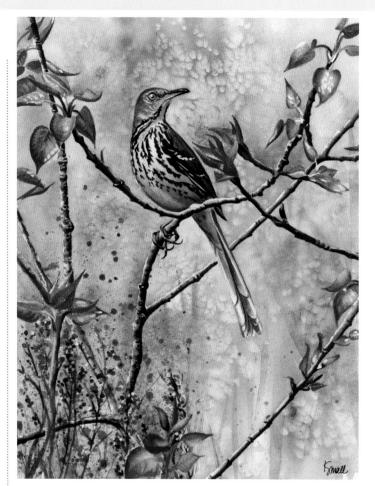

A KATRINA SMALL BROWN THRASHER

To achieve definition in the bird's plumage and the leaves and stems, the artist reserved these parts with masking fluid. She painted the soft background wet-in-wet, then sprinkled it with salt to add texture. When dry, the masking fluid was removed and the bird, stems and leaves were painted wet-on-dry.

W DAVID BOYS SKETCHBOOK STUDY

The free and spontaneous appearance of Boys' sketches should not blind us to the fact that they are extremely accurate, and each one is the end-product of several days of careful observation and constant drawing. However, they provide an excellent example of the use of watercolour as a medium for recording rapid impressions.

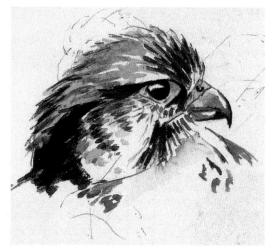

◀ LAURA WADE MACAWS

The artist has made good use of mixed media to build up the birds' vivid colours and delicate textures. Like many professional illustrators, she used photographs as well as drawings from life for her reference; this is the original of a printed illustration in a guide brochure.

Movement

When we watch an animal in movement, such as a horse galloping, our eyes take in an overall impression of shape and colour without precise details these become blurred and generalized in direct ratio to the speed of the animal's movement. The best way of capturing the essence of a movement is to choose a technique that in itself suggests it, so try to keep your work free and unfussy, applying the paint fluidly and letting your brush follow the direction of the main lines (see Brush Drawing, pages 54-55). Alternatively, you could try watercolour pastels or crayons, which can provide an exciting combination of linear qualities and washes. A sketchy treatment, perhaps with areas of paper left uncovered, will suggest motion much more vividly than a highly finished one - the surest way to 'freeze' a moving animal is to include too much detail. This is exactly what the camera does: a photograph taken at a fast shutter speed gives a false impression because it registers much more than the human eye can. Photographs, though, are enormously useful for helping you to gain an understanding of the way an animal moves, and there is no harm in taking snapshots to use as a 'sketchbook' in combination with observation and on-thespot studies.

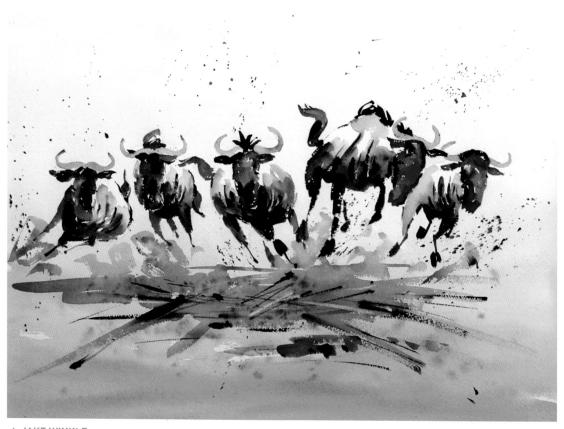

▲ JAKE WINKLE WILDEBEEST RAMPAGE

The artist has created a sense of movement and speed by simplifying the animals to a series of gestural brushstrokes. Warm and cool colours blended on the paper help to add luminosity and spatter from the hooves completes the impression.

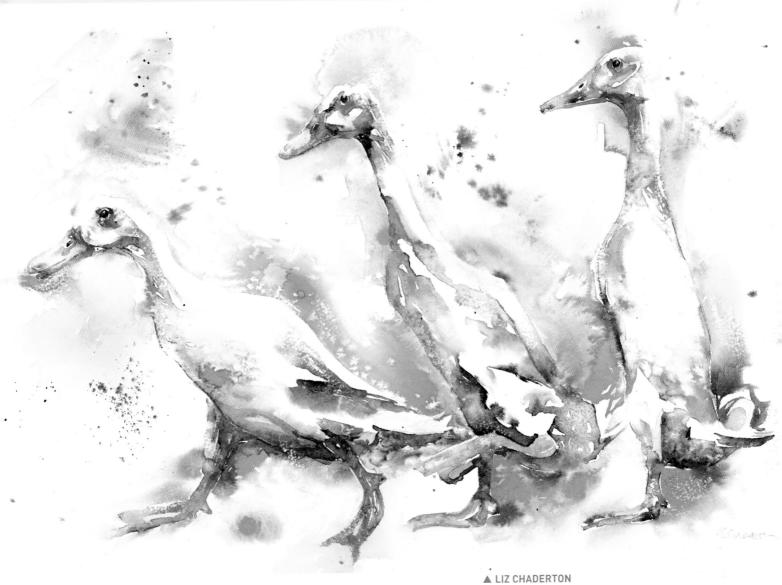

READY, STEADY, GO!

In this painting of Indian runner ducks, the artist has captured the essence of her subject by keeping the application of the medium loose and fluid. Whites were retained by reserving, not masking, and texture was added by sprinkling the wet paint with salt and encouraging backruns and watermarks.

Domestic and Farm Animals

All the best paintings in the history of art are of subjects that the artist is deeply familiar with. Much of John Constable's (1776–1837) artistic output was inspired by his native Suffolk. So if you want to paint animals and have a captive subject, such as your own pet, why not start at home?

One of the great advantages of pets is that they are always around and you can make studies of them sleeping (cats are particularly good for this), running, eating or simply sitting in contemplation. If you live in the country, on or near a farm, sheep, cows and goats are also willing models, since they tend to stand still for long periods when grazing.

One of the most common mistakes in painting an animal is to pay too little attention to its environment, so that it appears to be floating in mid-air. Always try to integrate the animal with the background and foreground, blurring the edges in places to avoid a cardboard cut-out effect.

The techniques you use are entirely a matter of personal preference and will be dictated by your particular interests, but if you opt for a very precise method, using small brushstrokes to build up the texture of an animal's fur or wool, you must use the same approach throughout the painting or the picture will look disjointed.

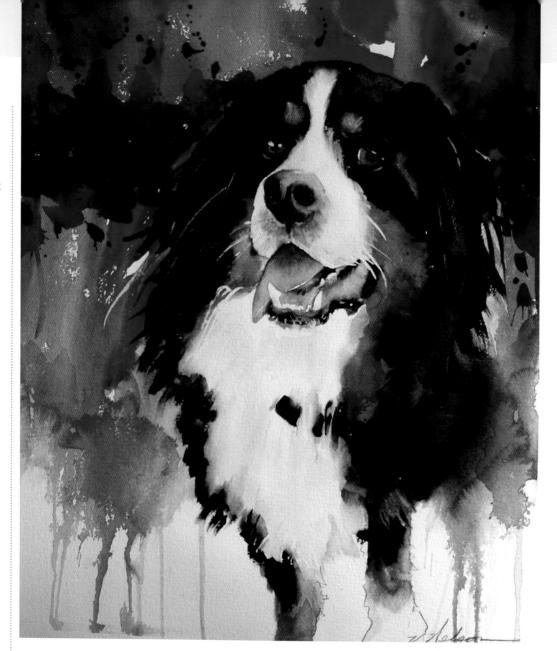

▲ VICKIE NELSON

BERNESE

When painting dogs, this artist always starts with the eyes. Here. she then moved to the snout and body and worked the background loosely to establish tone, blending dog and background in places to bring them onto the same visual plane. She never uses black or

white - French Ultramarine, Burnt Sienna, Alizarin Crimson and Translucent Orange have achieved the darks and lights here.

► BEV JOZWIAK CREATURE COMFORTS

The artist has included just enough information to express the character of the cat as well as embed it in its setting so that it does not float in space. She used stencils to create the fabric patterns, painting in the polka dots but scrubbing out the geometric design.

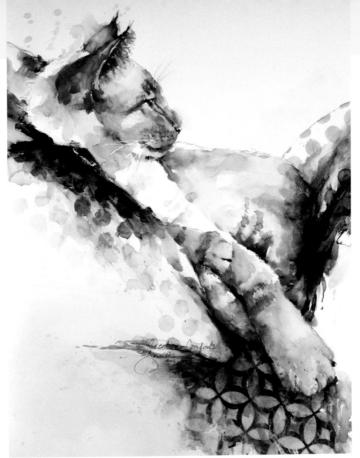

▼ ANNELEIN BEUKENKAMP TRIPLE THREAT

The spontaneous and slightly unpredictable nature of the watercolour medium is a feature that this artist particularly enjoys. Here, she has exploited the way the pigments mingle and interact on the paper to depict the rich colours and shapes of the plumage.

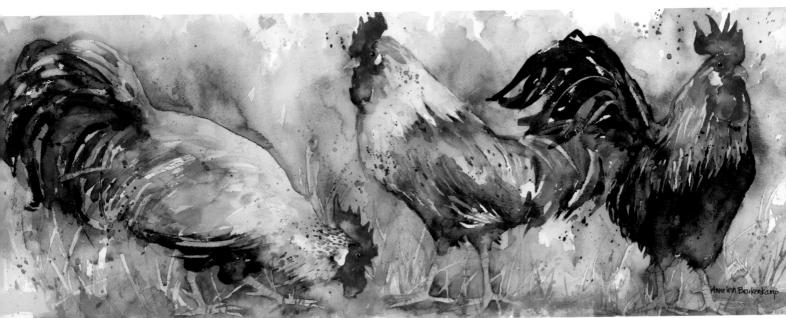

Buildings

A lot of people steer clear of painting buildings because they feel they cannot draw well enough or are unable to come to grips with perspective. This is a pity, as buildings form a major part of today's landscape.

If you want to make detailed, accurate and highly finished paintings of complex architectural subjects, such as the great palaces and cathedrals of Europe, a knowledge of perspective is vital, as are sound drawing skills. This is a specialized kind of painting, but most people have humbler aims, and it is perfectly possible to produce a broad impression of such subjects or a convincing portrayal of a rural church, farmhouse or street scene mainly by means of careful observation. Too much worrying about perspective can actually have a negative effect, causing you to overlook far more interesting things, such as a building's character, colour and texture. However, there is one important rule: receding parallel lines meet at a vanishing point on the horizon. The horizon is at your own eve level, and so is determined by the place you have chosen to paint from. If you are on a hill looking down on your subject, the horizon will be high and the parallels will slope up to it, but if you are sitting directly beneath a tall building, they will slope sharply down to a low horizon point.

If you intend to paint a 'portrait' of a particular building, shape and proportion are just as important as they are in a portrait of a person – these give a building its individuality. A common

◄ THIERRY DUVAL

LES MAUVAIS GARCONS ET LES TROIS PIGEONS

The artist was particularly drawn to this typically Parisian stone façade. He likes to obscure certain details – showing them only in reflection, for example – to test the viewer's powers of observation. The third of the three pigeons in the title is particularly hard to spot.

mistake is to misrepresent the size and shape of doors, windows and so on in relation to the wall area, which not only makes it fail as a portrait, but also creates a disturbing impression, as the building looks structurally impossible.

Before you start to draw or paint, look hard at the building and try to assess its particular qualities. Some houses are tall and thin with windows and doors occupying only a small part of each wall, while others seem to be dominated by their windows. In a street scene, there may be several completely different types of building, built at various periods, and all with distinct characters of their own.

Shapes and proportions can be checked by a simple measuring system. Hold a pencil or a small pocket ruler up in front of you and slide your thumb up and down it to work out the height or width of a door or window in relation to those of the main wall. Most professional artists do this; the human eye is surprisingly trustworthy when it comes to architecture.

The straight line problem

Unless you are a trained draftsman or just one of those lucky people, it can be extraordinarily hard to draw and paint straight lines, and a building that tilts to one side or that has outer walls that are not parallel to each other can ruin the impression of solidity as well as looking bizarre. The ruler is useful here, too – there is nothing wrong with using mechanical aids for your preliminary drawing. You can apply colours as freely as you like once you have a good foundation, using the ruled lines as a general guide.

Towns and Cityscapes

In industrialized countries, the rural populations are far outnumbered by those of towns and cities, and yet cityscapes do not rank high in popularity as painting subjects. This is perhaps not very surprising. Although most city dwellers can see a wealth of rich subject matter in their surroundings colours, textures, shapes and patterns - the prospect of painting them in a convincing manner seems daunting. There is perspective to contend with, not to mention the straight lines and the complex array of architectural details.

Town houses and streets. however, are marvellous subjects. It is mainly a matter of deciding what interests you and making sure that your technique expresses it. An artist whose obsession is architecture may want to paint panoramic townscapes, using fine, precise brushwork to describe every detail, but another might be concerned exclusively with the interplay of geometric shapes or the quality of light, using a broader, more impressionistic technique.

Start in a small way, perhaps with the view from an upstairs window, which provides an interesting viewpoint as well as intriguing details you would not see from street level. Practise drawing whenever possible, and avoid tackling over-ambitious projects until you are sure your skills are up to them.

◀ TIM WILMOTT YORK STREET, BATH

This painting was developed in stages, working from light to dark and allowing each stage to dry before laying down the next wash. Note the little highlights on the red awning and the pedestrians' heads, which serve to differentiate them from their surroundings and add spatial depth.

■ JOHN LIDZEY FRSA

ST PAUL'S AT NIGHT

The freedom of this wonderfully atmospheric painting contrasts strongly with the tighter techniques seen elsewhere on these pages. But it has to be said that the most spontaneousseeming effects in watercolour are usually the result of a thorough knowledge of the medium, and so it is here. The artist began with a careful drawing, a prerequisite for complex architectural subjects. Having given himself a firm foundation, he was then able to apply the paint freely, with a large, soft mop brush, controlling it on the paper with a piece of damp cotton wool. He proceeded by allowing clean water to flow on freshly painted areas, blotting out as necessary. The details were added wet-on-dry, but softened with damp cotton wool in order to keep the same effect throughout the painting.

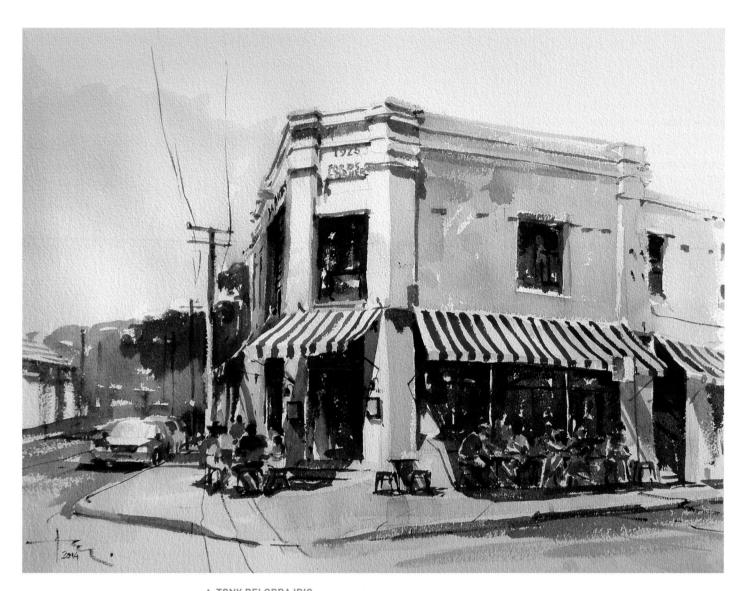

▲ TONY BELOBRAJDIC

LA REPUBLICA, BALMORAL BEACH

Before starting to paint, the artist waited until the interior of the café was totally in shadow. He then focused on the bright, striped awning and applied muted colours elsewhere. The contrast between the prominent awning and the receding dark interior creates a real sense of three-dimensional space.

Details and **Texture**

A building derives much of its character from the details of its architecture, such as doors. windows, balconies and decorative brick - and stonework, all of which make lovely painting subjects in themselves. An open shutter casting a shadow on a whitewashed wall, for instance, could make an exciting composition, providing a contrast of colours and an interplay of vertical and diagonal lines. This kind of subject can all too easily become static and dull, however, so try to keep your brushwork lively and varied, using a combination of fluid washes and crisp lines. You may find the line and wash technique (see page 60) adds

this kind of extra dimension, or vou could make texture the main theme of the painting, using the salt (see page 76) or wax resist (see page 68) methods.

Try to relate the chosen detail to the structure of the building and be careful about the

viewpoint you choose. If you paint a window from straight on, you will not be able to suggest the depth of the recess and hence the thickness of the wall, giving it the appearance of being stuck on rather than built in. Another common mistake when painting windows is to make

them the same dark tone all over, but window glass takes its colours and tones from the prevailing light, often reflecting colour from the sky or other buildings or showing glimpses from the room behind. If you look carefully, you will see variations.

▶ GERRY THOMPSON

STONEWALLED

To achieve unity, the artist first applied a toned ground. When this was dry, she painted the shadows that defined the stone shapes and spattered paint onto some of the rougher sections with a toothbrush. While continually rotating the paper, she added glazes to sharpen the darker shadows, without obscuring the details within them.

A DAVID POXON **WORN TEXTURES**

With its peeling paintwork, twisting iron bars and rusty old padlock, this old door, tucked away slightly off the tourist trail in Venice, provided an irresistible challenge for this artist. He build up the tones by glazing and used a variety of techniques, including spattering, to create texture.

► ANGUS McEWAN COLOUR OF TIME

What attracted the artist to this subject was the beautiful mix of colours accumulated through time and neglect. His challenge was to make it appear possible to peel off the flaking paint, which he achieved with multiple glazes, stippling, spattering, optical mixing and using water-soluble crayons and very fine brushes.

Interiors

Interiors are fascinating painting subjects as they provide so many possibilities for experimenting with the effects of light on composition.

Natural interior light is less intense than outdoor light, but it is more varied because the light source is channelled through the relatively small area of a window, creating warm, bright colours in some places and cool, dark ones in others. This also creates interesting patterns. For instance, the light coming in through a window on a sunny day will be partially blocked by the window bars, setting up an interplay of light and dark geometric shapes that can form a strong or dominant element in a painting.

Artificial light also has great potential for creating pattern and colour. A lamp placed in a dark corner, for example, will throw a strong pool of light below it, and a weaker, more diffused one on the wall behind. breaking up the surfaces into several distinct areas.

These effects of light superimposed on the architectural structure of a room with a framework of verticals and horizontals offer great possibilities. Remember, however, that artificial light is warm and imparts a yellow or orange tinge to colours – so if you intend to paint a lamp-lit interior, you will find it easier to block out the natural light (or wait until after dark).

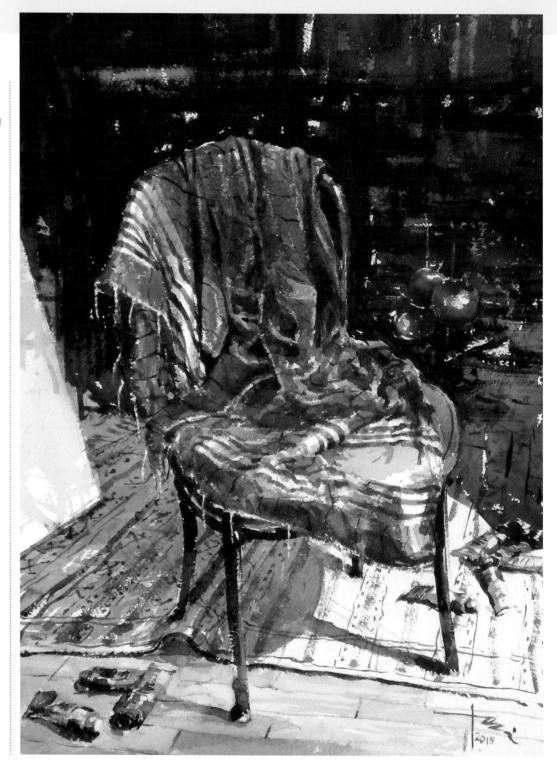

⋖ TONY BELOBRAJDIC

CHAIR

By restricting his palette and inventing an abstracted background, the artist has placed all the focus on the chair. Almost the only colour is on the throw draped across the chair, while the contrast between the dark shadows and the foreground rug and floor suffuses the scene with light.

JUST MOVED IN

No window is visible here, but the strong shafts of sunlight cast across the dust sheet are a key feature of this painting. Minimal information is given, but this enigmatic scene of sofa, jeans and bare wall invite the viewer to invent a story.

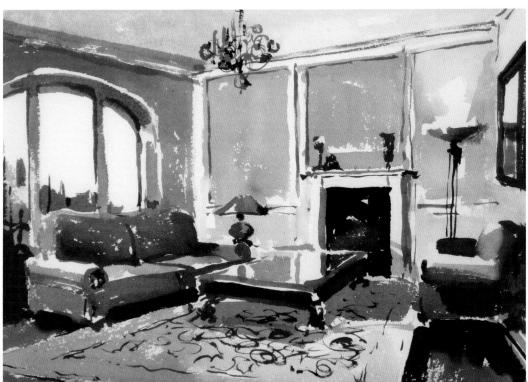

◀ TONY BELOBRAJDIC

INTERIOR

Working quickly and spontaneously, the artist has sketched in all the key elements of the room without doing a preliminary drawing. He never uses white for highlights, but instead reserves them as he works – for example, the convincing reflection on the glass table top.

Buildings in Landscape

In a town- or cityscape, buildings form the whole subject of the painting - although there may be a 'supporting cast' of people, cars and the occasional tree. A farmhouse, church or group of houses, however, can also be part of a landscape, forming just one of its features in the same way that an outcrop of rocks might.

This is a subject with great potential, because it allows you to exploit the contrast between man-made and natural forms in a way that can enhance the qualities of both. There is, however, a danger that the contrast may be too strong. Most people are familiar with the jarring effect of a new building whose architect has not considered its setting. It looks out of place and unrelated, the very quality you want to avoid in a painting.

Many old buildings look as if they have grown naturally out of the landscape they sit in, often because they are built from local materials and reflect the prevailing colours. So try to achieve a similar unity in your painting, in colour and above all in technique. Because buildings are less easy to draw and paint than fields and hills, it is always a temptation to treat them in a much tighter and more detailed way than the rest of the painting, which is a recipe for failure. If you would naturally paint the landscape wet-inwet, use the same method for the building. or at least parts of it.

MICHAEL REARDON **PLACIDA**

The artist has created a strong sense of depth and distance in this painting through his clever use of aerial, or atmospheric, perspective, making the furthest mountain much paler in tone than the one in the foreground.

◄ CARL PURCELL ENCROACHMENT

This painting employs spattering to create textural variations. In the sky area and the foreground shadow, the artist tapped a flat brush across his finger to spatter water and colours into these areas before they had a chance to dry.

▶ EDWARD PIPER MELLIEHA, MALTA

The rose-coloured church, rising up into the deep blue sky, is an important part of the composition, but it is not allowed to dominate. Pattern, colour and movement are the main themes of the painting, expressed through a lively use of the line and wash technique. Piper does not attempt to outline areas of colour with line, since this usually works to the detriment of both. Instead, he places the colours in an almost random way, so that they sometimes overlap the lines and sometimes end well within them, as on the left side of the church.

The figure

Today, more and more artists are finding that watercolour is a marvellous medium for figure and portrait work; it is ideal for freer, more impressionistic treatments, and perfectly suited for capturing impressions of light and the delicate living qualities of skin and hair.

Because watercolours cannot be reworked and corrected to any great extent, it is vital to start a painting on a good foundation. This means that, before you can paint figures or faces successfully, you must first be able to draw them.

The best way to approach the human figure is to see it as a set of simple forms that fit together - the ovoid of the head joining the cylinder of the neck that, in turn, fits into the broader, flatter planes of the shoulders, and so on. If you intend to tackle the whole figure, avoid the temptation to begin with small details; instead, map out the whole figure first in broad lines.

Proportion is particularly important, and many promising paintings are spoiled by a toolarge head or feet, for example. The best way to check proportions is to hold up a pencil to the subject and slide your thumb up and down it to measure the various elements and check their relative size.

Another way to improve your drawing is to look not at the forms themselves, but at the spaces between them. If a model is standing with one arm resting on a hip, there will be a space of a particular shape between these forms. Draw this, not the arm itself, and then move on to any other 'negative shapes' you can see. This method is surprisingly accurate.

Composition

It is easy to become so bogged down in the intricacies of the human figure and face that composition is forgotten, but it is every bit as important as in any other branch of painting. Even if you are painting just a head-and-shoulder portrait, always give thought to the placing of the head within the square or rectangle of the paper, the background and the balance of tones.

A plain, light-coloured wall might be the ideal foil for a dark-haired sitter, allowing you to concentrate the drama on the face itself, but you will often find you need more background or foreground interest to balance a subject. Placing your sitter in front of a window, for example. will give an interesting pattern of vertical and horizontal lines in the background as well as a subtle fall of light, while the lines also have pictorial potential.

Figures or groups of figures in an outdoor setting need equally careful preplanning. You will have to think about whether to make them the focal point of the painting, where to place them in relation to the foreground and background and what other elements you should include - or suppress. It is a good idea to make a series of small thumbnail sketches to work out the composition before you begin to paint.

▶ BEV JOZWIAK

RED VELVET, WHITE TULLE

Among the most striking features of this portrait are the strong highlights on the face, shoulder and arms. Much of the picture is worked loosely, wet-on-dry, but the crisply defined edges of the figure against the darker brushwork really increase the sense of rounded form.

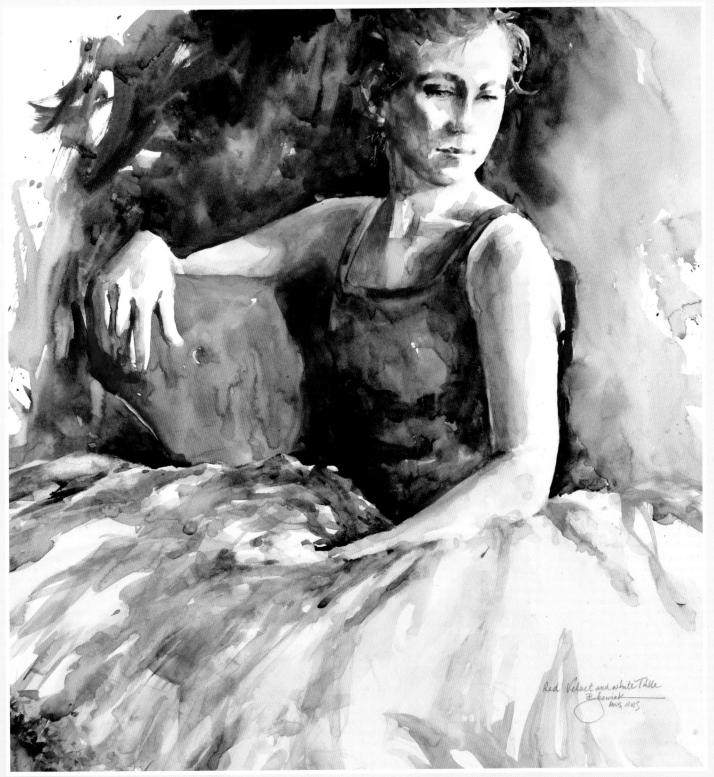

Figure Studies

Watercolour is eminently suitable for quick figure studies. whether done indoors or out. Making such studies is the best possible way of learning the figure - this is why they are called studies. They are a kind of visual note-taking, and they print impressions on the mind much more effectively than simply looking.

Anyone interested in painting their fellow human beings should carry a sketchbook at all times and perhaps a small watercolour box or a few watercolour crayons.

There are countless opportunities to draw and paint unobserved - on buses, in parks and gardens, beside swimming pools and at sports centres. Never attempt a detailed treatment, but try to grasp the essentials as quickly as you can using any method you find you are happy with.

Line and wash is much used for this kind of work, as is a combination of pencil and watercolour. You may find it easier to work in monochrome only, drawing with a brush and ink - an expressive and speedy way of conveying movement or blocking areas of tone. If you do use colour, restrict yourself to the minimum and don't bother about mixing the perfect subtle hue. If you want to use your sketches as reference for a later painting - or instance, a group of people in a café or a family picnic - write notes about colours on each sketch.

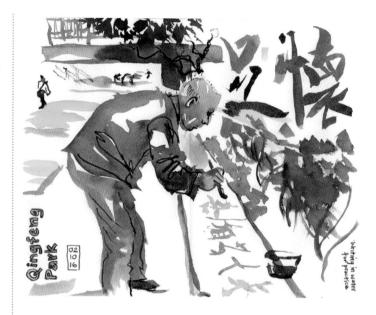

■ LYNNE CHAPMAN CALLIGRAPHY IN THE PARK. BEIJING

The Chinese calligrapher is watercolour first, to capture all the main shapes, then watercolour pencil to add definition here and there.

▼ LYNNE CHAPMAN CARD PLAYERS IN THE PARK, **BEIJING**

The card players are drawn in watercolour pencils, then watercolour added for stronger definition of tones and colours where needed.

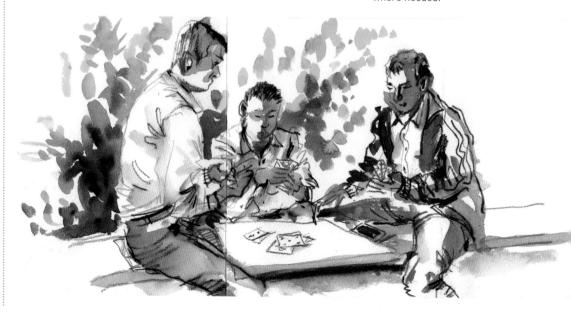

▼ JAKE SUTTON **CIRCUS CYCLIST**

Sutton draws with his brush (see brush drawing, pages 54-55) to convey a marvellous sense of excitement and urgency. The variation in the brushstrokes, some like fine pencil scribbles and others swelling and tapering, seems to increase the momentum of the figure, propelling it forward.

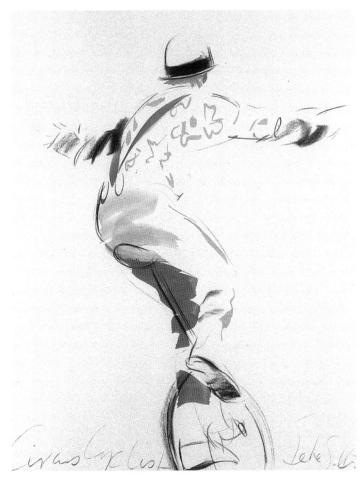

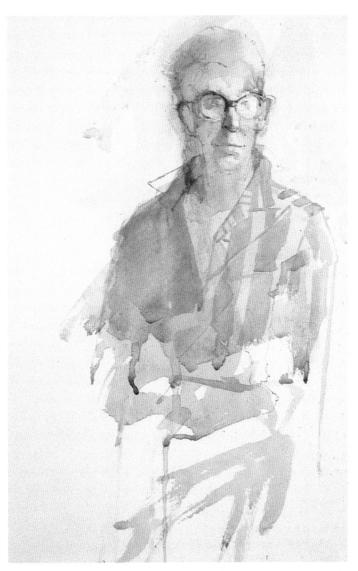

MICHAEL MCGUINESS SALLY

The lightness and delicacy of the artist's technique, and the way he has applied the paint so that it has dripped down the paper, combine to give a powerful impression of immediacy. Nevertheless, this is a careful and meticulous study, with

the shape of the head, the features and the direction and quality of the light described with precision.

Portraits

There is no doubt that portraiture is a tricky subject there are some people who have the knack of capturing faces and expressions without thinking about it, and they are fortunate, but they are not necessarily good artists. However, the idea that painting portraits is particularly difficult in watercolour should be resisted - it is simply not true, and an increasing number of artists are using its subtle qualities to produce fine and sensitive paintings that are also good likenesses.

No good painting, least of all a portrait, can be built on a shaky foundation, so before you begin to paint a face you must understand its structure and be able to draw it convincingly. A good way of getting to know the basics is to use yourself as a model and start with a selfportrait (there are few artists who have not painted themselves at one time or another). You can also practise by drawing from photographs, but unless they are very good ones, they are not always helpful, since shapes and forms are often obscured by dark shadows and bleached-out highlights. Photographs are more useful in the later stages of a portrait. Most professional portrait painters take them to use as reference for details of clothing and background, but not for the face itself.

▶BEV JOZWIAK H00PS

Painting the face and hair in some detail while just suggesting other parts with loose brushwork and sketchy lines makes for a more interesting picture. It was worked wet-on-dry, with spattered and dripped paint.

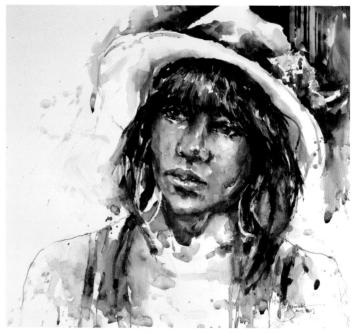

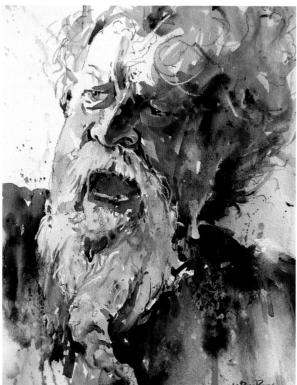

■ DAVID LOBENBERG PERTURBED

Critical areas of the white of the watercolour paper were left for the highlights on the left side of the face. Spatters, drips and runs, as well as salt in his shirt, were used for energetic and expressive texture.

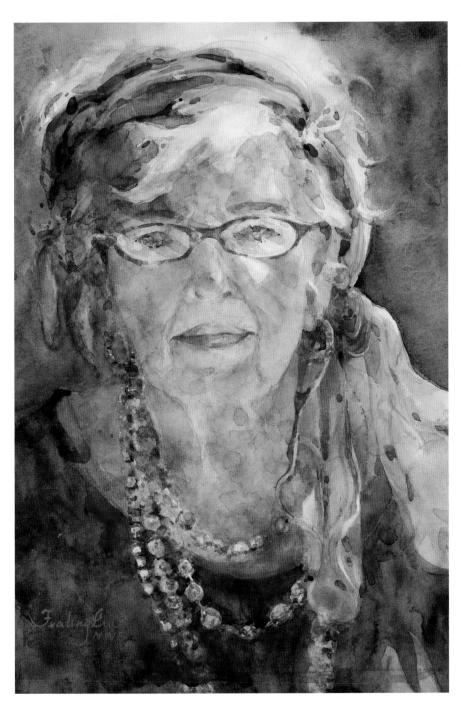

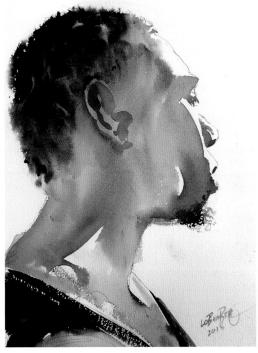

▲ DAVID LOBENBERG MY MAIN MAN

In this quick study, washes of different colours, applied wet-inwet, suggest shadows glowing with reflected light. The crisp, reserved whites show exactly where the light hits the face and neck, and the outline of the profile delicately defines the form.

⋖ FEALING LIN MRS FIELDS

Complementary colours – green to red on the scarf and cool yellow to dark violet on the dress – give this portrait a warm glow. The colours were repeated on the necklace to achieve unity. The spectacles were kept soft so as not to be too distinct from the rest of the face.

The Figure in Context

Because the figure is a complex subject in itself, there is a tendency to lavish all the attention on it and dismiss the setting as unimportant, but few people would think of painting a tree without including the ground from which it grows, and it is just as important to place a person in a specific environment, indoors or out.

Indoor figure paintings have many of the advantages of still lifes - you can control the lighting, the pose, the background and any other objects, such as furniture, that you may want to include in the composition. Another interesting facet of the subject is that the kind of setting you choose can tell a story about the person. Some of the most successful paintings of figures show people in their place of work or recreation; the marvellous series of ballet dancers by Edgar Degas (1834-1917) are among the bestknown examples. So, if you want to paint someone who is fond of reading, think about including books or placing the figure near some bookshelves. Degas did this in his portrait of the writer, Emile Zola.

If you plan a picture of someone who enjoys gardening or some sport, it makes sense to choose an outdoor setting. This is, of course, less controllable, as the light source will change, so you may have to work indoors from sketches made on the spot.

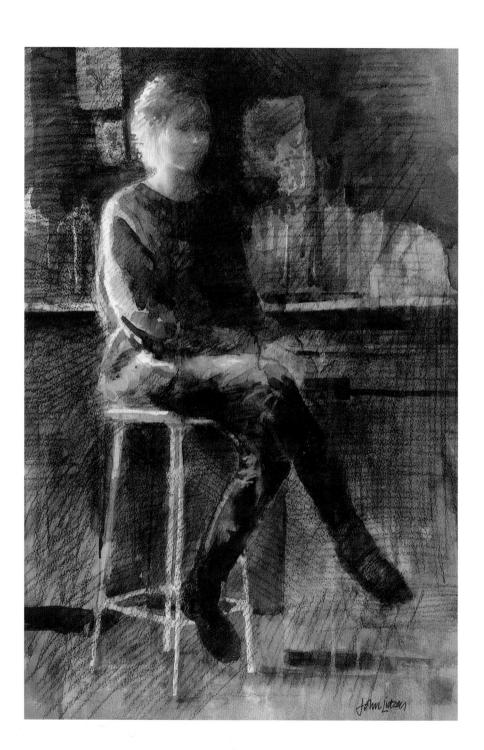

■ JOHN LIDZEY FRSA GIRL ON STOOL

Lidzey has been preoccupied with light, but his tonal contrasts are much stronger and his range of colours is considerable. He says that the technique he has used here was inspired by that used by French painter Georges Seurat (1859-91) in his magnificent tonal drawings. The underlayer is pure watercolour, used wet, as in most of his paintings. The highlights were reinforced with white gouache, and the picture was built up with successive layers of crosshatching with black conté crayon. The carefully varied crayon lines have been broken up by the grain of the paper to create the effect of a soft veil, which enhances the brilliance and depth of the colours below, as in the scumbling technique (see pages 78-79). This is an inspiring and completely successful use of mixed media (see pages 84-85), with a satisfying harmony between paint and line.

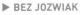

ON POINTE

Gesso – a white paint mixture – was used to add texture and depth to this painting. It can be mixed directly with watercolour to produce interesting effects. The artist used a palette knife to scrape out the textural forms.

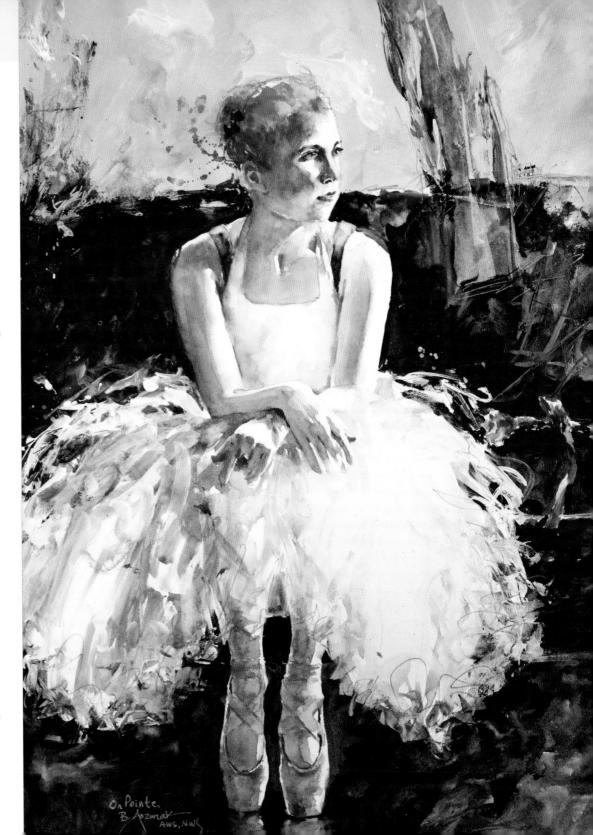

Groups

Although people are seen more often in groups than singly, particularly outdoors, multiple figure compositions tend to be avoided by all but the most experienced painters. However, groups are not only an exciting and challenging subject, they are in some ways easier than single figures. If you are painting a family picnic or people sunbathing on a beach, for example, you can treat them more broadly than you would a portrait, concentrating on an overall impression of colours and forms. Such paintings, though, usually have to be done from sketches rather than completed on the spot, as people have a way of packing up and going home just as you have got out your paints.

When you come to compose a group painting from sketches of individual figures, you may find that it is not easy to relate them either to each other or to your chosen setting (they may all be drawn to different scales), so try to regard your sketches as the first steps in a planned painting and make them as informative as possible. Avoid drawing figures in isolation; always indicate the foreground and background as well, if only in broad terms. This will provide a frame of reference and will also help you to avoid the pitfall of inconsistent scale. You could easily find that you have placed a group in front of a building or tree that is disproportionately small or large.

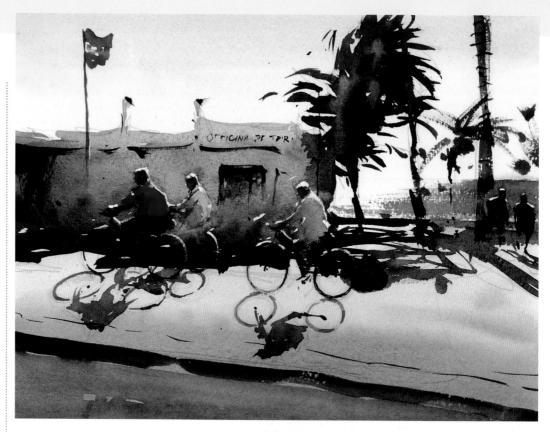

A TIM WILMOT CYCLE UP THE PROMENADE, PUERTO DEL CARMEN. LANZAROTE

The beach-side setting puts these cyclists in context and gives the painting a narrative. Graded washes suffuse the scene with sunlight - a darker cobalt blue coming down into yellow ochre for the sky, while warm tones becoming increasingly darker towards the viewer give definition to the pavement and road.

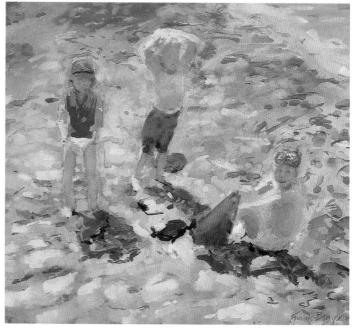

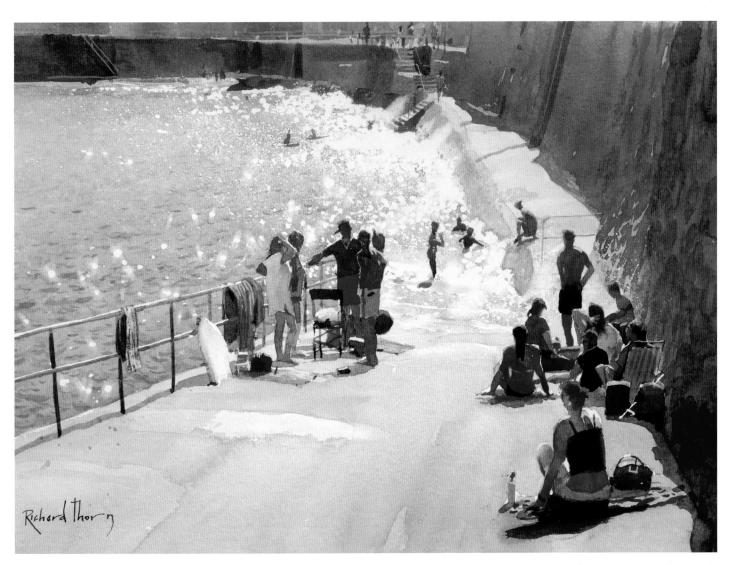

■ FRANCIS BOWYER

CHANGING FOR A SWIM

Although the treatment of the children is no more detailed than that of the beach, the poses are very carefully observed, and this, together with the suggestion of features on the face of the foreground boy, holds our interest. Bowyer has given a marvellous

unity to the composition by repeating versions of the same colours – violet-blues, yellows and warm pinks – throughout the painting.

A RICHARD THORN

AFTER HOURS

The late afternoon sun brought out the blues and purples in the shadowed areas in this image. These colours are pervasive and give a wholeness to the scene, even tinting the silhouettes of the people seen against the bright sunlight.

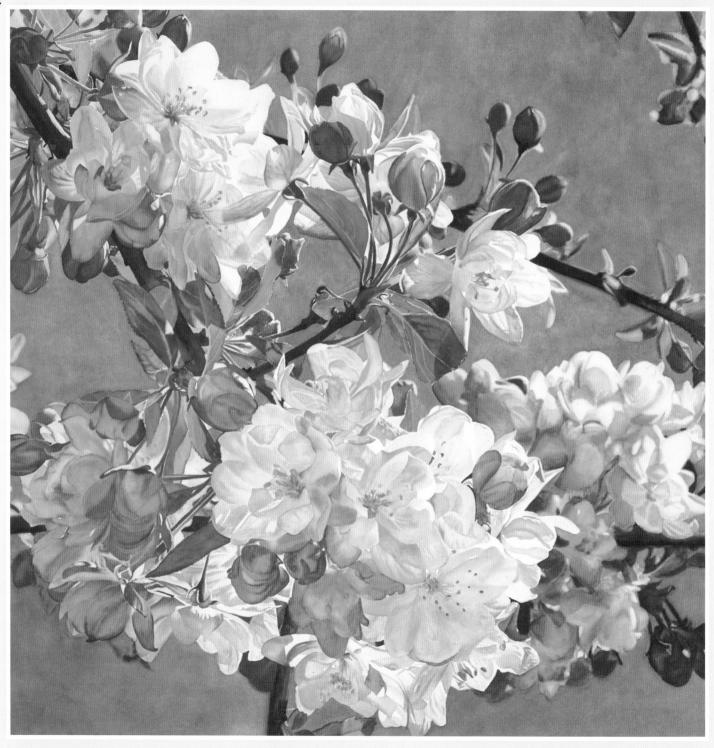

Flowers

Flowers, with their rich and varied array of glowing colours, intricate forms and delicate structures, are an irresistible subject for painters. There are many different approaches to this branch of painting, all suited to the medium of watercolour: flowers can be painted in their natural habitats or indoors as still-life arrangements; they can be treated singly or in mixed groups; they can be painted in fine detail or broadly and impressionistically.

Flower painting in history

Today flower paintings are hugely popular and avidly collected, and good flower painters can command high prices. This is a relatively recent trend in terms of art history, however. In the Medieval and Renaissance periods, when scientists were busily cataloguing herbs and plants, the main reason for drawing and painting them was to convey information, and a host of illustrated books, called herbals, began to appear, explaining the medicinal properties of various plants and flowers.

The concept of painting flowers for their own sake owes more to the Flemish and Dutch still-life schools than any other. The Netherlandish artists were always more interested in realism and the accurate rendering of everyday subjects than their Italian and French counterparts and, throughout the sixteenth, seventeenth and eighteenth centuries, they vied with one another to produce ever more elaborate flower pieces, with every petal described in minute detail. Although critics in France regarded flower pieces and still life as inferior art forms, even there they had become respectable by the mid-nineteenth century.

Working methods

Because flowers are so intricate and complex, there is always a temptation to describe every single petal, bud and leaf in minute detail. In some cases there is nothing wrong with this (for anyone intending to make botanical studies, it is the only possible approach), but too much detail can look unnatural and static, and there is also the everpresent danger of overworking the paint and losing the clarity of the colours.

Before you start, make some decisions about which qualities you are interested in. If you are inspired by the glowing colours in a flowerbed, treat the subject broadly, perhaps starting by working wet-in-wet, adding crisper definition in places to combine hard and soft edges.

Always remember that flowers are living things, fragile and delicate, so don't kill them off in your painting – try to suit the medium to the subject. You can make a fairly detailed study, while still retaining a sense of freedom and movement, by using the line and wash technique, combining drawn lines (pen or pencil) with fluid washes. Never allow the line to dominate the colour, however, because if you get carried away and start to outline every petal you will destroy the effect. Liquid mask can be helpful if you want to be able to work freely around small highlights, and attractive effects can be created by wax resist.

Finally, even a badly overworked watercolour can often be saved by turning it into a mixed media painting, so consider whether you might be able to redeem it by using pastel, acrylic or opaque gouache on top of the watercolour.

⋖ CARA BROWN

HAPPY

The artist wanted to do a big, bold painting of a cloud of cherry blossom, with a large area of strong blue sky. The image reminded her of the lyric 'room without a roof' from the Pharell Williams' song 'Happy', which inspired the title of the work.

Single Specimens

The most obvious example of flowers and plants treated singly rather than as part of a group are botanical paintings. Botanical studies have been made since pre-Renaissance times and are still an important branch of specialized illustration. Many of the best of these drawings and paintings are fine works of art, but their primary aim is to record precise information about a particular species. For the botanical illustrator, pictorial charms are secondary bonuses, but artists, who are more concerned with

these than with scientific accuracy, can exploit them in a freer, more painterly way.

However, this is an area where careful drawing and observation are needed. You may be able to get away with imprecise drawing for a broad impression of a flower group, but a subject that is to stand on its own must be convincingly rendered. Looking at illustrated books and photographs can help you to acquire background knowledge of flower and leaf shapes, but it goes without saying that you will also need to draw from life - constantly.

Most flowers can be simplified into basic shapes, such as circles or bells. These, like

everything else, are affected by perspective, so that a circle turned away from you becomes an ellipse. It is much easier to draw flowers if you establish these main shapes before you begin to describe each petal or stamen.

▼WILMA VAN DER VLIET LOVE-IN-A-MIST

This flower painting evokes the style of traditional botanical art. The delicate stems, buds and bloom are painted in a highly realistic way. The insects around it add a decorative element and help to complete the image that might otherwise be too empty.

▶ JENNY MATTHEWS CROWN IMPERIAL

The shapes, structures and colours of some flowers are so fascinating that they seem to demand the right to shine out proud and alone, without the need for background, foreground or other diversions. This is certainly the case here, and the artist has made the most of her chosen specimen by her sensitive but tough use of linear brushmarks over delicate washes.

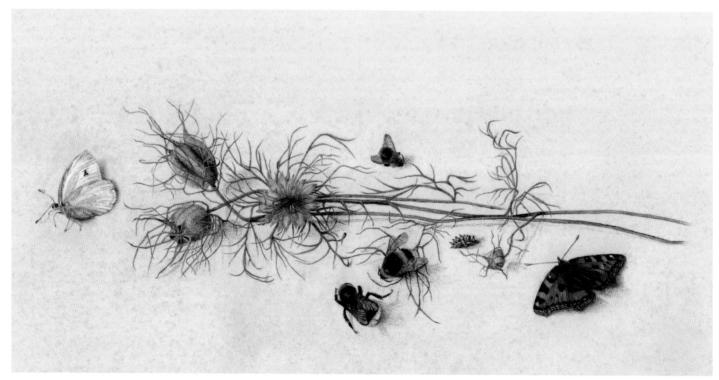

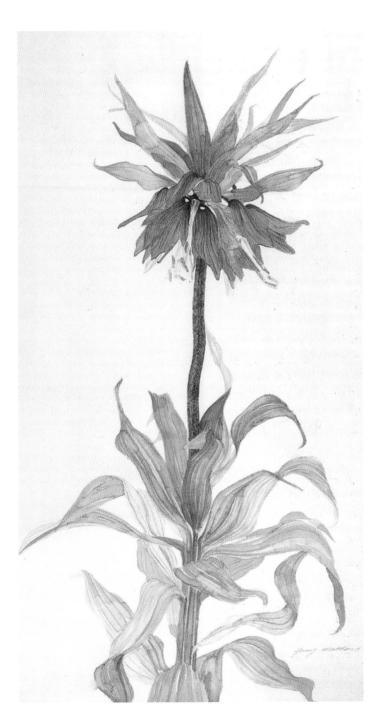

▲ JEAN CANTER CORN MARIGOLDS

The oval format chosen for this delightful study gives it a rather Victorian flavour. The artist has created a strong feeling of life and movement, with the sinuously curving stems and leaves seeming to grow outwards towards the boundary of the frame.

▼ SHARON BEEDEN APPLES AND PLUMS

Each of these specimens was the subject of painstaking research, drawn from life, with the blossoms redrawn from sketchbook studies done earlier in the year. The composition was worked out on tracing paper and then transferred to the working paper.

Composition

A group of flowers tastefully arranged in an attractive vase always looks enticing - that, after all, is the point of putting them there - but it may not make a painting in itself. Placing a vase of flowers in the centre of the picture, with no background or foreground interest, is not usually the best way to make

the most of the subject - though there are some notable exceptions to this rule. So you will have to think about what other elements you might include in order to make the composition more interesting without detracting in any way from the main subject.

One of the most-used compositional devices is that of placing the vase asymmetrically

and painting from an angle, so that the back of the tabletop forms a diagonal instead of a horizontal line. Diagonals are a powerful weapon in the artist's armoury, as they help to lead the eye in to the centre of the picture, while horizontal lines do the opposite.

One of the difficulties with flower groups is that the vase leaves a blank space at the

bottom of the picture area. This can sometimes be dealt with by using a cast shadow across part of the composition; alternatively, you could scatter one or two blooms or petals beneath or to one side of the vase, thus creating a relationship between foreground and focal point.

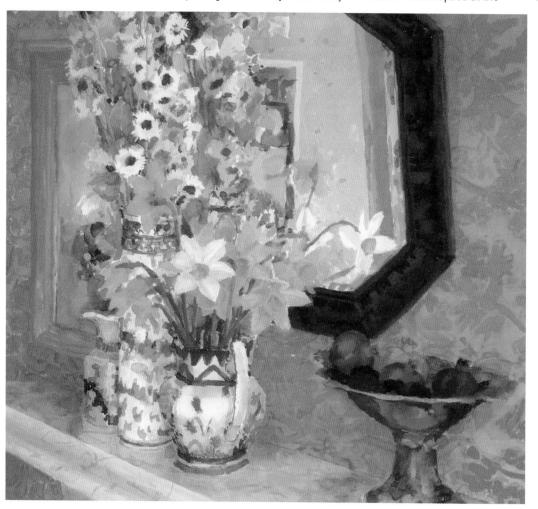

■ GERALDINE GIRVAN STUDIO MANTELPIECE

Girvan has used a combination of diagonals and verticals to lead the eye into and around the picture. Our eye follows the line of the mantelpiece, but instead of going out of the frame on the left, it is led upwards by the side of the picture frame and then down through the tall flowers to the glowing heart of the picture - the daffodils. She has avoided isolating this area of bright yellow by using a slightly muted version of it in the reflection behind and has further unified the composition by repeating the reds from one area to another.

▼ CAROLYNE MORAN

HYDRANGEAS IN A BLUE AND WHITE JUG

Here the flowers occupy an uncompromisingly central position, with the rounded shapes of the blooms and vase dominating the picture, but counterpointed by the rectangles formed by the background window frame. Interestingly, we do not immediately perceive this painting as square because the verticals give it an upward thrust. The artist has made cunning use of intersecting diagonals in the foreground to break up the predominantly geometric grid, and has linked the flowers to the background by using the same blue under the windowsill. There is considerable overpainting on the flower heads, as they kept changing colour while the artist worked – one of the flower painter's occupational hazards.

► RONALD JESTY

SWEET PEAS IN A TUMBLER

Jesty's compositions are always bold, and often surprising, as this one is. We are so conditioned by the idea of 'correct' settings for flower pieces and still lifes that the idea of placing a vase of flowers on a newspaper seems almost heretical. But it works perfectly, with the newspaper images providing just the right combination of geometric shapes and dark tones to balance the forms and colours of the sweet peas.

Natural Habitat

Oddly, the terms 'flower painting' makes us think of cut flowers rather than growing ones, perhaps because most of the paintings of this genre that we see in art galleries are of arranged rather than outdoor subjects. Flowers, however, are at their best in their natural surroundings, and painting them outdoors, whether they are wild specimens in woods, fields or city wastelands or cultivated blooms in the backyard, is both rewarding and enjoyable.

It can, however, present more problems than painting arranged groups indoors, because you cannot control the background or the lighting and you may have to adopt a ruthlessly selective approach in order to achieve a satisfactory composition. You will also have a changing light source to contend with. As the sun moves across the sky, the colours and tones can change dramatically, and a leaf or flower head that was previously obscured by shadow will suddenly be spotlit so that you can no longer ignore its presence. The best way to deal with this problem, if you think a painting may take more than a few hours to complete, is to work in two or three separate sessions at the same time of day or to make several quick studies that you can then combine into a painting in the studio.

■ JULIETTE PALMER PINK ROSES, WHITE PHLOX

This was the artist's own garden. She had a strong sense of design and composition and, as she observed a subject, various elements would fall into place to form a satisfactory whole. She

was not interested in dramatic effects but, as she herself put it, 'elegance of line and the delight of the particular bound in gentle relationship of colour and tone'.

A DEB WATSON **CONEFLOWERS**

These flowers are one of the artist's favourite subjects and she likes to start with the backgrounds, working wet-inwet and dropping in colours that mix naturally on the paper. Larger and more complex groups such as this require careful planning and, for greater precision and definition, the flowers would need to be painted wet-on-dry.

◄ CAROLINE LINSCOTT

TEARS OF PASSION

This dramatic flower was fully completed first before the artist turned her attention to the background, which she painted wetin-wet in a loose, abstract style. She created the droplets of water by lifting out - from the petals while still damp and from the background by splattering it with water.

► KEITH MANNING KENNEDY **BUMBLE BEE**

The bumble bee was taken from the artist's photograph. The rest of the painting is from observation spanning several days starting with the bougainvillea, which was the only flower in bloom when he started. The 'spaces between' are a crucial part of the overall pattern.

Landscape

Whatever the medium used, landscape is among the most popular of all painting subjects. One of the reasons for this is the common belief that it is easier than other subjects. Many who would never attempt a figure painting or flower study turn with relief to country scenes, feeling them to be less exacting and thus more enjoyable.

However, a painting will certainly be marred by poor composition or mishandled colours - these things always matter, whatever the subject. The best landscapes are painted by artists who have chosen to paint the land because they love it.

Direct observation

Another factor that separates the really good from the adequate is knowledge, not of painting methods - though this is necessary, too - but of the subject itself. This is why most landscape painters work outdoors whenever they can. Sometimes they only make preliminary sketches. but often they will complete whole paintings on the spot. Even if you only jot down some rapid colour impressions, it is still the best way to get the feel of a landscape.

If you use photographs as a starting point - and many professional artists do take photos as a back-up to sketches - restrict yourself to a part of the countryside you know well and have perhaps walked through at different times of the year so that you have absorbed its atmosphere.

Composition

Nor should you attempt to copy nature itself: painting is about finding pictorial equivalents for the real world. This means that you have to make choices and decide how much to put in or omit.

The medium

The fluidity and translucency of watercolour are perfectly suited to creating impressions of light and atmosphere. Light and portable, it has always been popular for outdoor work, but until you have gained some practice, it can be tricky to handle as a sketching medium. There is always the temptation to make changes in order to keep up with the changing light, and if there is too much overworking, the colours lose their freshness. There are ways of dealing with this, however. One is to work on a small scale, using the paint with a minimum of water so that you cut down the time spent waiting for each layer to dry, and another is to work rapidly wet-in-wet, concentrating on putting down impressions rather than literal descriptions. Gouache can be used thinly, just like watercolour, but dries much more quickly and can be built up in opaque layers for the later stages.

CAROL EVANS **BEACH AT MONTAGUE**

The natural beauty of Galiano Island in British Columbia, Canada, is captured in this exquisite watercolour landscape. The composition follows the classic landscape 'rule' of foreground, middle ground and distance: the trees in the foreground frame the picture, inviting the viewer to look through them to the shoreline. water and distant trees.

Trees and Foilage

Trees are among the most enticing of all landscape features. Unfortunately, they are not the easiest of subjects to paint, particularly when foliage obscures their basic structure and makes its own complex patterns of light and shade.

In order to paint a leafy tree successfully, it is usually necessary to simplify it to some extent. Start by establishing the broad shape of the tree, noting its dominant characteristics. such as the width of the trunk in relation to the height and spread of the branches. Try not to get bogged down in detail. If you try to give equal weight and importance to every separate clump of foliage you will create a jumpy, fragmented effect. Look at the subject with your eyes half closed and you will see that some parts of the tree, those in shadow or further away from you, will read as one broad colour area, while the sunlit parts and those nearer to you will show sharp contrasts of tone and colour.

A useful technique for highlighting areas where you want to avoid hard lines is that of lifting out, while sponge painting is a good way of suggesting the lively brokencolour effect of foliage. Dry brush is another favoured technique, and one that is well suited to winter trees with their delicate, hazy patterns created by clusters of tiny twigs.

▲ RANDY EMMONS ALDER GROVE

The crisp, clean shapes in this gloriously colourful painting demonstrate the artist's distinctive style in which foliage and other elements are expressed as blocks of colour, rather like pieces in a collage. In depicting local scenes, he tries to balance design and colour and to keep the whites intact so that the painting will sparkle.

◆ CARL PURCELL

AFTER THE RAIN

In contrast to the more graphic treatment of foliage above, the handling of the watercolour medium is much looser here. Quick brushmarks sketch in the forms and different colours are dropped in, wet-in-wet and wet-on-dry. The restricted palette gives unity to the whole.

▶ RICHARD THORN A WALK THROUGH THE

A WALK THROUGH THE MORNING SUN

In this evocative scene, the artist wanted to capture the light filtering through trees and the shadow patchwork on the lane – this merry dance of shadows and light was the main aspect of the subject, achieved with watercolour and body colour.

Rocks and Mountains

Mountains are a gift to the painter - they form marvellously exciting shapes, their colours are constantly changing and. best of all, unless you happen to be sitting on one, they are far enough away to be seen as broad shapes without too much worrving detail.

Distant mountains can be depicted using flat or semi-flat washes, with details such as individual outcrops lightly indicated on those nearer to hand. For atmospheric effects. such as mist lying between one mountain and another or light cloud blending sky and mountain tops together, try working wet-in-wet or mixing watercolour with opaque white.

Nearby rocks and cliffs call for a rather different approach, since their most exciting qualities are their hard, sharp edges and their textures - even the rounded, sea-weathered boulders seen on some seashores are pitted and uneven in surface and are far from soft to the touch. One of the best techniques for creating edge qualities is the wet-on-dry method, where successive small washes are laid over one another (if you become tired of waiting for them to dry, use a hairdryer to speed up the process). Texture can be built up in a number of ways. The wax resist, scumbling or salt spatter methods are all excellent.

▲ PAUL TALBOT GREAVES LAST FARM

The angular shapes within this drystone wall were first built up using thin washes of weak colour. To add darker values and sculpt the overall form, subsequent layers of wet-on-dry were applied. Finally, the texture of the stones was suggested by spattering very dilute gouache over the dry painting.

► RONALD JESTY RBA **PORTLAND LIGHTHOUSE**

Jesty has worked wet-on-dry using flat washes of varying sizes to describe the crisp, hard-edged quality of the rocks. He has created texture on some of the foreground surfaces by 'drawing' with an upright brush to produce dots and other small marks, and has cleverly unified the painting by echoing the small cloud shapes in the light patches on the foreground rock. This was painted in the studio from a pen sketch.

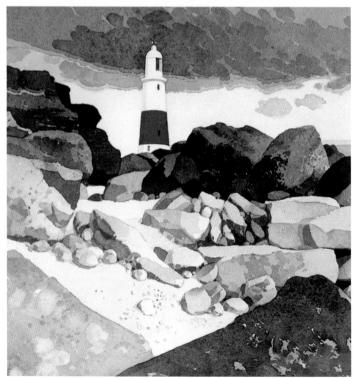

► RANDY EMMONS CANYON DE CHELLY

Horizontal bands of colour depict the different rock strata in this cliff face in northeastern Arizona. Using his characteristic blocky shapes, the artist has included a tree in the foreground that frames the scene and leads the eye on into the deep cave with its ancient Anasazi Indian dwellings.

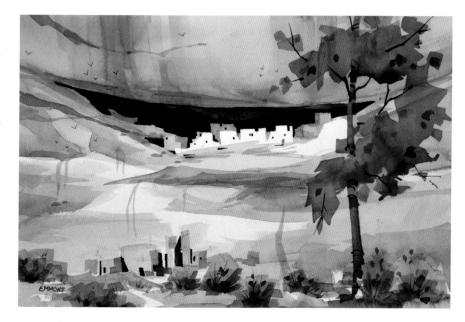

► ROBERT HIGHSMITH VIEW OF THE DONA ANAS

The blue and greys of the distant mountains were painted in one pass with a large flat sable brush, including a warmer colour at the base to bring it forward in space. When this was dry, paint was spattered on sparingly with a toothbrush for a little extra definition. Finally, the shadows were drawn across the mountains, leaving some parts untouched to delineate the craggy forms.

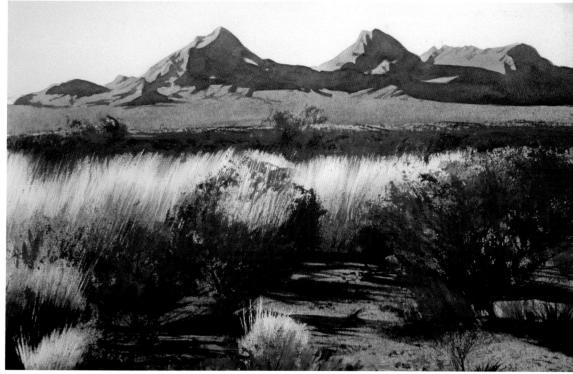

Cloud **Formations**

Clouds are always on the move - gathering, dispersing, forming and re-forming - but they do not behave in a random way. There are different types of cloud. each with its own individual structure and characteristics. It is not necessary to know the name of each type, but to paint clouds convincingly you need to recognize the differences. It is also helpful to realize that they form on different levels. because this affects their tones and colours.

Cirrus clouds, high in the sky, are fine and vaporous, forming delicate, feathery plumes where they are blown by the wind. The two types of cloud that form on the lowest level are cumulus clouds, with horizontal bases and cauliflower-like tops, and storm clouds (or thunderclouds) - great, heavy masses that rise up vertically, often resembling mountains or towers. Both these low-level clouds show strong contrasts of light and dark. A storm cloud will sometimes look almost black against a blue sky, and cumulus clouds are extremely bright where the sun strikes them and surprisingly dark on their shadowed undersides. Between these two extremes of high and low, there is often an intermediate level of cloud with gentler contrasts than the low layer, so a single sky with a mixture of all these types of clouds can present a fascinating ready-made composition.

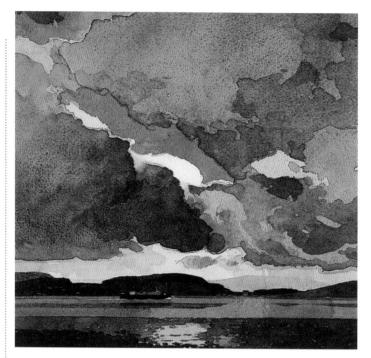

■ RONALD JESTY RBA

OUT OF OBAN

This dramatic cloud study was painted in the studio from a pen sketch. Built up entirely by means of superimposed washes painted wet-on-dry, the colours are nevertheless fresh and clear. Although many watercolourists avoid overlaying washes for subjects such as these, which are easily spoiled by too great a buildup of paint, Jesty succeeds because he takes care to make his first washes as positive as possible. Notice the granulated paint in the clouds caused by laying a wet wash over a previous dry one, an effect often used to add extra surface interest.

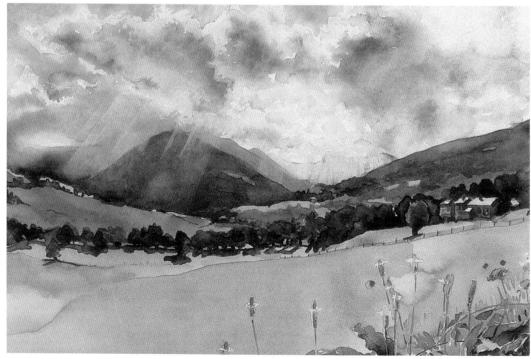

► ROBERT HIGHSMITH SUNSET OVER THE ROBLEDOS

For this brooding sky, the artist allowed the wet-in-wet technique to dictate the shape of the clouds. He began with yellow washes on the horizon and pale blue in the sky. Using large housepainter's brushes, he then applied the paint in large patches and allowed the darker colours to form the clouds.

There is often quite sharp definition as well as strong contrasts of tone in the low level of cloud (that nearest to us). Clinch has given form to the clouds by using a combination of wet-on-wet, which creates soft, diffused shapes, and wet-on-dry, which forms crisp edges where one wash overlaps another. The effect of the rain has been achieved by careful lifting out.

Water

Perhaps more than any other subject, water requires very close observation. The shapes and colours of trees or hills can, to some extent, be re-created from memory, but water has no permanent shape or presence of its own. A completely still lake will present a mirror image of the sky, but one tiny breeze can transform the water surface into a steely grey, solid-looking mass. A fast-running stream seen from a certain distance away may provide a reassuringly simple surface and an even colour, but as soon as you sit down beside it, the real paradox of water becomes apparent. It is undeniably there, but at the same time it is a transparent and ethereal presence through which you can clearly see the sand and rocks below.

To paint water successfully, it is necessary to simplify what you see, but you cannot hope to distill the essence of a subject until you are familiar with its complexities. So be prepared to spend time watching water – it is a pleasing pastime in itself. If you sit quietly by a river or on the seashore, you will begin to see that the movements of water, like its changing colours, follow certain patterns.

Understanding, for instance, the way the sea swells to become a wave, before breaking into foam will enable you to paint it with assurance and freedom.

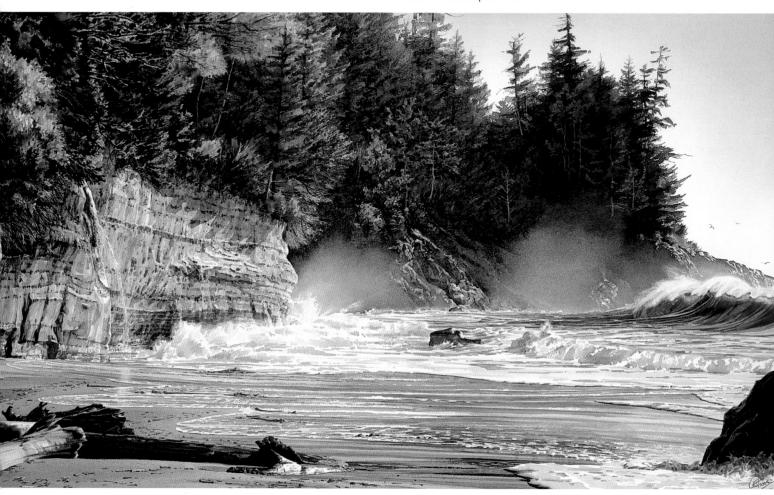

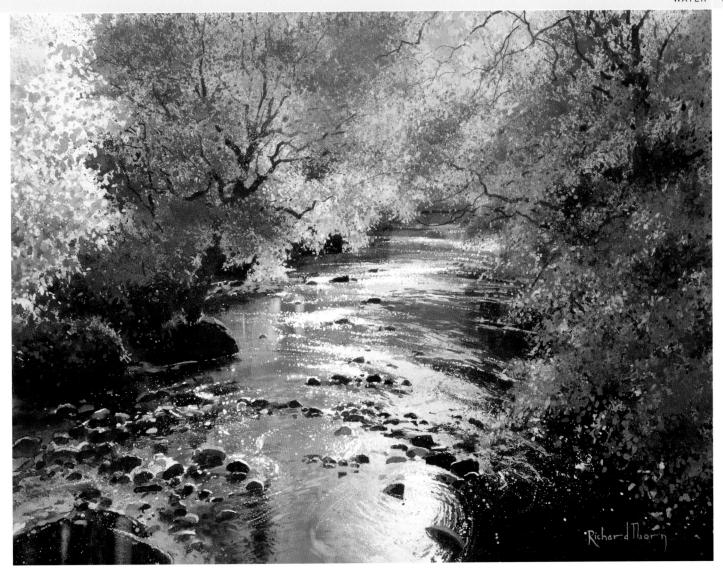

⋖ CAROL EVANS

MYSTIC BEACH

Many of Carol Evans' watercolours depict scenes on Canada's west coast and she takes advantage of the wet, delicate and raw subtleties of watercolour washes to convey natural phenomena like the waves here, crashing into the bluffs and bursting into foam and spray.

A RICHARD THORN

EARLY AUTUMN

This subject was a complex interplay of light and reflection. The artist underpainted with a series of watercolour washes to build up the picture, then overlaid the dry paint with spots of gouache to add detail.

Reflections and Still Water

Reflections are one of the many bonuses of water provided free of charge to the painter. Not only do they form lovely patterns in themselves, they can also be used as a powerful element in a composition, allowing you to balance solid shapes with their watery images and to repeat colours in one area of a painting in another.

The most exciting effects are seen when small movements of water cause ripples or swells that break up the reflections into separate shapes, with jagged or wavering outlines.

Water can, of course, be so still that it becomes literally a mirror, but this does not necessarily make a good painting subject because it loses much of its identity.

As in all water subjects, try to simplify reflections and keep the paint fresh and crisp. Let your brush describe the shapes by drawing with it in a calligraphic way (see Brush Drawing, pages 54-55) and never put on more paint than you need. The amount of detail you put into a reflection will depend on how near the front of the picture it is. A distant one will be more generalized because the ripples will decrease in size as they recede from you, so avoid using the same size of brushmark for both near and far reflections, or the water will appear to be flowing uphill. You could emphasize foreground reflections by painting wet-on-dry, and give a softer, more diffused, quality to those in the background by using the wet-in-wet or lifting out methods.

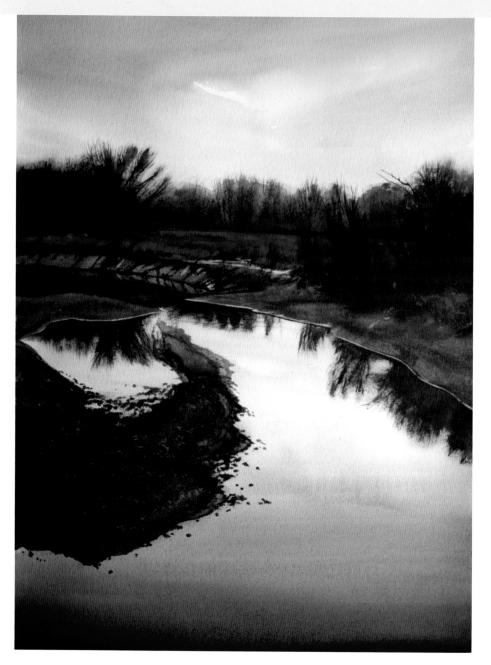

▲ RICHARD HIGHSMITH RIO GRANDE REFLECTIONS The water was very shallow w

The water was very shallow when this painting was done, hence the almost mirrored reflection. Starting at the upper shore and working downwards, the washes progressed from light to fairly dark blues. All of the reflections and land shapes went in last, using bristle brushes and a feathering technique.

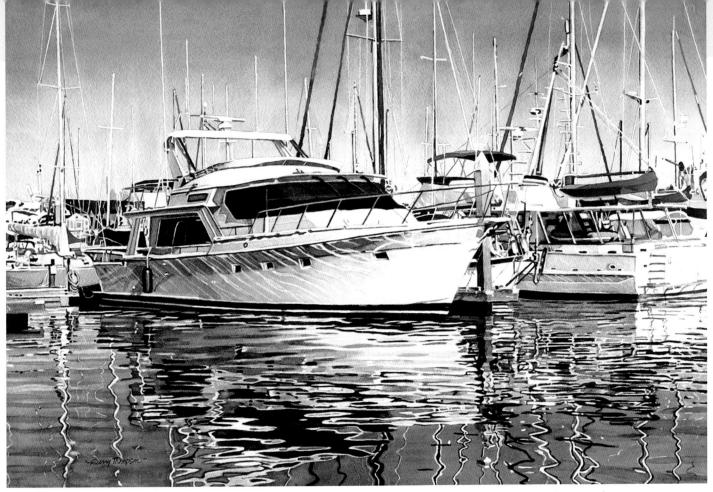

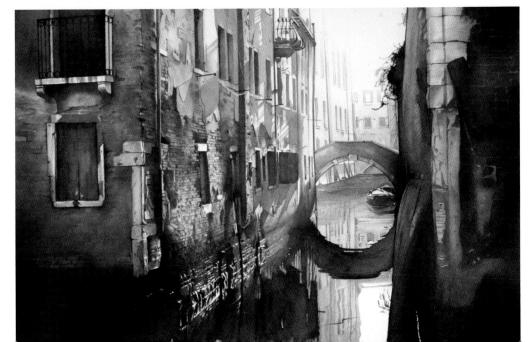

▲ GERRY THOMPSON LIFE OF LEISURE

Capturing the abstract shapes of reflections in water is key to making water look 'real'. A number of transparent glazes were used to build up the reflections. Both the initial use of masking fluid and final touches of white acrylic paint to clean up edges helped to make the reflections 'sparkle'.

■ DENIS RYAN

CRUMBLING DECADENCE

The artist has skilfully captured the glassy reflections of the buildings in this Venetian canal. The contrast in tone between dark and light areas reinforces the mirror-like surface of the water.

Light on Water

The effects of light on water are almost irresistible, particularly the more dramatic and fleeting ones caused by a changeable sky. Obviously they can seldom be painted on the spot; a shaft of sunlight suddenly breaking through cloud to spotlight an area of water could disappear before you lay out your colours. But you can recapture such effects in the studio as long as you have observed them closely,

committed them to memory and made sketches of the general lie of the land.

When you begin to paint, remember that the effect you want to convey is one of transience, so try to make your technique express this quality. This does not mean splashing on the paint with no forethought - this is unlikely to be successful. One of the paradoxes of watercolour painting is that the most seemingly spontaneous effects

are, in fact, the result of careful planning.

Work out the colours and tones in advance so that you do not have to correct them by overlaying wash over wash. It can be helpful to make a series of small preparatory colour sketches to try out various techniques and colour combinations. Knowing exactly what you intend to do enables you to paint freely and without hesitation. If you decide to paint wet-in-wet, first practise

controlling the paint by tilting the board. If you prefer to work wet-on-dry, establish exactly where your highlights are to be and then leave them strictly alone or, alternatively, put them in last with opaque white used drily.

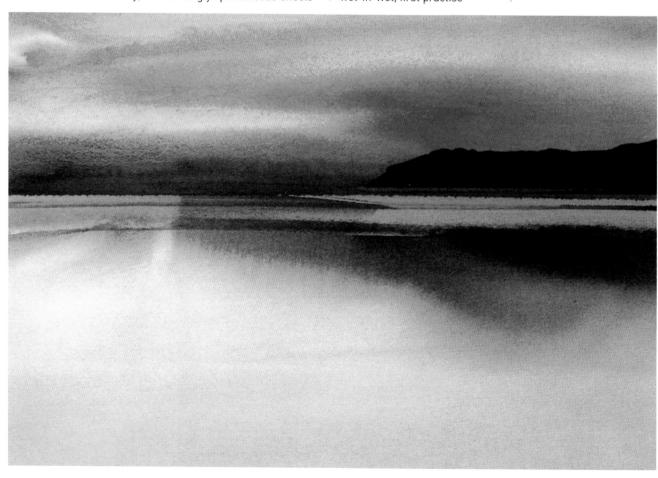

■ ROBERT TILLING NOIDMONT EVENING IEE

NOIRMONT EVENING, JERSEY

The magical effects of still water under a setting sun have been achieved by a skillful use of the wet-in-wet technique. Tilling works on paper with a moderately textured surface, stretched on large blackboard supports. He mixes paint in considerable quantities in old teacups or small food tins and applies it with large brushes, tilting his board at an angle of 60° or sometimes even more to allow the paint to run. This

method, although looking delightfully spontaneous, can easily get out of control, so he watches carefully what happens at every stage, ready to lessen the angle of the board if necessary.

▲ CAROL EVANS OCEAN FALLS

Light is this artist's prime concern and her painting process is entirely influenced by it. Here she has used various techniques, including reserving whites and working wet-in-wet, to capture the way sunlight illuminates the spray, the foam and the sparkles on the water.

Still life

There was a time when drawing objects such as plaster casts, bottles and bowls of fruit was regarded as the first step in the training of art students. Only after a year or two spent perfecting their drawing technique would they be allowed to move on to using actual paint.

This now seems an arid approach, almost designed to stifle any personal ideas and talent, but like many of the teaching methods of the past, it contained a grain or two of sense – drawing and painting 'captive' subjects is undeniably a valuable exercise in learning to understand form and manipulate paint. But still-life painting can be very much more than this. It is enormously enjoyable, and presents almost unlimited possibilities for experimenting with shapes, colours and composition as well as technique.

The great beauty of still life lies in its total controllability. You, as the artist, are entirely in charge: you decide which objects you want to paint, arrange a set-up that shows them off to advantage, and orchestrate the colour scheme, lighting and background. Best of all, particularly for those who dislike being rushed, you can take more or less as long as you like over the painting. If you choose fruit and vegetables, they will, of course, shrivel or rot in time, but at least they will not move. This degree of choice allows you to express your own ideas in an individual manner, whereas in a portrait or landscape painting, you are more tied to a specific subject.

The still-life tradition

Almost all artists have at some time turned their hands to still life, and long before it became an art form in its own right, lovely little still lifes often appeared among the incidental detail in portraits and religious paintings. The first pure still-life paintings were those with an allegorical significance that became popular in the sixteenth century. Typical of these paintings, known as

vanitas, were subjects such as flowers set beside a skull, signifying the inevitable triumph of death. It was the Flemish and Dutch painters of the seventeenth and eighteenth centuries, though, who really put still-life and flower painting on the map, with their marvellously lavish arrangements of exotic fruit and flowers, rich fabrics and fine china and glass. The vanitas still lifes reminded their religious patrons of the transience of life, but these exuberant and unashamedly materialistic works, painted for the wealthy merchant classes, were celebrations of its many sensual pleasures.

Still-life painting has remained popular with artists ever since, and, although it was regarded as an inferior art form by the French Academy, who favoured paintings with grand historical or mythological themes, it gained respectability when the Impressionists altered the course of painting forever.

■ BARBARA FOX SWEETNESS AND LIGHT

This exquisite still life evokes the work of the Dutch masters, and indeed the artist's working procedure mirrors their method of painting. She begins with a detailed drawing and then painstakingly builds up the picture with numerous glazes to achieve rich colours and deep tonal values. A painting like this may take many weeks to complete.

Found Subjects

Many still-life paintings are the result of carefully planned arrangements. Paul Cézanne (1839–1904) reputedly spent days setting up his groups of fruit and vegetables before so much as lifting his brush. Sometimes, though, you may just happen to see a subject

such as plates and cups on a table or a few vegetables lying on a piece of newspaper that seems perfect in itself, or needs only small adjustments to make it so. These 'found' groups have a charm of their own, hinting at impermanence and the routines of everyday life - the vegetables will shortly be made into soup and the crockery put back in the cupboard.

Found groups obviously have to be painted more quickly than arranged ones, but this is in some ways an advantage, since you want to achieve a spontaneous, unposed effect. So make your technique express this and paint freely, putting down broad impressions of shape and colour.

Alternatively, you can use the idea of the found group as the

basis for a more deliberate setup, placing the objects in a more convenient place for painting or one where they have better light. Be careful, however, not to destroy the essence of the subject by overplanning and including too many extra elements.

◀ THIERRY DUVAL **VÉLO À COPENHAGEN**

Thierry Duval is often inspired by apparently insignificant details in an image. Here, the design of the wheels and the spokes of the bike presented a particular challenge for him. He blocked out the highlights with masking fluid and where these highlights were particularly fine and light - for example, the wheel spokes - he applied the fluid with a pen.

■ GIRALDINE GIRVAN **VICTORIA DAY**

Here the background is as busy and eventful as the foreground, as befits a painting in which colour and pattern are the dominant themes. Notice how the artist has echoed the shapes of the blue fish (bottom right) in the patterned wallpaper above.

▲ RICHARD BÉLANGER MOBILE HOME

The beautiful surface texture of these wooden boards attracted this artist's attention. Both boards and the bleached-out skull are similar in colour and tone and this highly restricted palette serves to unify the whole image. The only accent in an otherwise almost monochrome work is the little brown bird sitting on the skull.

Arranging Groups

Planning the disposition of objects in a still-life painting so that they provide a satisfactory balance of shapes and colours is as important as painting it, so never rush at this stage.

A good still life, like any other painting, should have movement and dynamism, so that your eye is drawn into the picture and led around it from one object to another. It is wise to avoid the parallel horizontals formed by the back and front of a tabletop, as the eye naturally travels along straight lines and these will lead out of the painting instead of into it. A device often used to break up such horizontals is to arrange a piece of drapery so that it hangs over the front of the table and forms a rhythmic curve around the objects. An alternative is to place the table at an angle so that it provides diagonal lines that will lead inwards to the centre of the picture.

Never arrange all the objects in a regimented row with equal spaces between them, as this will look static. Try to relate them to one another in pictorial terms by letting some overlap others, and give a sense of depth to the painting by placing them on different spatial planes. Finally, make sure that the spaces between the objects form pleasing shapes - these 'negative shapes' are often overlooked, but they play an important role in composition.

A DENNY BOND **CANNED PEACHES**

Painted in extraordinarily realistic detail, this still life of peaches and canned fruit uses a variety of different techniques to achieve the finished result: flat washes, wet-in-wet, masking and scraping back.

► CHERRYL FOUNTAIN STILL LIFE WITH PHEASANT AND **HYACINTH**

This artist also paints landscapes, in the same highly detailed style, but she likes still life particularly because she can control her set-up in a way that allows her to express her love of both pattern and texture.

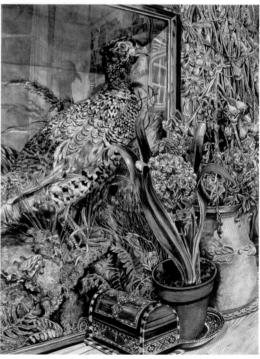

▼ GERRY THOMPSON

THE GATHERING

Although the colours are the same, each of the jugs in this tightly arranged group is unique in form.

Note how the two jugs in the foreground have been cropped off at the bottom edge, as if they do not need to be seen in their entirety but just belong to an overall pattern.

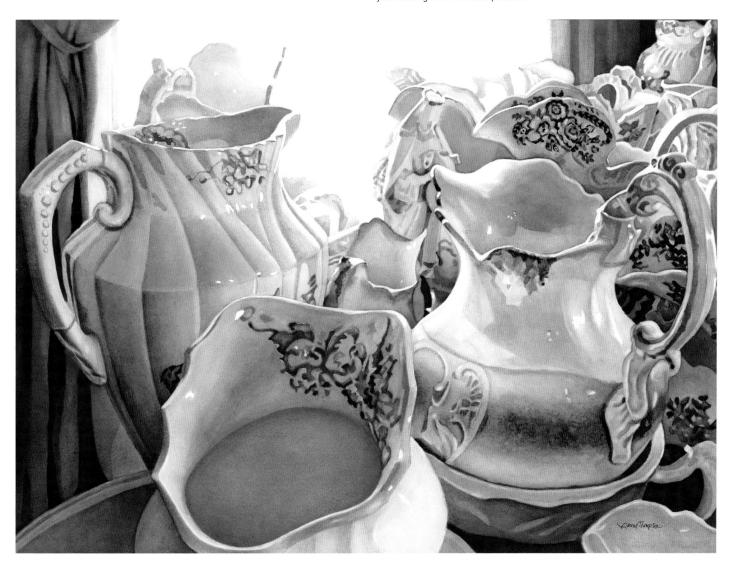

Α

Index

acrylic paints 11 aluminium foil 15, 81 analagous palette 97 animals 116-117 domestic and farm animals 122-123 movement 120-121 B back runs and blossoms 40-41 birds 118-119 blending 34-35 blending tones 27 blots 74-75 body colour 82-83 bristle brushes 56 brush drawing 54-55 brushes 9, 14, 55, 56 choosing and caring for your brushes 15 brushwork 52-53 bubble wrap 15 buildings 124-125 buildings in landscape 132-133 details and texture 128-129 interiors 130-131 line and wash 60 order of working 112 towns and cityscapes 126-127 C candles 15 Chinese brushes 14, 55

cityscapes 126-127

clingfilm 15,81 cloud formations 160 cold-pressed paper 16 colour 92 analogous colours 95, 97 body colour 82-83 choosing a palette 96-99 colour in shadow 106-107 colour wheels 92, 94, 95. complementary colours 94.99 mixing and overlaying 100primary colours 92-93, 97 wet versus dry 101 complementary palette 99 composition figures 134 flowers 148-149 landscape 154 correcting mistakes 88-89 cotton balls/buds 15, 19 craft knives 15

D

drawing boards 18 drops 74-75 dropping in 51,75 dry-brush 53, 56-57

F

easels 18, 20 easel carriers 20 edges 88 hard edges 36-37 intricate edges 23 erasers 15

F

feathering 42-43 figures 134-135 figure in context 140-141 figure studies 136-137 groups 142-143 portraits 138-139 flat wash 24-25 flowers 144-145 composition 148-149 natural habitat 150-153 single specimens 146-147 foliage 156-157 found subjects 170-171

G

glazing 38-39 goat-hair brushes 14 gouache paints 11 gouache and pastels 86 graded wash 26-27 granulation 40, 47-49 granulation medium 13, 48 groups of figures 142-143 objects 172-173 gum arabic 13 gummed tape 15

hair dryers 19 highlights 57, 65, 71 reserving highlights 62-63 hogshair brushes 14 hot-pressed paper 16

inks 11 interference paints 12

interiors 130-131 iridescent medium 13 iridescent paints 12

Κ

knives 15

L

lamps 18 landscape 154-155 buildings in landscape 132-133 cloud formations 160-161 light on water 166-167 order of working 113 reflections and still water 164-165 rocks and mountains 158trees and foliage 156-157 water 162-163 lifting out 44-45 light 106-107 light on water 166-167 working with light sources 108-109 light bulbs, daylight 18 light source 19 line and wash 60-61 liquid frisket 13

M

mark-makers 15 masking 66-67 masking fluid 13 permanent masking medium 13 media 13

mixed media 84-87 mixing colour 100 monochromatic palette 96 mottling 42-43 mountains 158-159

0

order of working 112-113 overlaying colour 101

Р

paints 9, 10-12 mixing paint 28 quality 11 palette knives 15 palettes 15, 19 pans 10 pan paintbox 10 paper 9, 16, 21, 65 finding the right side 17 pads or sheets? 17 priming paper 22-23 stretching paper 17 types of paper 16 weights of paper 16 paper towels 15, 19 pastels 86 pearlescent paints 12 pencils 15 pens 15 perspective 110-111 portraits 138-139 primary palette 97 priming paper 22-23

R

reflections 164-165 reserving highlights 62-63

rocks 158-159 rough paper 16 running in 50-51

S

sable brushes 14 salt 19.76-77 scalpels 15 scraping back 64-65, 88 scumbling 78-79 shadow 106-107 softening a shadow 89 working with light sources 108-109 sketching from life 116 soap 19 spattering 72-73 sponges 15 sponging 70-71 sponging off excess colour 88 using a sponge 25 spraying water 46 squirrel-hair brushes 14 still life 168-169 arranging groups 172–173 found subjects 170-171 order of working 113 straight lines 125 synthetic brushes 14

Т

texture 73, 80-81 buildings 128-129 tone 27, 70, 102-103 identifying tonal contrasts 103 make a tonal panel 104

toned ground 58-59, 82, 85 translating tone to colour 102 using a tonal viewer 105 toothbrushes 15 towns 126-127 trees 156-157 tubes 10

variegated wash 28-29 Velásquez palette 98 viewfinders 21

W

washes see flat wash; graded wash: line and wash: variegated wash water 162-163 light on water 166-167 painting moving water 32 reflections and still water 164-165 water jars 15, 19 waterbrush pens 14 watercolour 6, 9 types of watercolour 10 watercolour and pastel 86 watercolour board 17 watercolour crayons 86 watercolour medium 13 wax cravons 15 wax resist 68-69 wet-in-wet 32-33, 58, 75 wet-on-dry 23, 30-31, 59, 74 working areas 18-19 drawing boards 18

lamps 18

light bulbs 18 light source 19 organization 19 using an easel 18 working surfaces 19 working outdoors 20-21 checklist 21 choosing a location 20 equipment 20-21 landscape 154 paper 21 seating 20 shade 20 using a viewfinder 21

Credits

Bartel, Eva. www.evabartel.com 27 Beeden, Sharon, 147 Bélanger, Richard, www.richardbelanger.ca 131, 171 Belobrajdic, Tony. www.artiscon.com 56, 127, 130, 131 Beukenkamp, Annelein. www.abwatercolours.com 123, Bond, Denny. www.dennybondillustration.com 108, 172 Bowyer, Francis. www.francisbowyer.com 142 Boys, David. 53, 118 Brooks, Clare. www.clarebrooks.co.uk 87 Brown, Allen, 94 Brown, Cara. www.lifeinfullcolour.com, back jacket r (detail), 6, 144 Canter, Jean. www.jeancanter.co.uk 147 Cassells, Julie. www.juliecassels.co.uk 54 Chaderton, Liz. www.lizchaderton.co.uk 116-7, 121 Chapman, Lynne. www.lynnechapman.co.uk 136 Clinch, Moira. www.londonart.co.uk 31, 49, 160 Dawson, Paul. 84 Dowden, Joe. www.joedowden.net 42 Duval, Thierry. www.aquarl.free.fr 5, 29, 114-5, 124-5, 170 Emmons, Randy, www.randyemmons.com 156, 159 Evans, Carol. www.carolevans.com 154-5, 162, 167 Evans, Ray. 60 Fountain, Cherryl, www.cherrylfountain.artweb.com 172 Fox. Barbara. www.bfoxfineart.com 34, 168-9 Girvan, Geraldine. 148, 171 Hall, Tracy. www.watercolour-artist.co.uk 78, Hart, Jan. www.janhart.com 42 Highsmith, Robert. www.rhighsmith.com, back jacket l (detail), 25, 159, 161, 164 Hills, Shari. www.sharihills.com 12 Huntly, Moira. 80 Jesty, Ronald. 149, 158, 160

Jozwiak, Bev. www.bevjozwiak.com 123, 135, 138, 141

Lidzey Frsa, John. www.johnlidzey.co.uk 126, 140

Lobenberg, David. www.lobenbergart.com 138, 139.

Matthews, Jenny. www.jennymatthews.co.uk 146

McEwan, Angus. www.angusmcewan.com 129

Jacket r (detail), 2 (detail), 62, 152

Knight, Charles. RWS. ROI. 68

McGuiness, Michael, 137

Lamar, Jeanne. 74

7, 62, 139

Kennedy, Keith. www.sussexwatercoloursociety.com.uk153

Lin, Fealing, www.fealingwatercolour.com Front Jacket I (detail),

Linscott, Caroline. www.watercolorsbycarolinelinscott.com Front

Moran, Carolyne. www.carolynemoran.co.uk 149 Nelson, Vickie. www.vickienelson.com 122 Palmer, Juliette. 150 Pickett, Roger. www.rogerpickett-artist.com 47 Piper, Edward. 133 Poxon, David. www.davidpoxon.co.uk, front jacket (detail) lc, Quarto Publishing commission, 129 Purcell, Carl. www.thewatercolourteacher.com 133, 156, Reardon, Michael. www.mreardon.com 7, 132, Rogers, Mary Ann. www.marogers.com 52 Ryan, Denis. www.denis-ryan.com 165 Small, Katrina. www.katrinasmallstudios.com 76, 118 Smith, Anne. www.annesmithstudio.net 38 Sutton, Jake. www.jakesutton.co.uk 54, 137 Talbot-Greaves, Paul. www.talbot-greaves.co.uk 72, 158 Thorn, Richard, www.richardthornart.co.uk 90, 143, 157, 163 Tilling, Robert. 166 Tompson, Gerry. www.gerrytompson.ca 128, 165, 173 Van der Vliet, Wilma. www.wilmavandervliet.nl 146, Wade, Laura. www.laurawade.ie 119 Watson, Deb. www.debwatsonart.com. Photography thanks to Alan Lade 151 Wilmot, Tim. www.timwilmot.com 32, 126, 142 Wilson, Carolyn. www.carolynwilsonartist.com 86 Winkle, Jake. www.winkleart.com 120

With thanks to Jan Hart for her contribution to the Picture Making chapter.

All step-by-step and still life photography are the copyright of Quarto Publishing plc. While every effort has been made to credit contributors, Quarto would like to apologize should there have been any omissions or errors – and would be pleased to make the appropriate corrections for future editions of the book.

With special thanks to L.Cornelissen & Son who supplied the featured tools and materials used in this book. Contact them at L. Cornelissen & Son, 105 Great Russell Street, London WC1B 3RY. For online enquiries, go to www.cornelissen.com.

Art Director: Caroline Guest
Design: Nick Clark (www.fogdog.co.uk)
Editorial Assistant: Danielle Watt
Picture Researcher: Nick Wheldon
Creative Director: Moira Clinch
Publisher: Samantha Warrington